THOMSON

COURSE TECHNOLOGY

Professional ■ Trade ■ Reference

D1538623

Adobe®
Photoshop® CS
Type Effects

THOMSON

COURSE TECHNOLOGY

Professional ■ Trade ■ Reference

Adobe®
Photoshop® CS
Type Effects

Ron Grebler, Dong Mi Kim, Kwang Woo Baek, and Kyung In Jang

SVP, Thomson Course Technology PTR: Andy Shafran

Publisher: Stacy L. Hiquet

Senior Marketing Manager: Sarah O'Donnell

Marketing Manager: Heather Hurley

Manager of Editorial Services: Heather Talbot

Senior Acquisitions Editor: Kevin Harreld

Senior Editor: Mark Garvey

Associate Marketing Managers: Kristin Eisenzopf and Sarah Dubois

Project Editor/Copy Editor: Cathleen D. Snyder

Technical Reviewer: John Freitas and Burt LaFontaine

Thomson Course Technology PTR Market Coordinator: Amanda Weaver

Interior Layout Tech: Bill Hartman

Cover Designer: Mike Tanamachi

CD-ROM Producer: Brandon Penticuff

Indexer: Sharon Shock

ISBN: 1-59200-363-x

Library of Congress Catalog Card Number: 2003115723

Printed in the United States of America

04 05 06 07 08 BU 10 9 8 7 6 5 4 3 2 1

THOMSON

COURSE TECHNOLOGY

Professional ■ Trade ■ Reference

MUSKA & LIPMAN Publishing

Thomson Course Technology PTR, a division of Thomson Course Technology
25 Thomson Place ■ Boston, MA 02210 ■ http://www.courseptr.com

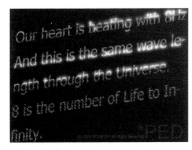

Effect 1

Kinetic flash Type 1

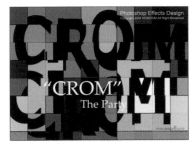

Effect 2

Mosaic Type 15

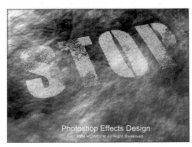

Effect 3

Road Sign Type 23

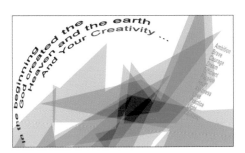

Effect 4

Creative Wave 37

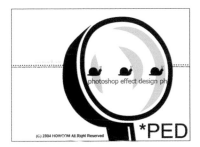

Effect 5

Playing a Magnifier 47

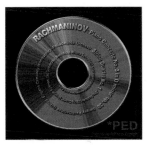

Effect 6

Spiral CD Title 57

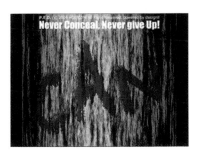

Effect 7

Painted on the Bark 71

Effect 8

Stone-Like Type 83

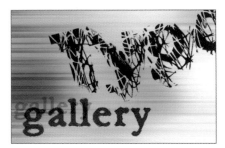

Effect 9

Grunge Type 95

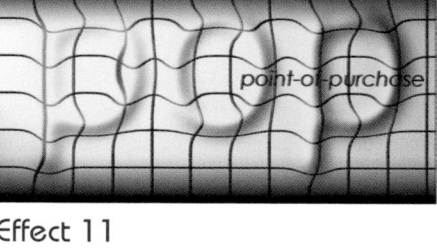
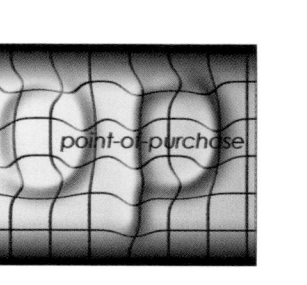

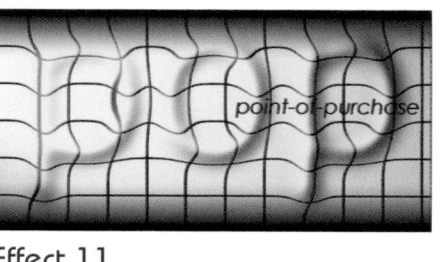

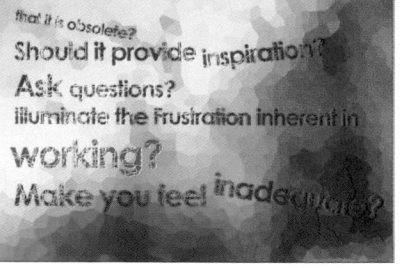

Our heart is beating with 8Hz
And this is the same wave le-
ngth through the universe.
8 is the number of Life to in-
finity.

*PBD

Effect 1 : Kinetic Flash Type

In our fast-paced society, the flashing signs we see all around us are more than just words. The slightly offset and partially flashing words create a modern feel.

Kinetic Flash Type

Our heart is beating with 8Hz.

And this is the same wave length through the Universe.

8 is the number of Life to Infinity.

Effect 1: Kinetic Flash Type

Total Steps

STEP 1. Creating a New Work Window

STEP 2. Creating the Text Field

STEP 3. Entering the Text

STEP 4. Creating an Alpha Channel

STEP 5. Applying Noise to the Alpha Channel

STEP 6. Creating a Horizontal Stripe Alpha Channel

STEP 7. Magnifying the Stripes

STEP 8. Selecting in the Shape of the Completed Channel

STEP 9. Adding a Text Layer Mask

STEP 10. Copying the Text Layer

STEP 11. Overlapping the Mask Image

STEP 12. Setting the Text Color

STEP 13. Creating the Third Text Layer

STEP 14. Editing the Alpha Channel

STEP 15. Darkening the Alpha Channel Image

STEP 16. Blurring the Alpha Channel Image

STEP 17. Selecting in the Shape of the Completed Alpha Channel

STEP 18. Applying a Text Layer Mask

STEP 19. Flashing Text

STEP 20. Strengthening the Flashing Effect

STEP 21. Setting Up the Gradient

STEP 22. Partial Flashing Text

STEP 23. Setting Up the Gradient Again

STEP 24. Applying the Gradient to the Background

STEP 25. Slanting the Text

STEP 26. Entering a Title

STEP 1. Creating a New Work Window

Press Ctrl+N to create a new work window. Click on the Preset box and choose 640×480 to create a 640×480-pixel workspace. Set the Background Contents parameter to Background Color.

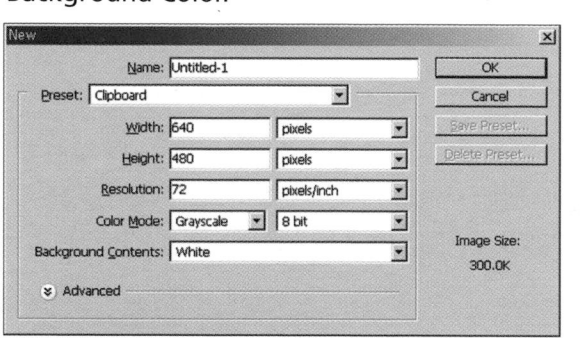

STEP 2. Creating the Text Field

In the toolbox on the left, first click on the Default Foreground and Background Colors button to set up the default color and then click on the Switch Foreground and Background Colors button to set the foreground color to white and the background color to black.

Choose the Horizontal Type Tool from the toolbox, and then, in the Character Palette, set the font to Tahoma, the font size to 45 pt, and the leading to 69.62. If you can't see the Character Palette, choose Window > Character from the menu at the top. Then, drag the mouse over the work window to create a text field the size of the entire work window.

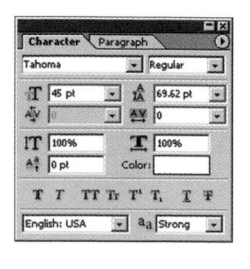

STEP 3. Entering the Text

Type in the text as shown here.

> Our heart is beating with 8Hz. And this is the same wave length through the Universe.
> 8 is the number of Life to Infinity.

STEP 4. Creating an Alpha Channel

Open the Channels Palette and click on the Create New Channel button at the bottom to create a new channel. Click on the new alpha channel (Alpha 1) to select it. This will make the work window black.

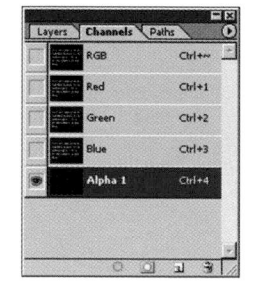

STEP 5. Applying Noise to the Alpha Channel

Choose Filter > Noise > Add Noise from the menu at the top and set the Amount to 80% and the Distribution to Gaussian, Monochromatic. This will create noise particles on the work window.

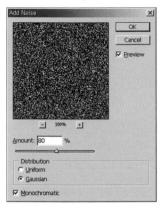

STEP 6. Creating a Horizontal Stripe Alpha Channel

Choose Filter > Blur > Motion Blur from the menu at the top and set the Angle to 0 and the Distance to 999 pixels. This will convert the noise into horizontal stripes. As you can see, the stripes are stronger at the ends, but blurry in the middle.

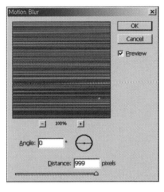

STEP 7. Magnifying the Stripes

Choose the Rectangular Marquee Tool from the toolbox and use it to select the top-right of the image, as shown here.

Then, press Ctrl+T to apply the Free Transform command. Drag the handles on the image to fit the size of the image to the screen. This completes the horizontal stripes. Click on the Move Tool, and then click on Apply to apply the transformation.

Choose Image > Adjustments > Auto Levels to make the image sharper and more focused.

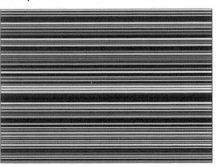

STEP 8. Selecting in the Shape of the Completed Channel

Choose Filter > Texture > Grain from the menu at the top and set the Intensity to 82, the Contrast to 50, and the Grain Type to Horizontal. This adds a grainy texture to the horizontal stripes. You have now completed editing the channel image.

Click on the Alpha 1 channel in the Channels Palette while holding down the Ctrl key to create a selection frame in the shape of the alpha channel.

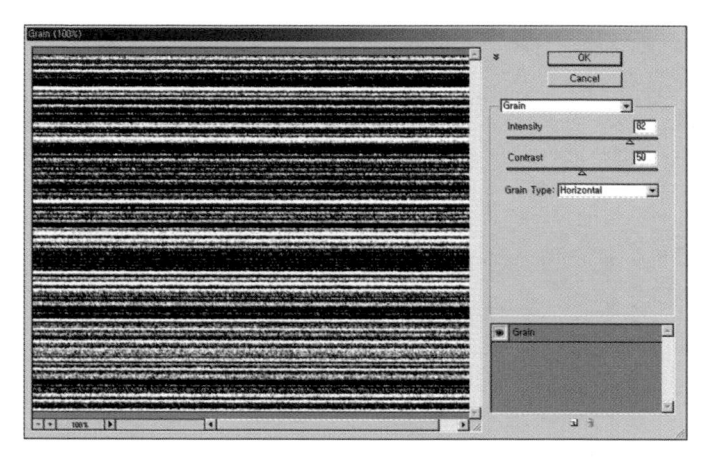

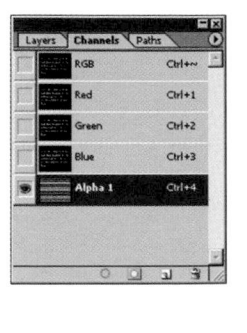

STEP 9. Adding a Text Layer Mask

Click on the Layers Palette to open the palette, and click on the text layer to select it. The edited image will appear in place of the alpha channel image. With the selection frame (in the shape of the alpha channel) selected, click on the Add a Layer Mask button at the bottom of the Layers Palette. This will create a layer mask in the shape of the selection frame on the text layer. Areas that are not selected will be covered and made transparent. Looking at the Layers Palette, you will see a mask icon appear to the right of the text layer icon.

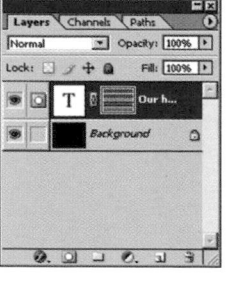

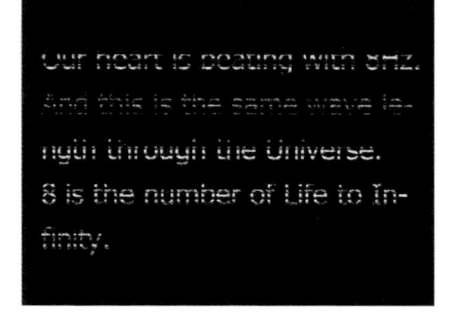

STEP 10. Copying the Text Layer

In the Layers Palette, drag and drop the text layer on the Create a New Layer button at the bottom. Clicking on the mask icon of the copied text layer will create a mask edit icon in front of the copied text layer, indicating that the mask image can be now be edited. Press Ctrl+I to invert the color of the mask image. This will invert the hidden and visible areas in the copied text layer.

Our heart is beating with 8Hz.
And this is the same wave length through the Universe.
8 is the number of Life to Infinity.

STEP 11. Overlapping the Mask Image

In the Layers Palette, click on the layer icon of the original text layer to select the layer, and then click on the link icon between the layer icon and the mask icon to break the link. This will allow you to move the two layers independently of each other. Hold down the Ctrl key and press the ? key on the keyboard two to three times to create the slightly offset and overlapping text image shown here.

Our heart is beating with 8Hz. And this is the same wave length through the Universe. 8 is the number of Life to Infinity.

STEP 12. Setting the Text Color

In the Layers Palette, click on the layer icon of the first text layer to select it.

Then, click on the Set the Text Color button in the Character Palette.

Color the selected text layer orange (RGB=253, 109, 11).

Next, click on the second text layer in the Layers Palette and again click on the Set the Text Color button in the Character Palette to color the selected text layer brown (RGB=94, 30, 0).

Our heart is beating with 8Hz. And this is the same wave length through the Universe. 8 is the number of Life to Infinity.

STEP 13. Creating the Third Text Layer

In the Layers Palette, drag and drop the first text layer onto the Create a New Layer button to copy the layer.

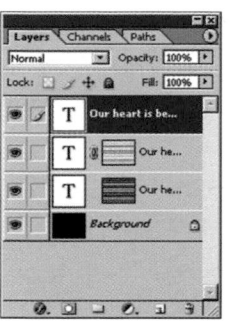

Then, drag and drop the mask icon on the right side of the copied text layer onto the Delete Layer button.

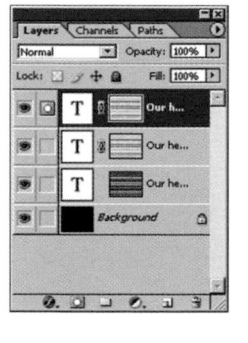

In the warning dialog box that appears, click on Discard to delete the selected layer mask.

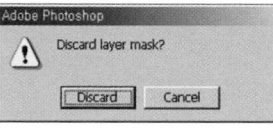

Our heart is beating with 8Hz. And this is the same wave length through the Universe. 8 is the number of Life to Infinity.

STEP 14. Editing the Alpha Channel

Click on the Channels Palette to open the palette, and then click on Alpha 1 to select the alpha channel.

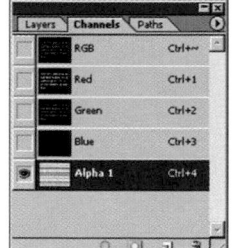

The text image will disappear, leaving behind the horizontal stripes alpha channel. Press Ctrl+I to invert the colors of the alpha channel.

STEP 15. Darkening the Alpha Channel Image

Choose Image > Adjustments > Levels from the menu at the top. Move the black and white tabs at the bottom of the histogram as shown here. This will further darken the dark areas of the image.

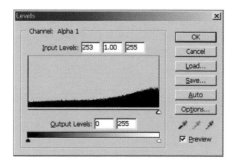

STEP 16. Blurring the Alpha Channel Image

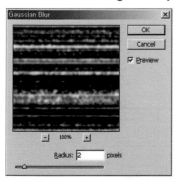

Choose Filter > Blur > Gaussian Blur from the menu at the top and set the Radius to 2 pixels. This will blur the alpha channel image.

STEP 17. Selecting in the Shape of the Completed Alpha Channel

Choose Image > Adjustments > Levels from the menu at the top and move the black and white tabs at the bottom of the histogram as shown here. This will make the black areas of the image wider and the white stripes narrower.

Choose Alpha 1 from the Channels Palette while holding down the Ctrl key to create a selection frame in the shape of the alpha channel.

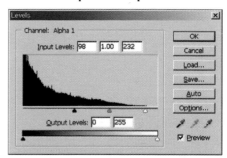

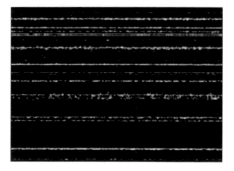

STEP 18. Applying a Text Layer Mask

Select the text layer at the very top of the Layers Palette and click on the Add a Layer Mask button to create a layer mask in the shape of the selection frame. Areas that are not selected will be covered and made transparent.

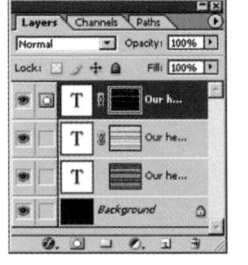
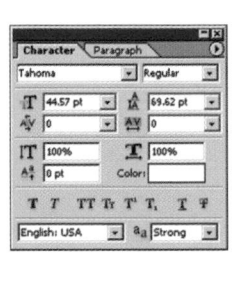

Click on the layer icon of the text layer at the top of the Layers Palette, go to the Character Palette, click on the Set the Text Color button, and choose white. Only the top part of the text will appear white.

STEP 19. Flashing Text

Select the text layer at the very top of the Layers Palette and click on the Add a Vector Mask button. Double-click on the vector mask, and then choose Outer Glow in the Layer Style Panel.

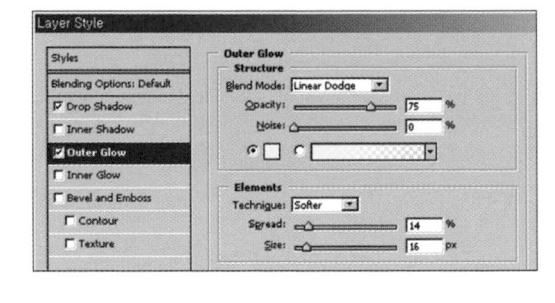

Set up the Outer Glow, as shown here. Set the Blend Mode to Linear Dodge, the Opacity to 75%, the Noise to 0%, the color to light yellow (RGB=255, 255, 190), the Spread to 14%, and the Size to 16 px. The white part of the text makes the text look like it's flashing.

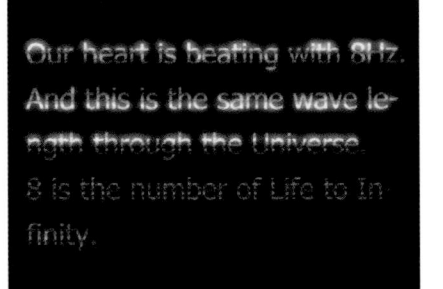

STEP 20. Strengthening the Flashing Effect

Choose Drop Shadow from the list on the left side of the Layer Style Panel and set up the values as shown here. Set the Blend Mode to Linear Dodge, the color to white, the Opacity to 100%, the Distance to 0 px, the Spread to 6%, and the Size to 4 px. This makes the flashing effect stronger.

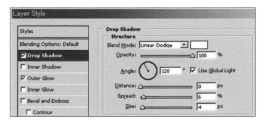

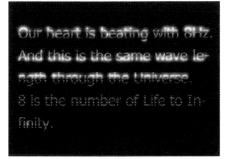

STEP 21. Setting Up the Gradient

Choose the Gradient Tool from the toolbox, click on the Foreground Color button, and set the color to black. In the option bar at the top, click on the Radial Gradient button and set the Mode to Color Burn and the Opacity to 60%, and check Reverse.

Click on the Gradient Picker arrow toward the left side of the option bar to open the Gradient Preset Panel, and choose the Foreground to Transparent gradient, as shown here. If you can't see the icon, click on the Option button on the top-right of the Preset Panel and choose Reset Gradients.

STEP 22. Partial Flashing Text

Select the text layer at the very top of the Layers Palette. The mask edit icon in front of the layer indicates that the mask image can now be edited.

Click on the top-right part of the image, as shown here, and drag it down to the bottom-left corner to apply the gradient color to the layer mask image. The black color of the gradient gets darker the farther away you get from the point where the mouse was first clicked, and the image becomes more transparent. The glow effect also gets weaker the farther away you get.

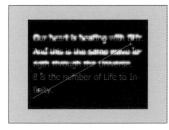

STEP 23. Setting Up the Gradient Again

In the toolbox, set the foreground color to dark brown (RGB=104, 23, 0) and the background color to black.

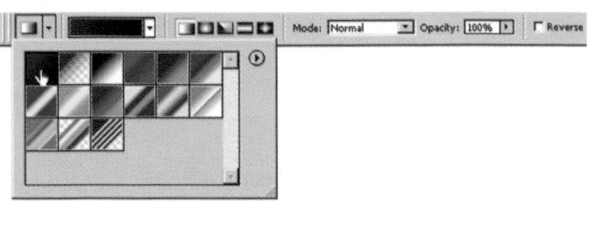

Choose the Gradient Tool, click on the Gradient Picker arrow, and choose the first gradient icon (Foreground to Background). Click on the Linear Gradient button on the left to create a linear gradient. Then, set the Mode to Normal and the Opacity to 100%, and check Reverse.

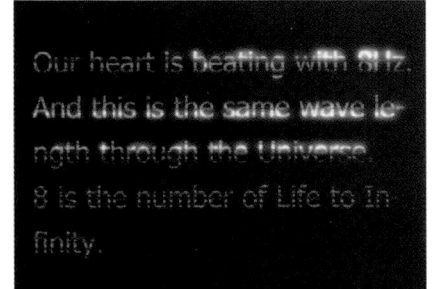

STEP 24. Applying the Gradient to the Background

Choose the Background layer, which is located at the very bottom of the Layers Palette.

Click the mouse on the top-right of the work window and drag it down to the bottom-left corner to apply the gradient to the background, as shown here.

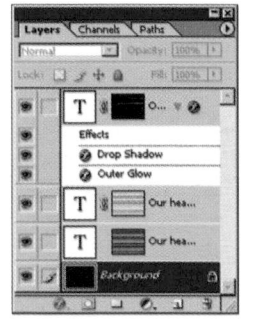

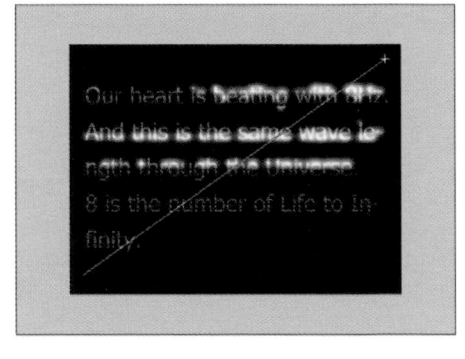

STEP 25. Slanting the Text

Click on the layer icon of the text layer at the very bottom of the Layers Palette and click on the link icon so that it is visible again. This will allow you to edit the layer image and the mask at the same time. Click on the link icon in front of the two

remaining layers to link the three text layers together. Press Ctrl+T to apply the Free Transform command.

Hold down the Ctrl key and drag the handles on the corners of the image to slant the image, as shown here. This will apply the effects to all three text layers and their masks.

STEP 26. Entering a Title

Choose the Horizontal Type Tool from the toolbox and type in the title.

Choose the font, font size, and font color in the Character Palette, as shown here.

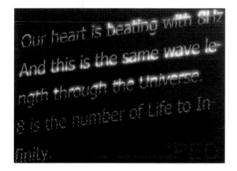

Effect 2: Mosaic Type

The slightly offset characters of this mosaic-type text allow you to create a slightly irregular rhythm from an otherwise uniform mosaic. For viewers, this type of text is reminiscent of fun puzzles.

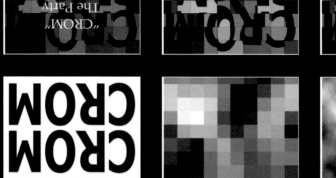

Photoshop Effects Design
Copyright 2004 HOWCOM All Right Reserved

www.designB.co.kr

Mosaic Type

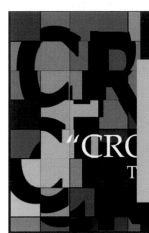

Effect 2: Mosaic Type

Total Steps

STEP 1. Creating a New Work Window

STEP 2. Creating the Mosaic

STEP 3. Saving the Source for the Displace Filter

STEP 4. Making the White Background

STEP 5. Entering the Text

STEP 6. Adjusting the Text Size

STEP 7. Applying the Displace Map

STEP 8. Blending the Tile Image

STEP 9. Creating the Tile Border

STEP 10. Blending the Borders

STEP 11. Entering a Title

STEP 12. Adjusting the Font Size and Alignment

STEP 13. Completing the Image

STEP 1. Creating a New Work Window

Press Ctrl+N to create a new work window. Click on the Preset box and choose 640×480 to create a 640×480-pixel workspace.

In the toolbox, click on the Default Foreground and Background Colors button to set up the default color and set the foreground color to black and the

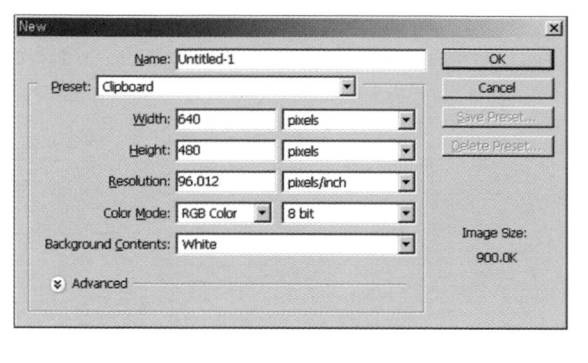

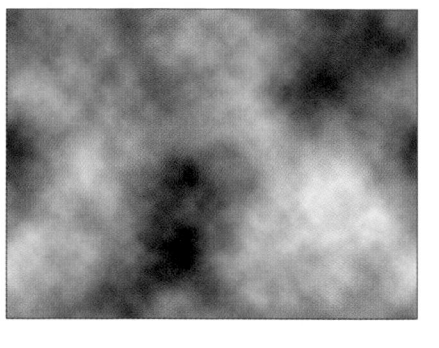

background color to white. Choose Filter > Render > Clouds from the menu at the top to create irregular black and white clouds. Press Ctrl+F to apply the command again. Every time the command is repeated, a different cloud shape will be created. Continue repeating the command until you arrive at the shape you like.

STEP 2. Creating the Mosaic

Choose Filter > Pixelate > Mosaic from the menu at the top and set the Cell Size parameter to 64. A square mosaic pattern with a cell size of 64 will be created. Choose Image > Adjustments > Auto Levels from the menu at the top to make the image sharper and more focused.

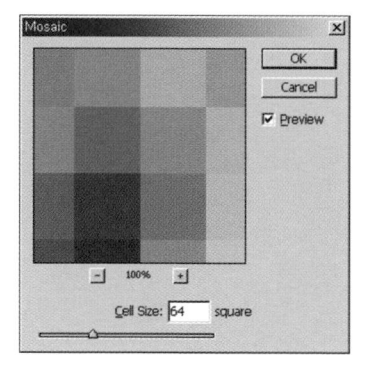

STEP 3. Saving the Source for the Displace Filter

All the work you've done up to this point will be saved as the source for the Displace filter. Press Ctrl+Alt+S to save the mosaic image as a PSD file of a different name (disp_map.psd). This file is included on the supplementary CD-ROM.

STEP 4. Making the White Background

Press Ctrl+J to copy the mosaic background. You should see the new layer (Background copy) in the Layers Palette. (Change the name of the new layer to Background Copy if it was created with a different name.) Click on the Layer Visibility icon in front of the copied layer to hide the layer. Then, select the Background layer and press Ctrl+Del to fill in the selected layer with the background color (white).

STEP 5. Entering the Text

Choose the Horizontal Type Tool from the toolbox.

Type in the text as shown here. Press Ctrl+Enter when you are finished entering the text.

In the Character Palette, set the font to Tahoma, the font size to 72 pt, the font style to Bold, and the leading to 60 pt.

STEP 6. Adjusting the Text Size

Press Ctrl+T to apply the Free Transform command. Drag out the handles on the text to make the text larger. Press Enter to apply the transformation.

In the Layers Palette, click on the Option button and choose Merge Down to merge together the text layer and the white background layer.

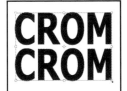
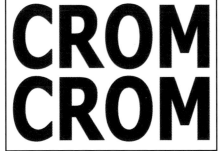

STEP 7. Applying the Displace Map

Choose Filter > Distort > Displace from the menu at the top. Set the Horizontal Scale to 50 and the Vertical Scale to 50 and click on OK. You should now see a dialog box from which you can choose the displace map source. Choose the source file you made earlier (disp_map.psd). This file is included on the supplementary CD-ROM. The text will have been displaced further on the light tile to create a non-uniform and random image overall.

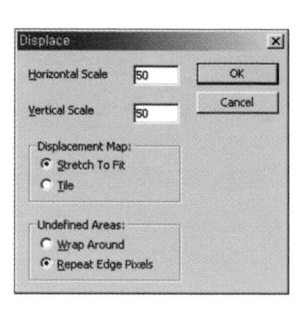

STEP 8. Blending the Tile Image

From the Layers Palette, click on the tile layer (which was hidden) so that it is visible again, and then set the Blend Mode to Multiply. This will blend the tile image and the text layer. You will notice that the cropped text lines up perfectly with the edges of the tile image.

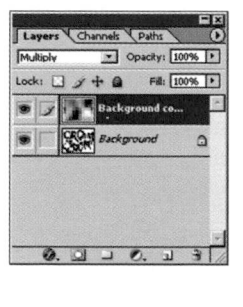

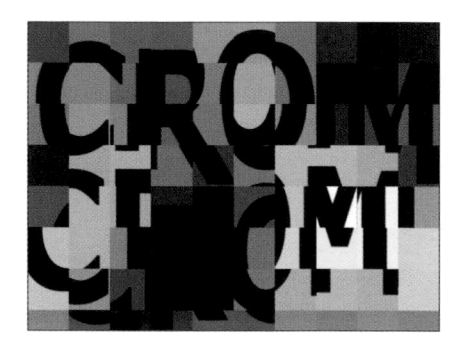

STEP 9. Creating the Tile Border

Drag and drop the mosaic layer at the very top of the Layers Palette onto the Create a New Layer button to copy the layer. Select the copied layer and choose Filter > Stylize > Find Edges from the menu at the top to find the different-colored edges.

STEP 10. Blending the Borders

Choose the border layer from the Layers Palette and set the Blend Mode to Multiply. This will blend the black border with the image.

 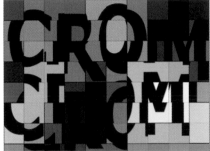

STEP 11. Entering a Title

Click on the Foreground Color button in the toolbox and set the foreground color to white. Choose the Horizontal Type Tool from the toolbox and type in the title as shown here.

In the Character Palette, set the font to Palatino Linotype and the font size to 48 pt.

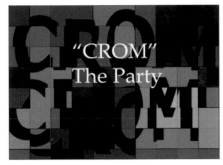

STEP 12. Adjusting the Font Size and Alignment

Double-click on the text layer in the Layers Palette. This allows you to edit the text layer. Choose some of the text and adjust the font size or press the spacebar to adjust the alignment.

 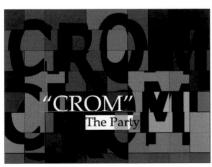

STEP 13. Completing the Image

Use the Horizontal Type Tool to enter the remaining subtitles.

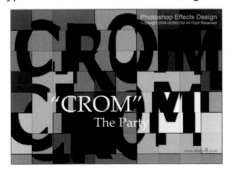

Effect 3: Road Sign Type

In this section, you will make a faded road sign.
A realistic perspective and a roughened texture of a
wet road that faintly reflects the surroundings create
a very real-looking image.

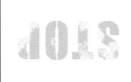

Photoshop Effects Design
(c) 2004 HOWCOM All Right Reserved

Road Sign Type

Effect 3: Road Sign Type

Total Steps

STEP 1. Creating a New Work Window

STEP 2. Entering the Text

STEP 3. Adjusting the Text Size

STEP 4. Making the Cloud Texture

STEP 5. Adding Noise to the Clouds

STEP 6. Copying the Cloud Image as a Mask for the Text Layer

STEP 7. Editing the Layer Mask

STEP 8. Making a Grainy Mask Image

STEP 9. Adding Noise to Semitransparent Areas of the Text

STEP 10. Adding Noise to Transparent Areas of the Text

STEP 11. Blending the Two Text Layers

STEP 12. Adding Space between Characters

STEP 13. Changing Text Color

STEP 14. Creating Clouds in the Background

STEP 15. Using Background Light to Create Dimension

STEP 16. Slanting the Text

STEP 17. Adding Dimension to the Image

STEP 18. Choosing the Background Image

STEP 19. Pasting the Background Image

STEP 20. Editing the Background Image

STEP 21. Distorting the Image

STEP 22. Blending the Background Image

STEP 23. Blending the Text Layers

STEP 24. Entering the Subtitle

STEP 1. Creating a New Work Window

Press Ctrl+N to create a new work window.
Click on the Preset box and choose 640×480
to create a 640×480-pixel workspace.

STEP 2. Entering the Text

In the toolbox, click on the Default Foreground and Background
Colors button to set up the default color and set the foreground color
to black and the background color to white.

Choose the Horizontal Type Tool from the toolbox and type in the text
as shown.

In the Character Palette, set the font to Impact and the font size to 72
pt. If you can't see the Character Palette, choose Window > Character
from the menu at the top.

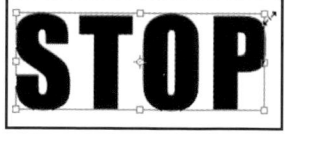
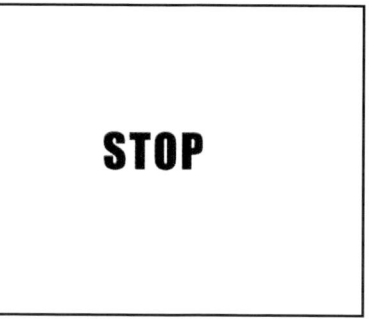

STEP 3. Adjusting the Text Size

Press Ctrl+T to apply the Free Transform command. Drag
out the handles on the text to make it larger. Holding
down the Shift key while you drag the handles allows you
to change the text size proportionately with respect to the
height and width. Holding down the Alt key allows you to adjust the size of the text
with respect to the center. You can also adjust the text size while holding down both
the Shift and Alt keys. Press Enter to finalize the transformation.

STEP 4. Making the Cloud Texture

In the Layers Palette, click on the Create a New Layer button at the bottom to create a new layer at the very top of the palette.

Choose Filter > Render > Clouds from the menu at the top to create irregular clouds. Choose Filter >

Render > Difference Clouds from the menu at the top to apply the filter again. Press Ctrl+F to apply the command again. Continue repeating the command until you arrive at the shape you like.

STEP 5. Adding Noise to the Clouds

Choose Filter > Sketch > Conte Crayon from the menu at the top. Set the Foreground Level to 13, the Background Level to 13, the Texture to Sandstone, and the Relief to 20. This filter will open in the Filter Gallery. In the middle of the Filter Gallery panel, there is a selection of thumbnails; this is where you would click and choose the filter you want. Click on the inverted triangle button at the top-right to hide the thumbnails and see the preview window. Click on OK to apply the filter.

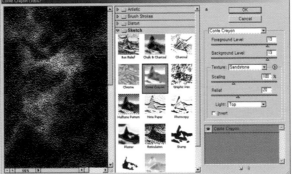

STEP 6. Copying the Cloud Image as a Mask for the Text Layer

Click on the Channels Palette to open it. Hold down the Ctrl key and click on the RGB channel at the top to create a selection frame in the shape of the image. The selection frame that is created will select only the lighter parts of the image, not the darker areas.

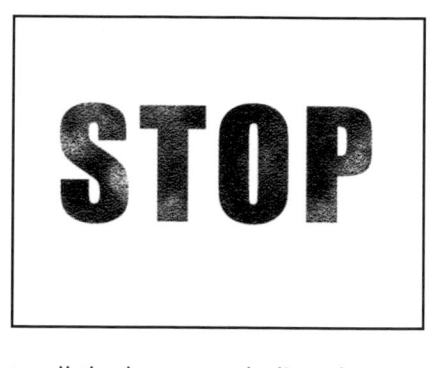

Click on the Layers Palette again and drag and drop the text layer onto the Create a New Layer button at the bottom to copy the layer. Click on the Layer Visibility icon next to all the layers, excluding the Background layer and the duplicate text layer, to hide them. Select the duplicate text layer and click on the Add a Mask button at the bottom to create a mask for the selected layer in the shape of the selection frame. The unselected areas will be transparent, allowing you to see the image underneath.

STEP 7. Editing the Layer Mask

In the Layers Palette, click on the mask thumbnail that was created for the duplicate text layer. A mask edit icon in front of the copied text layer indicates that the mask image can be edited now. Choose Image > Adjustments > Levels from the menu at the top.

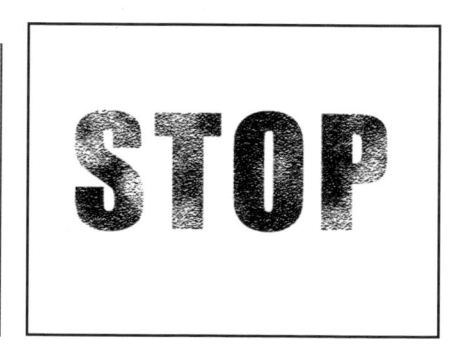

Move the black and white tabs at the bottom of the histogram, as shown here. If the bulk of the histogram appears on the left for you, enter 45, 1.00, and 60 in the Input Levels text boxes. This will make the black areas of the mask image (the transparent areas of the layer image) darker and wider.

STEP 8. Making a Grainy Mask Image

Choose Filter > Noise > Median from the menu at the top and set the Radius to 2 pixels. This will produce clumps of grainy particles on the image and create a rough texture.

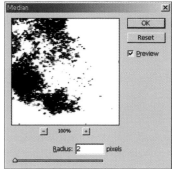

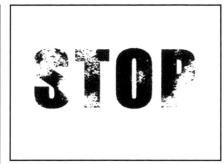

STEP 9. Adding Noise to Semitransparent Areas of the Text

In the Layers Palette, click on the thumbnail of the duplicate text layer and set the Blend Mode to Dissolve and the Fill to 92%. This will make the text image transparent. However, the entire text does not become transparent; it is only certain areas, as if transparent noise was scattered over the text.

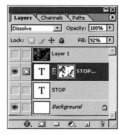

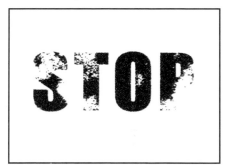

STEP 10. Adding Noise to Transparent Areas of the Text

In the Layers Palette, click on the hidden text layer so that it is visible again and set the Blend Mode to Dissolve and the Fill to 25%. Noise makes the text blurry and overlaps with the transparent text on top.

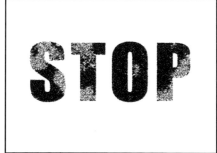

STEP 11. Blending the Two Text Layers

Select the text layer in the Layers Palette.

Click on the link icon of the duplicate layer to link the layers, and then press Ctrl+E to blend the linked layers.

STEP 12. Adding Space between Characters

Stamped letters or letters such as O and P need a connecting line to connect them together.

Choose the Rectangular Marquee Tool from the toolbox.

Click on the area where the connecting line will be made and then press Del.

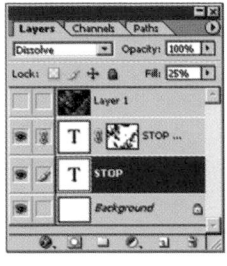
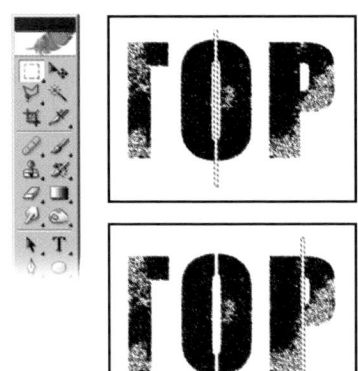
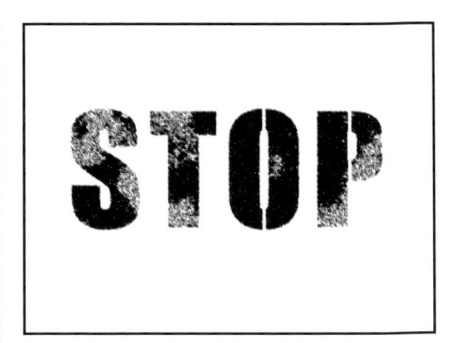

STEP 13. Changing Text Color

Choose Image > Adjustments > Hue/Saturation from the menu at the top. Check Colorize and then set the Hue to 50, the Saturation to 100, and the Lightness to 54. The text color will change to a dark yellow.

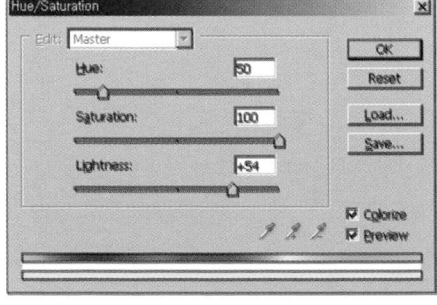
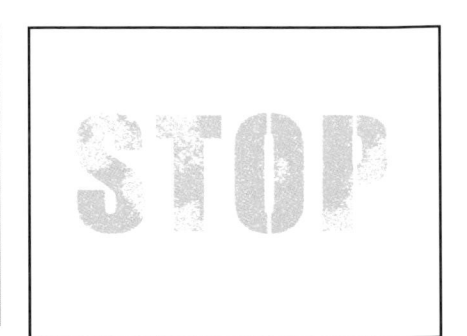

STEP 14. Creating Clouds in the Background

In the Layers Palette, click on the hidden layer so that it is visible again, and then drag the Layer 1 layer down one.

Choose Filter > Render > Clouds from the menu at the top to create irregular clouds. Press Ctrl+F to apply the command again. Continue repeating the command until you arrive at the shape you like.

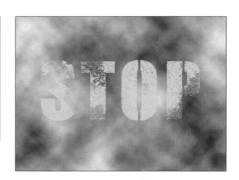

STEP 15. Using Background Light to Create Dimension

Choose Filter > Render > Lighting Effects from the menu at the top and adjust the graph on the left side of the panel, as shown here. The line in the center shows the direction of the light. As the rounded border becomes more elongated, the angle at which the light shines becomes smaller. Drag the handles at the edges to adjust the angle and direction of light and drag the handles in the center to adjust where the light shines. On the bottom-right of the panel, set the Texture Channel to Red to create dimensionality.

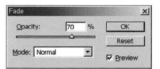
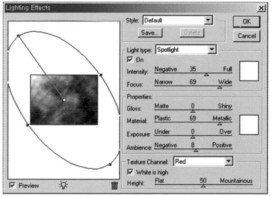
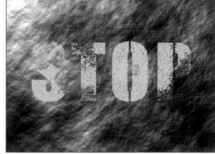

After you apply the filter, choose Edit > Fade Lighting Effects from the menu at the top and set the Opacity to 70% to reduce the effect of the filter.

STEP 16. Slanting the Text

Choose the STOP text layer from the Layers Palette. Press Ctrl+T to apply the Free Transform command.

Drag the handles on the corners of the image to slant it, as shown here. Press Enter to apply the transformation.

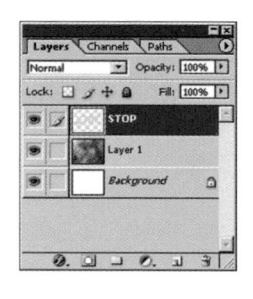 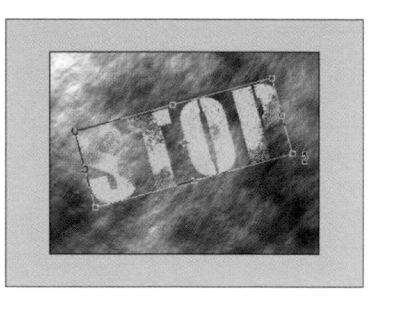

STEP 17. Adding Dimension to the Image

Select the text layer from the Layers Palette and click on the link icon in front of the texture layer below the text layer to link the two layers. Press Ctrl+T to apply the Free Transform command.

Hold down the Ctrl key and drag the handles on the corners of the image to spread them out, as shown here. Dragging out the edges of the work window will create a convenient gray space on the outside of the screen. Dimension is added to the image, making it appear more natural. Press Enter to apply the transformation.

 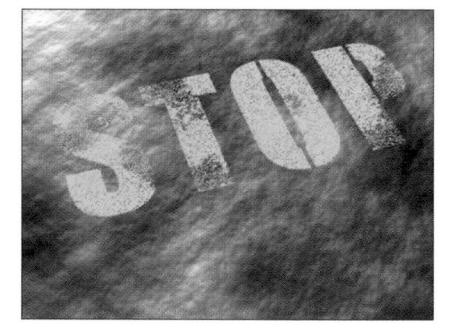

STEP 18. Choosing the Background Image

The background is reflected gently off the slightly wet road. Press Ctrl+O and open the city.jpg file. This file is included on the supplementary CD-ROM. Choose the Rectangular Marquee Tool from the toolbox.

Drag the tool over the part of the image you want to use and press Ctrl+C to copy the section you have selected.

STEP 19. Pasting the Background Image

Click on the active text window and then click on the Layer Visibility icon in front of the text layer in the Layers Palette to hide it from view. Then select the texture layer (Layer 1). Press Ctrl+V to paste the copied background image onto the new layer. You should see the new layer (Layer 2) in the Layers Palette.

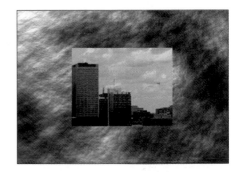

STEP 20. Editing the Background Image

Choose the duplicate background image layer (Layer 2) from the Layers Palette. Choose Edit > Transform > Flip Vertical from the menu at the top to flip the background image vertically. Press Ctrl+T to apply the Free Transform command. Hold down the Shift and Alt keys and drag out the handles on the corners of the image to increase its size (with respect to the height/width and center) so that the image fills up the entire work window. Press Enter to apply the transformation.

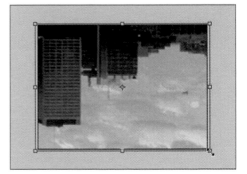

STEP 21. Distorting the Image

Choose Filter > Distort > Wave from the
menu at the top and set the Number of
Generators to 5, the Wavelength to 1/146,
the Amplitude to 6/43, the Scale to 32/24%
and the Type to Sine. The image will be dis-
torted into an irregular wave.

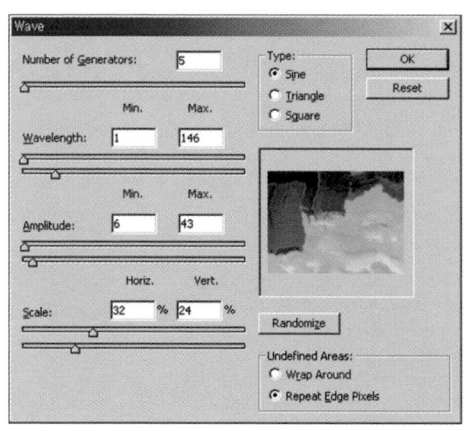

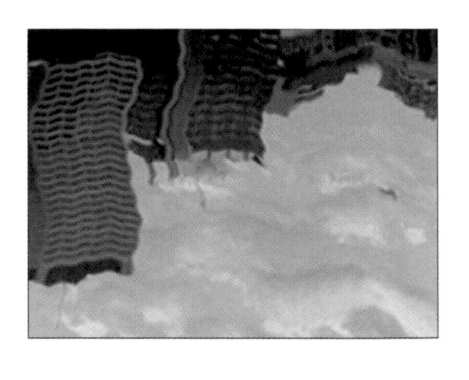

STEP 22. Blending the Background Image

Select the background layer (Layer 2) and set the Blend Mode
to Vivid Light and the Fill to 30%. A faint image of the back-
ground image will be blended with the rough texture of the
road.

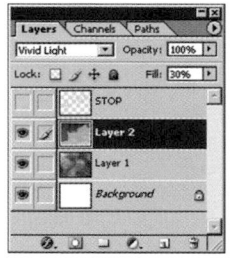

STEP 23. Blending the Text Layers

Click on the hidden text layers at the top of the Layers Palette
so that they are visible again, and then set the Blend Mode to
Linear Light and the Fill to 55%. This blends the text image nat-
urally with the 3D texture below it.

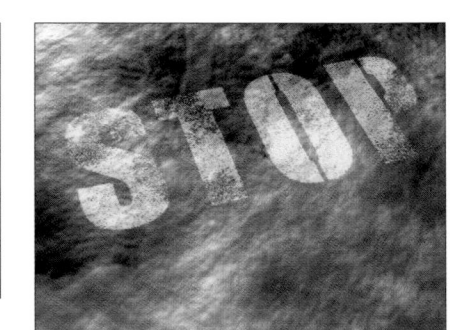

STEP 24. Entering the Subtitle

Choose the Horizontal Type Tool from the toolbox and then click on the Foreground Color button to set it to white. Click the tool on the work window and type in the desired text.

Choose the font and font size in the Character Palette, as shown here.

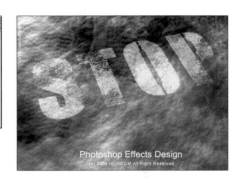

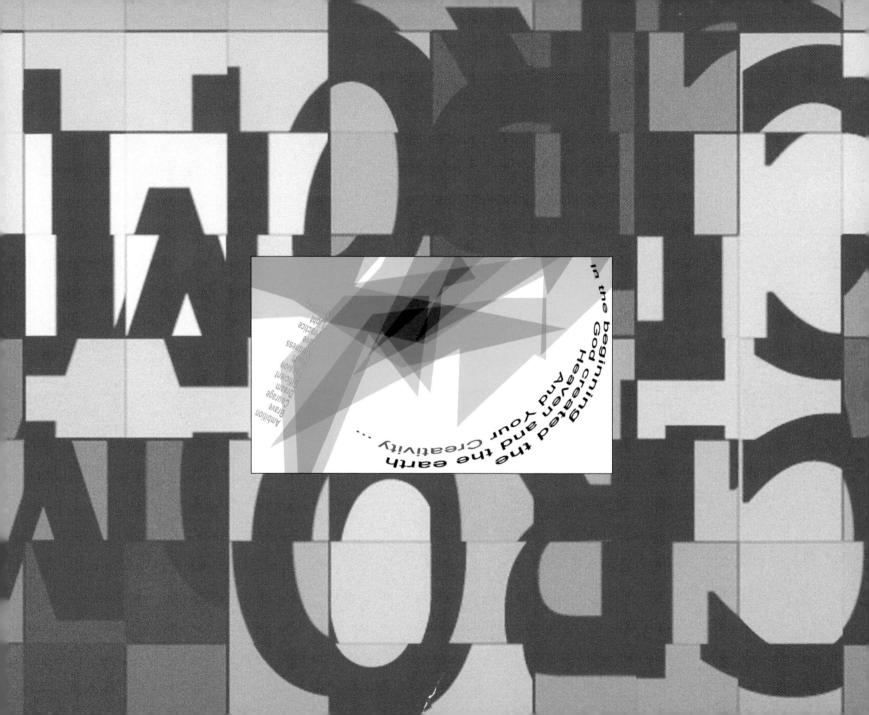

Effect 4: Creative Wave

The Polar Coordinates filter enables you to curve text in an image. In this project, you will use the Polar Coordinates filter to create a wave effect with several lines of text.

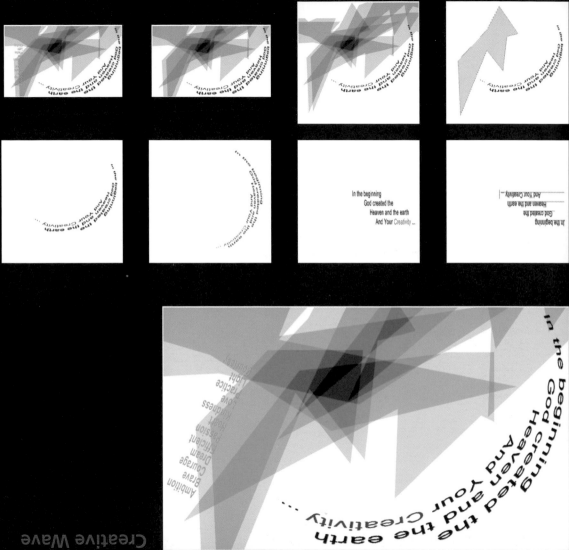

Effect 4: Creative Wave

Total Steps

STEP 1. Entering Text in a Stair Shape

STEP 2. Flipping the Text and Moving It to the Bottom of the Image

STEP 3. Merging the Text with the Background Layer

STEP 4. Rolling the Text

STEP 5. Rotating the Text

STEP 6. Reshaping the Text and Rotating It Again

STEP 7. Sharpening the Text

STEP 8. Reducing the Image to Actual Size

STEP 9. Making a Sharp Shape

STEP 10. Overlapping and Arranging Shapes

STEP 11. Cropping the Image

STEP 12. Adding More Text

STEP 13. Rotating and Arranging the Text

STEP 1. Entering Text in a Stair Shape

Choose File > New (Ctrl+N) to create a new file. In the New dialog box, set both the Width and Height of the new file to 1600 pixels, and make sure the rest of the settings match what is shown in the figure. Click on OK.

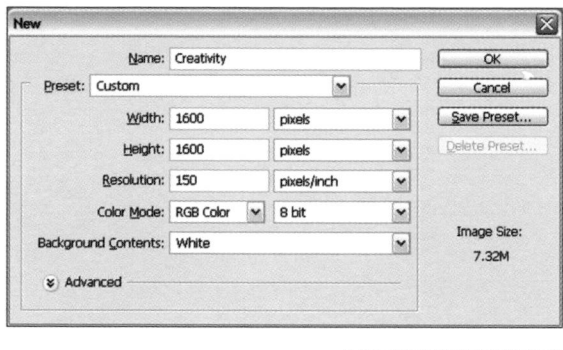

Eventually, you will reduce the image to half this size. Use the Horizontal Type Tool from the toolbox to enter in the text in the stair-stepped manner shown here.

Be sure to use the Character Palette to reduce the Horizontal Scale setting to 50%.

Format the final word, "Creativity," in red. Click on the Commit Any Current Edits button at the right end of the Options bar to finish entering the text.

STEP 2. Flipping the Text and Moving It to the Bottom of the Image

Choose Edit > Transform > Rotate 180° to flip the text over.

Click on the Move Tool in the toolbox and drag the text to the lower-left corner of the image. Then, choose Edit > Free Transform (Ctrl+T), and drag one of the corner handles to

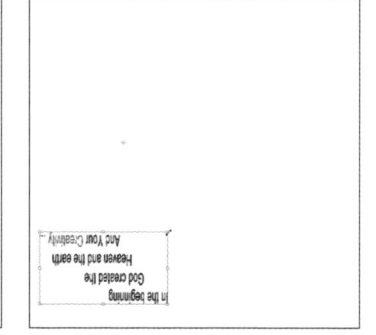

reduce the size of the text object. Hold down the Shift key while you do this to ensure that the proportions are retained. Press Enter to finish resizing the text.

STEP 3. Merging the Text with the Background Layer

With the text layer selected in the Layers Palette, choose Layer > New > Layer via Copy (Ctrl+J) to duplicate the layer. Click on the eye icon beside the new layer to hide it. Click on the original text layer to select it.

Click on the Palette Menu button at the top of the Layers Palette, and click on Merge Down (Ctrl+E) to merge the original text layer with the Background layer.

STEP 4. Rolling the Text

Choose Select > All (Ctrl+A) to select the contents of the Background layer. Choose Filter > Distort > Polar Coordinates. Click on the minus (–) button in the Polar Coordinates dialog box until you can see the preview of the text rounded into a semicircle. Click on OK to close the dialog box and apply the new shape. Choose Select > Deselect (Ctrl+D) to deselect the area.

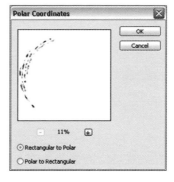
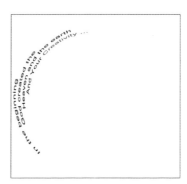

STEP 5. Rotating the Text

Choose the Rectangular Marquee Tool from the tool-box, and then drag a corner of the selection marquee to adjust its size, as shown here.

Choose Edit > Transform > Rotate. Drag the upper-right selection handle to the left to rotate the text a bit. Press Enter to apply the change. Choose Select > Deselect (Ctrl+D) to remove the current selection.

STEP 6. Reshaping the Text and Rotating It Again

Use the Rectangular Marquee Tool to select the text, and then choose Edit > Transform > Distort. Drag the four selection handles to distort the text to the shape shown here.

Press Enter, and then choose Edit > Transform > Rotate. Drag the upper-right selection handle down to rotate the text, as shown here. Then, press Enter. (Drag the text from the center to reposition it to match the figure, and then press Enter.)

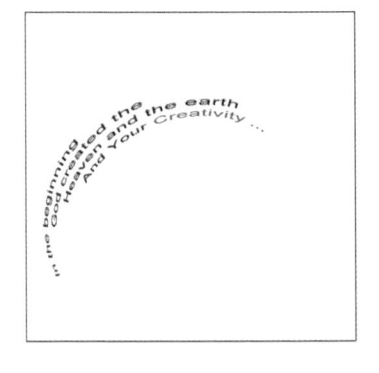

STEP 7. Sharpening the Text

Choose Image > Adjustments > Levels (Ctrl+L) from the menu bar. In the Levels dialog box, drag the leftmost Input Levels slider to the right to increase the first Input Levels setting to 100, and then click on OK.

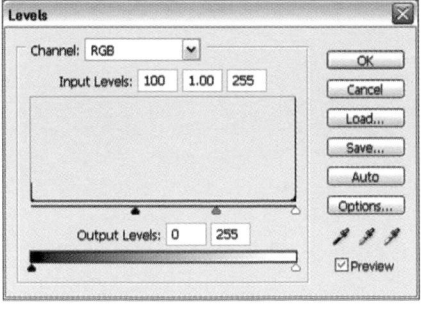
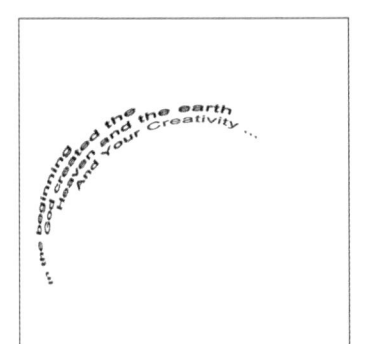

STEP 8. Reducing the Image to Actual Size

The Polar Coordinates filter severely distorts the image, so the text can appear blurred. Reducing the image size after applying the Polar Coordinates filter helps sharpen the image. Choose Image > Image Size. Enter new Height and Width dimensions of 800 pixels, and then click on OK. Zoom in on the image window, if needed.

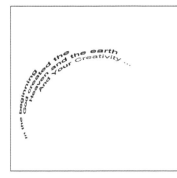

STEP 9. Making a Sharp Shape

Use the Polygonal Lasso Tool from the toolbox to create the freeform selection shown here. Click on the Create a New Layer button (Shift+Ctrl+N) in the Layers Palette to create a new layer named Layer 1.

Set the foreground color to the blue color shown in the figure (RGB=140, 245, 249). Select the Paint Bucket Tool from the toolbox and click within the selection marquee (Alt+Del) to fill the selection with the sky blue color.

With Layer 1 (the shape layer) selected, click on the Add a Layer Style button at the bottom of the Layers Palette, and then click on Blending Options. Choose Linear Burn from the Blend Mode drop-down list, and then click on OK.

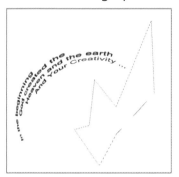

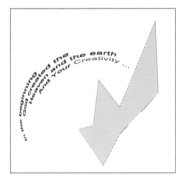

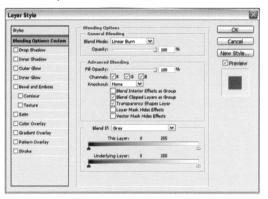

STEP 10. Overlapping and Arranging Shapes

With Layer 1 selected in the Layers Palette, choose Layer > New > Layer via Copy (Ctrl+J). Use the Edit > Free Transform command (Ctrl+T) to slightly alter the placement, size, and angle of the copied shape, allowing it to overlap the original shape. Press Enter to finish adjusting the shape. Make several copies of Layer 1 and reposition the copies until you achieve the desired overlapping effect. Apply the Edit > Transform > Flip Horizontal command to a few of the copied shape layers to create a more diverse effect.

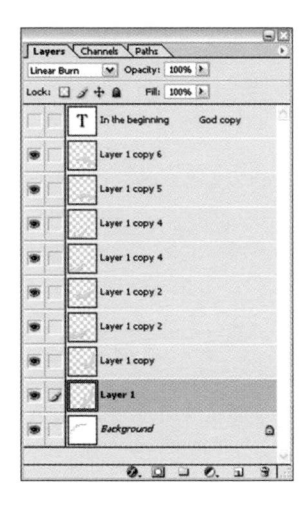

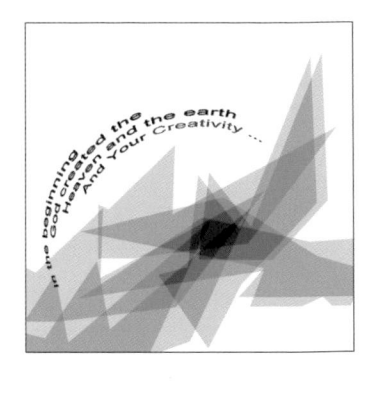

STEP 11. Cropping the Image

Use the Rectangular Marquee Tool to select the most interesting part of the image. Choose Image > Crop from the menu bar to discard the image area outside the selection. Choose Select > Deselect (Ctrl+D) to remove the selection.

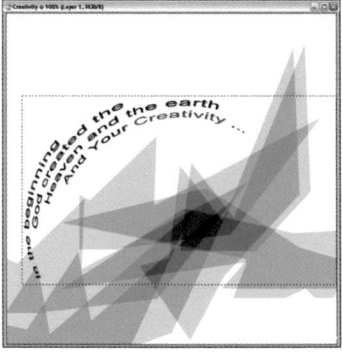

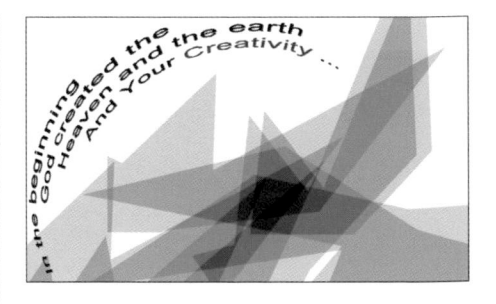

STEP 12. Adding More Text

Choose the Horizontal Type Tool from the toolbox. Drag over an area at the right side of the image to define an area to hold text. Open the Character Palette and choose the desired font size. Also, specify a gray color (RGB=131, 131, 131) for the text.

Then, type in the text as shown here. Click on the Commit Any Current Edits button on the Options bar to finish entering the text.

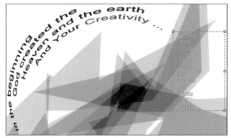
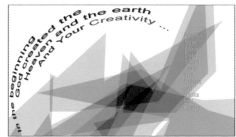

STEP 13. Rotating and Arranging the Text

With the new text layer selected, choose Edit > Transform > Rotate. Drag a selection handle to rotate the text as desired. Drag from the center of the text to reposition the text as desired. Press Enter to finish adjusting the text.

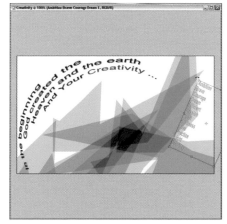
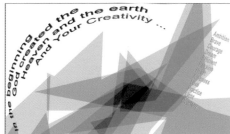

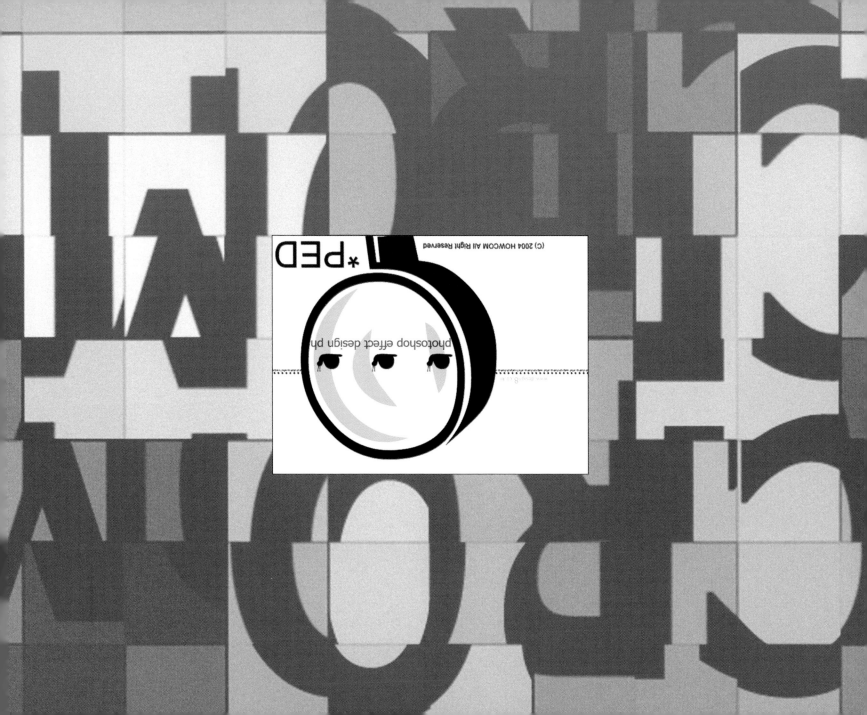

Effect 5: Playing a Magnifier

You can create a neat effect in which what looks like a simple straight line turns out to be a logo and a title when observed under a magnifying glass. This is the type of illustration you will create in this chapter. You'll notice some graphics that appear rather complex, but they were actually created using the Dingbat font and custom shapes.

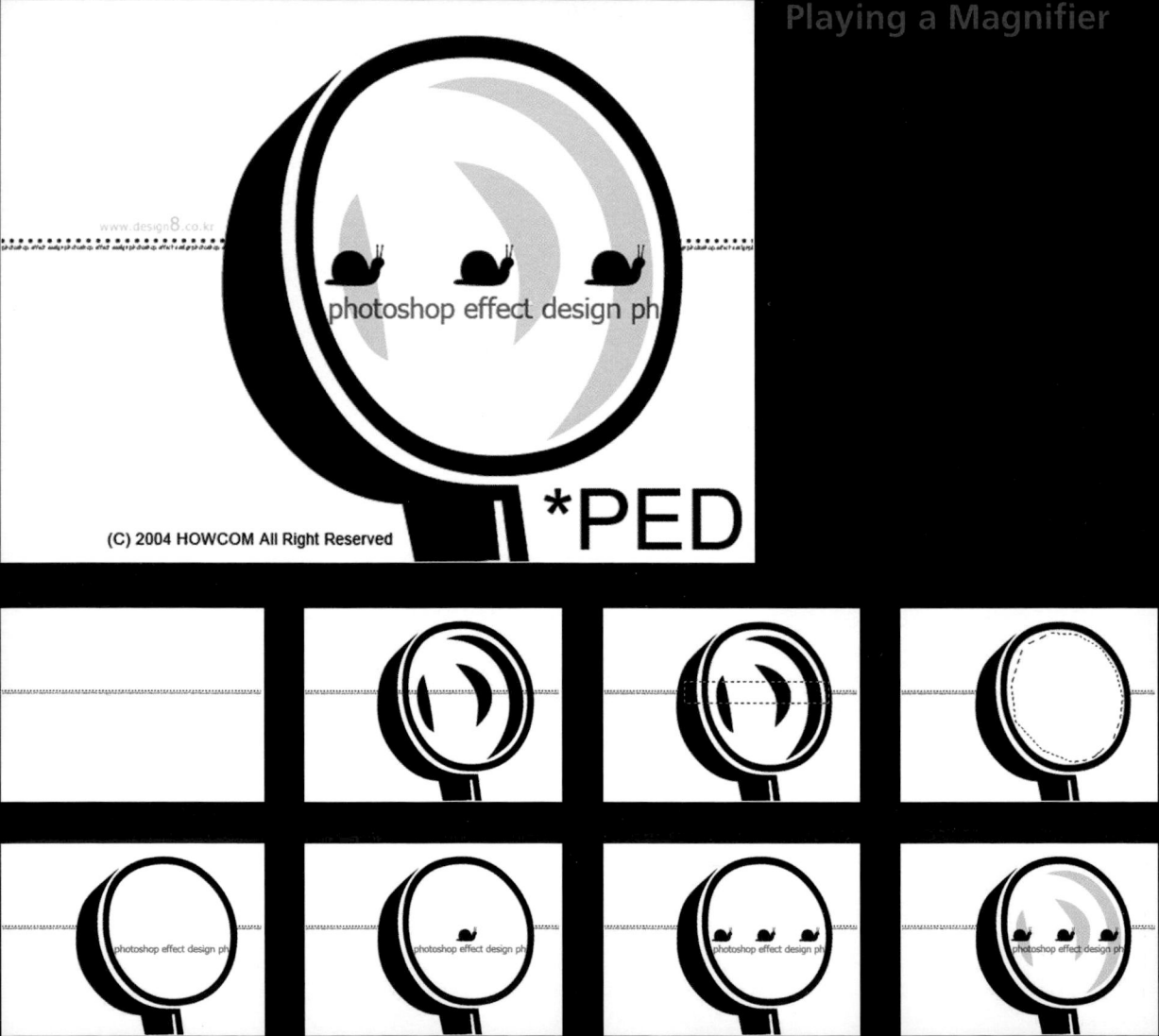

photoshop effect design ph

*PED

www.design8.co.kr

(C) 2004 HOWCOM All Right R...

Total Steps

STEP 1. Creating a New Work Window

STEP 2. Setting Up the Brush

STEP 3. Drawing with the Brush

STEP 4. Entering the Text

STEP 5. Making the Text Smaller

STEP 6. Copying the Text

STEP 7. Adding a Magnifying Glass (Dingbat Font)

STEP 8. Making the Magnifying Glass Larger

STEP 9. Erasing the Dotted Line inside the Magnifying Glass

STEP 10. Erasing the Reflection inside the Magnifying Glass

STEP 11. Entering the Title

STEP 12. Creating a Snail Shape

STEP 13. Drawing the Snail Icon

STEP 14. Copying the Snail Icon

STEP 15. Creating a Reflection for the Magnifying Glass

STEP 16. Entering the Subtitle

STEP 1. Creating a New Work Window

Press Ctrl+N to create a new work window. Click on the Preset box and choose 640×480 to create a 640×480-pixel workspace.

STEP 2. Setting Up the Brush

Choose the Brush Tool from the toolbox, and then right-click on the work window to open the Brush Preset panel.

Choose a basic brush, as shown here, and set the size to 4 px.

Click on the Brushes tab in the Palette Well (in the option bar at the top) to open the Brushes Palette. Choose Brush Tip Shape from the left side of the palette and set the Spacing to 200%. The newly configured brush—a round brush that stamps at 200% intervals—will appear at the bottom of the palette.

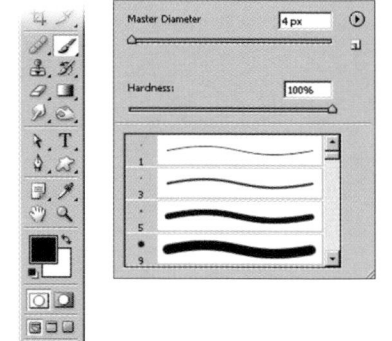

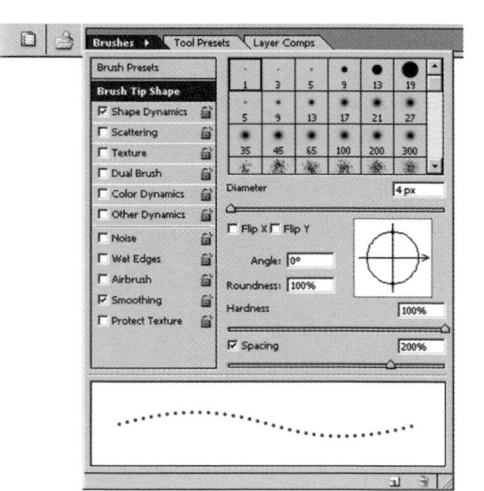

STEP 3. Drawing with the Brush

In the Layers Palette, click on the Create a New Layer button to create a new layer (Layer 1).

Then, use the brush you configured in the previous step to draw a horizontal line in the middle of the work window. Click on the left edge of the work window, hold down the Shift key, and drag the mouse over to the right side to draw a straight line. This will create a 4-pixel dotted line.

STEP 4. Entering the Text

Choose the Horizontal Type Tool from the toolbox, click on the Foreground Color button at the bottom, and set it to red. Click on the middle of the work window and type in the desired text. Press Ctrl+Enter when you are finished entering the text.

photoshop effect design

STEP 5. Making the Text Smaller

In the Character Palette, set the font to Tahoma and the font size to 5 pt to make the text very, very small. If you can't see the Character Palette, choose Window > Character from the menu at the top.

You can move the text that you entered by dragging it while holding down the Ctrl key. Move the text below the dotted line and toward the left corner, as shown here.

STEP 6. Copying the Text

Double-click on the text layer in the Layers Palette.

Copy (Ctrl+C), paste (Ctrl+V), and repeat until the text extends all the way to the edge. Press Ctrl+Enter when you are finished copying and pasting the text.

STEP 7. Adding a Magnifying Glass (Dingbat Font)

You can easily create a magnifying glass using the Dingbat font. Click on the Foreground Color button in the toolbox and set it to black. Then, choose the Horizontal Type Tool.

Click on the center of the work window. In the Character Palette, set the font to Webding and the font size to 72 pt. Webding font is a type of Dingbat font that is used to type in graphics rather than letters.

Type in L. Instead of the letter L, you will see a magnifying glass.

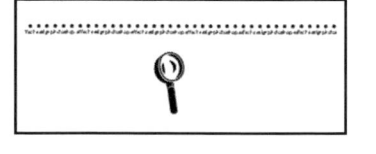
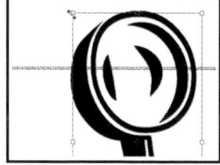

STEP 8. Making the Magnifying Glass Larger

Click on the Move Tool. Press Ctrl+T to apply the Free Transform command. Hold down the Shift and Alt keys and drag the handles on the corners of the image to increase the size of the image (with respect to the height/width and center). Drag the area inside the handles to move the image. Press Enter to apply the Free Transform.

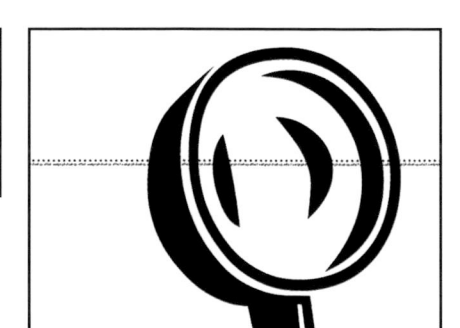

STEP 9. Erasing the Dotted Line inside the Magnifying Glass

You will now cover up the dotted line reflected in the magnifying glass with the white background color. Click on the Create a New Layer button in the Layers Palette to make a new layer (Layer 2), and then drag it right below the magnifying glass layer (L).

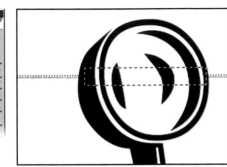

Choose the Rectangular Marquee Tool from the toolbox.

Drag over the area that will be hidden (the dotted lines). Then, press Ctrl+Del to hide the area with the white background. This makes it appear that the dotted lines under the magnifying glass have been erased, when in fact they've simply been covered up.

STEP 10. Erasing the Reflection inside the Magnifying Glass

The reflection inside the magnifying glass makes it difficult to see the words you entered. Click on the Create a New Layer button in the Layers Palette to make a new layer, and then drag it to the very top.

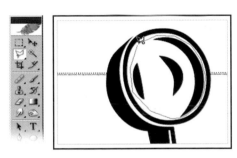

Choose the Polygonal Lasso Tool from the toolbox.

Click on the inside of the magnifying glass to create a selection frame.

Press Ctrl+Del to hide the area with the white background. Press Ctrl+D to deselect the selection frame.

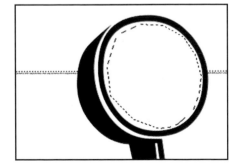

STEP 11. Entering the Title

Click on the Foreground Color button, set it to red, and then choose the Horizontal Type Tool from the toolbox. Click on the Create a New Layer button in the Layers palette to create a new layer.

In the Character Palette, set the font to Tahoma and the font size to 24 pt.

 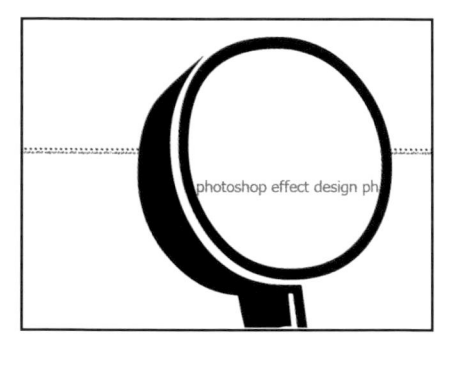

Type the title inside the magnifying glass, as shown here. If you have space left over, repeat the title so that the words fill up the entire width of the magnifying glass.

STEP 12. Creating a Snail Shape

Click on the Foreground Color button and set the color to black. Choose the Custom Shape Tool from the toolbox.

Click on the Shape Layers icon in the option bar at the top to create a shape layer, and then click on the Custom Shape icon to open the Shape Preset panel.

Click on the Option button and choose All to see all the default Photoshop custom shapes. If a Photoshop dialog box appears, asking you whether you want to replace the current shapes, click on OK. Choose the snail shape at the very top.

STEP 13. Drawing the Snail Icon

Drag the mouse over the work window to draw the snail icon. Hold down the Shift key while dragging to keep the height and width proportionate.

 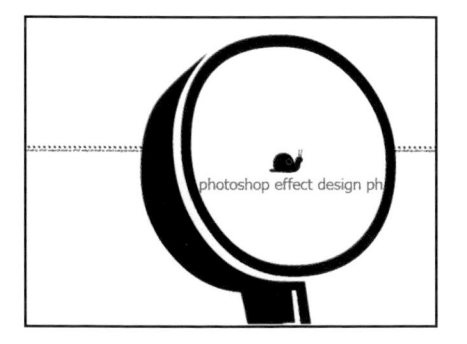

STEP 14. Copying the Snail Icon

Choose the Move Tool from the toolbox and drag the snail icon to the side while holding down the Alt key. This creates two additional and evenly spaced copies of the snail icon.

Hold down the Shift key while dragging to make the copies in a straight line.

 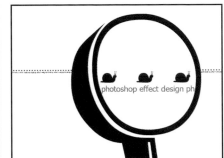

STEP 15. Creating a Reflection for the Magnifying Glass

You will now attempt to create a faint reflection inside the magnifying glass. In the Layers Palette, drag and drop the magnifying glass layer (L) onto the Create a New Layer button to make a copy of the layer. Then drag the layer to the very top of the Layers Palette. Set the Fill value of the duplicate layer to 18%.

 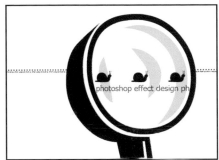

STEP 16. Entering the Subtitle

Choose the Horizontal Type Tool from the toolbox and type in the desired text.

Choose the font and font size in the Character Palette, as shown here.

 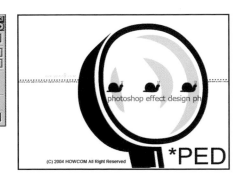

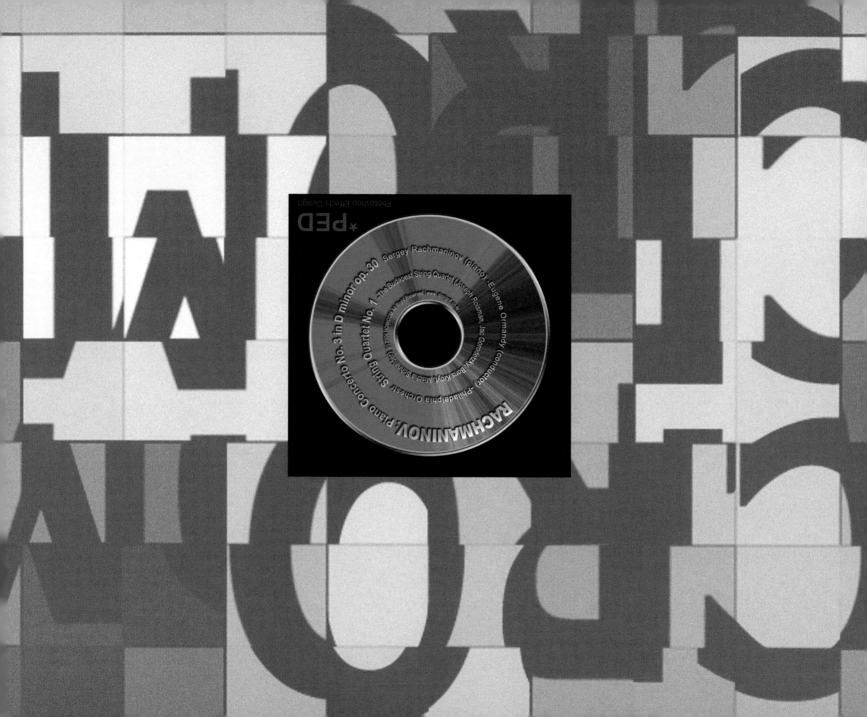

Photoshop Effects Design

*PED

RACHMANINOV: Piano Concerto No. 3 in D minor op. 30 Sergey Rachmaninov (piano) -Eugene Ormandy (conductor) -Philadelphia Orchestr String Quartet No. 1 -The Budapest String Quartet (Joseph Roisman, Jac Gorodetzky, Boris Kroyt, Mischa Schneider) @2004 now.com All Right Reserved | www.design.co.kr

Effect 6: Spiral CD Title

In this section, you will create a unique CD title image using spiraling text. You can match the size of the image to that of a CD, print it out on a CD label, and affix it to a CD to create a one-of-a-kind compact disc.

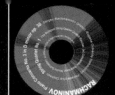

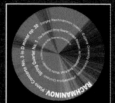
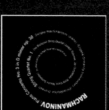
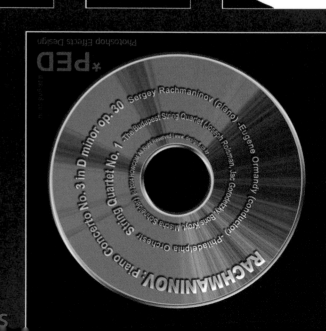

Spiral CD title

Photoshop Effects Design

*PED

RACHMANINOV: Piano Concerto No. 3 in D minor op. 30 Sergey Rachmaninov (piano) -Eugene Ormandy (conductor) -Philadelphia Orchestr String Quartet No. 1 -The Budapest String Quartet (Joseph Roisman, Boris Kroyt, Mischa Schneider, Jac Gorodetski)

Effect 6: Spiral CD Title

Total Steps

STEP 1. Creating a New Work Window

STEP 2. Making Half the Image White

STEP 3. Making the Spiral Image

STEP 4. Creating a Spiral Path

STEP 5. Editing the Center of the Path

STEP 6. Deleting the Center of the Path

STEP 7. Deleting the Unnecessary Spiral Shape

STEP 8. Entering Spiral Text

STEP 9. Adjusting the Text Size

STEP 10. Rotating the Text

STEP 11. Making a Round Path

STEP 12. Making a Vector Mask in the Shape of the Path

STEP 13. Setting Up the Gradient

STEP 14. Applying the Gradient

STEP 15. Editing the Vector Mask

STEP 16. Punching a Hole in the Center of the Path

STEP 17. Applying a Layer Style to the Text

STEP 18. Setting Up the Layer Style for the Text

STEP 19. Setting Up a Layer Style for the CD

STEP 20. Adding Dimension to the CD

STEP 21. Entering the Subtitle

STEP 1. Creating a New Work Window

Press Ctrl+N to create a new work window. Set the Width and Height to 800 and the Resolution to 72 pixels/inch to make an 800×800-pixel work window.

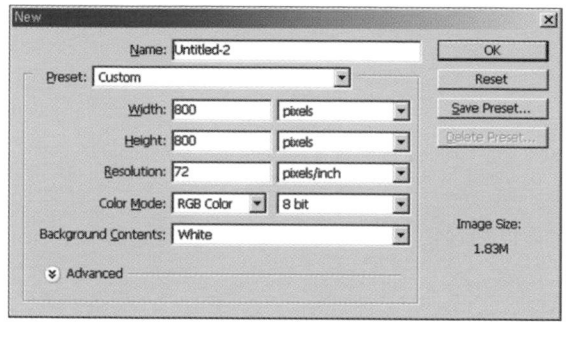

In the toolbox, click on the Default Foreground and Background Colors button to set up the default color, and then click on the Switch Foreground and Background Colors button to set the foreground color to white and the background color to black. Then press Ctrl+Del to fill in the work window with the background color (black).

Press Ctrl+R to show the rulers. If necessary, right-click on the ruler and click on Pixels to display the ruler measurements in pixels. Click on the ruler and drag it toward the inside twice to create a cross-shaped guideline in the center of the work window. The snap function will snap the guideline to the exact center.

STEP 2. Making Half the Image White

Choose the Rectangular Marquee Tool from the toolbox and use it to select exactly half of the image.

Use the guidelines to help you. Press Alt+Del to change the color of the selected area to white. Click on the workspace to accept the change.

STEP 3. Making the Spiral Image

Choose Filter > Distort > Twirl from the menu at the top and set the Angle to 999. This creates a clockwise spiral.

Press Ctrl+F to apply the filter again to create a more densely packed spiral.

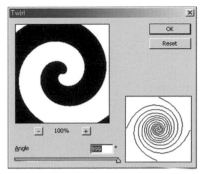 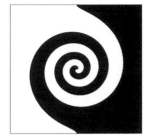 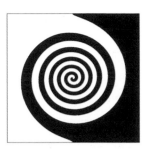

STEP 4. Creating a Spiral Path

Click on the Channels Palette to open it and click on the RGB channel at the top while holding down the Ctrl key to create a selection frame in the shape of the image. The selection frame that is created will select only the white areas of the image, not the black areas.

Click on the Paths Palette to open it. Then click on the Make Work Path from Selection button at the bottom to make a path in the shape of the selection frame. Press Ctrl+Del to fill in the image using the background color (black). This makes it easier to see what the path looks like.

STEP 5. Editing the Center of the Path

Choose the Direct Selection Tool from the toolbox.

Click on the segment near the center of the path. Press Del to erase the selection. Click on the outside of the path to deselect the selection.

Next, click on the part of the deleted line that extends outside the path and press Del.
Click again on the outside of the path to deselect the selection.
The center of the path has now been made into a separate path.

STEP 6. Deleting the Center of the Path

Choose the Direct Selection Tool and click on the center of the path while holding down the Alt key to select. Then press Del.

Click on the part of the deleted line that extends outside the path and press Del. The doubled-up spiral shape is now separated into two shapes. Click on the outside of the path to deselect the selection.

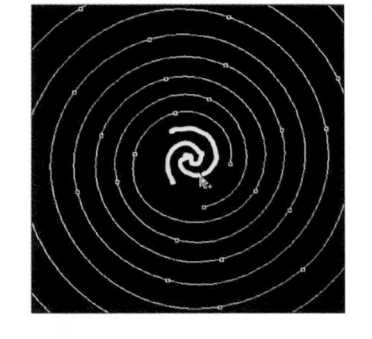 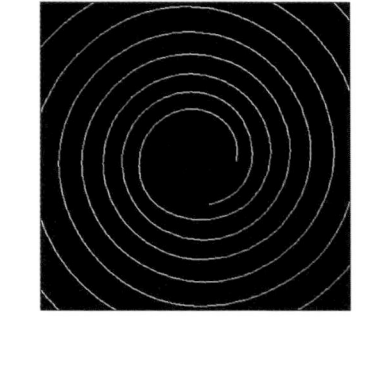 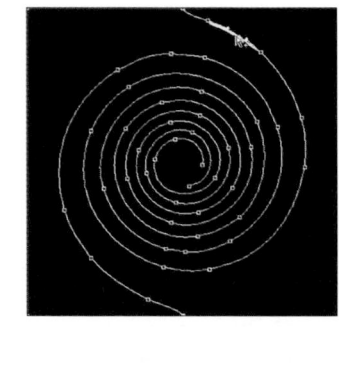 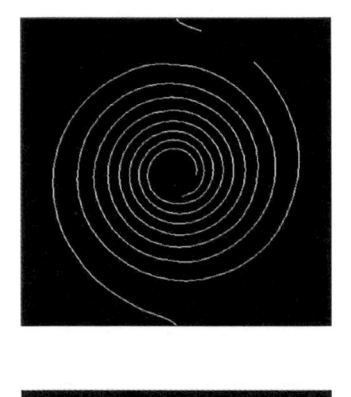

STEP 7. Deleting the Unnecessary Spiral Shape

You will now delete one of the two spiral shapes. Click the Direct Selection Tool on the spiral shape to be deleted while holding down the Alt key. Then press Del. Click on the outside of the path to deselect the selection. The spiral shape is now complete.

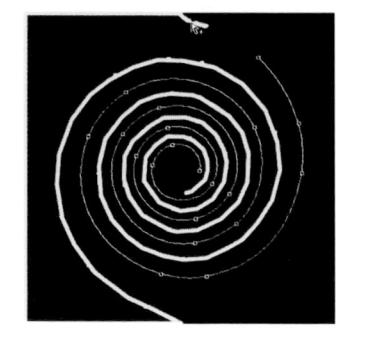 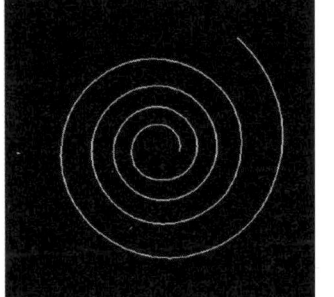

STEP 8. Entering Spiral Text

The upgraded version of Photoshop CS offers a feature that allows you to enter text along a path.

Choose the Horizontal Type Tool from the toolbox.

In the Character Palette, set the font to Arial and the font size to 24 pt.

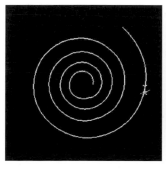
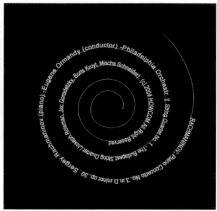

Click on the outside of the path, and you will see a blinking cursor.

Type a title for your CD at the blinking cursor. Typing in text along a path will slow down your computer; it is a good idea to first type your title in Notepad or your word processing program and then copy and paste it into Photoshop. One thing to note is that when you are typing text on a path, the Enter key does not function as it does in a normal word processing program. In other words, pressing the Enter key will not move you to the next line. Therefore, when you are typing on a path, do not press Enter; instead, type the text in one straight line.

STEP 9. Adjusting the Text Size

Select part of the text and adjust the font size in the Character Palette. Change the font size of the CD title to 36 pt and the font style to Bold. Change the font size of the two song titles to 30 pt and the font style to Bold. Press Ctrl+Del when you are finished typing.

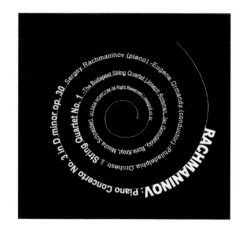

STEP 10. Rotating the Text

Press Ctrl+T to apply the Free Transform command and drag out the handles on the text to rotate it. Press Enter to finalize the transformation. You won't be able to see a preview of how the rotated text will look; instead, you will have to rely on the position of the handles to determine the appearance of the rotated text.

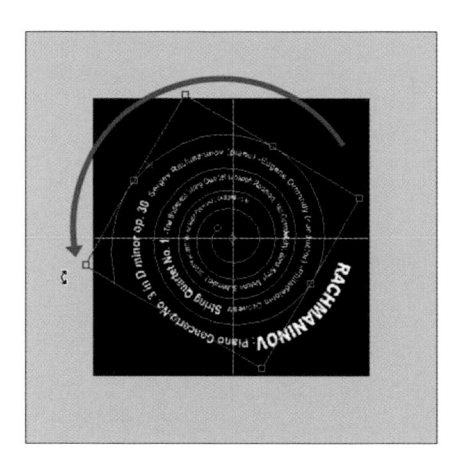

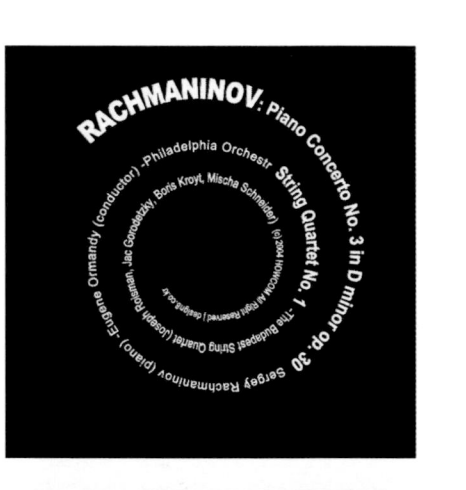

STEP 11. Making a Round Path

Choose the Ellipse Tool from the toolbox.

Next, click on the Paths icon in the option bar at the top to create a shape path.

Press Ctrl+; to see the hidden guidelines again. Drag the tool while holding down Shift+Alt to make a circular path that extends out from the center.

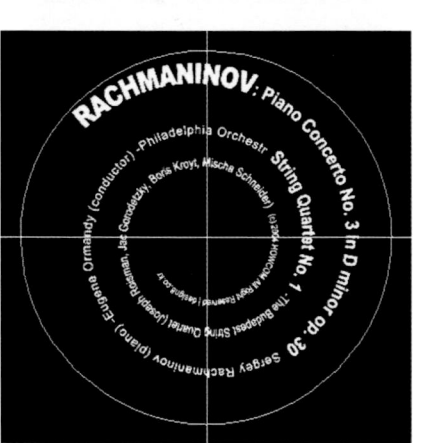

STEP 12. Making a Vector Mask in the Shape of the Path

In the Layers Palette, click on the Create a New Layer button to make a new layer, and then drag the new layer right below the text layer. Select the new layer and click on the Add a Mask button at the bottom while holding down the Ctrl key to make a vector mask in the shape of the selected path. The layer image that is not masked by the path will be made transparent.

STEP 13. Setting Up the Gradient

Choose the Gradient Tool from the toolbox.

Next, click on the Angle Gradient button in the option bar at the top to make a rotating, fan-shaped gradient. Click on the Gradient Color button to open the Gradient Editor Panel.

Click on the Option button and choose Noise Samples to see the various noise gradient presets. Click on OK to replace the current gradients.

Choose the gradient shown here and set the Roughness to 60%.

STEP 14. Applying the Gradient

Click the Gradient Tool in the middle of the work window and then drag the tool in any direction to create a rotating, fan-shaped gradient.

You will notice that the vector mask creates a mask for the outer part of the gradient image.

Press Ctrl+; to hide the guidelines.

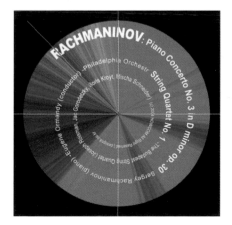

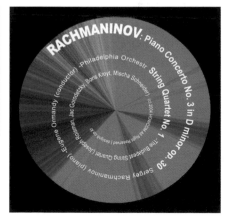

STEP 15. Editing the Vector Mask

Choose the Path Selection Tool from the toolbox.

Next go to the Layers Palette and click on the vector mask thumbnail on the right side of the gradient image layer.

 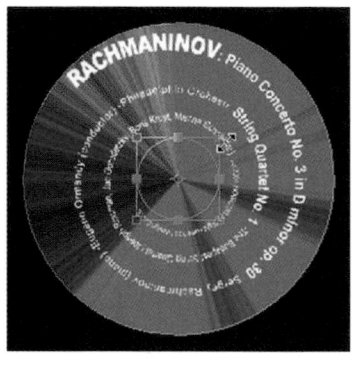 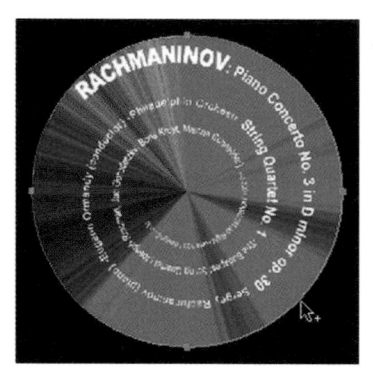

A path will appear on the vector mask in the work window, indicating that the mask can now be edited. Select the circular path, and press Ctrl+C and then Ctrl+V to copy and paste the selected path.

Press Ctrl+T to apply the Free Transform command. Hold down Shift+Alt and drag in the handles at the corners to make the image smaller, as shown here.

STEP 16. Punching a Hole in the Center of the Path

Select the inner path. Click on the Subtract from Path Area icon in the option bar. This will remove the overlapping regions of the path and punch a hole in the inner path.

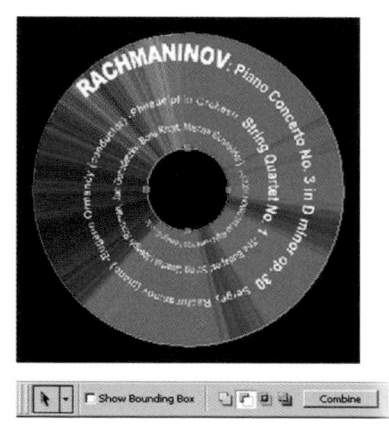 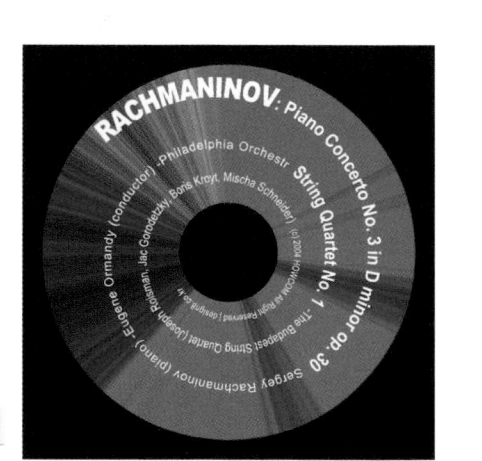

STEP 17. Applying a Layer Style to the Text

You will now attempt to apply a style to the white text. Select the text layer from the Layers Palette and set the Fill to 0% to make the text transparent. Click on the Add a Layer Style button at the bottom of the palette and choose Drop Shadow to open the Layer Style Panel.

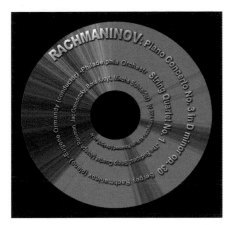

STEP 18. Setting Up the Layer Style for the Text

Choose Drop Shadow from the list on the left side of the Layer Style panel. Set the Opacity to 75%, the Distance to 3 px, the Spread to 13%, and the Size to 5px.

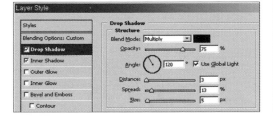

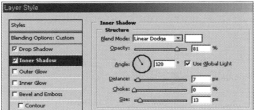

Now choose Inner Shadow from the list and set the Blend Mode to Linear Dodge, the color to white, the Opacity to 81%, the Distance to 7 px, the Choke to 0%, and the Size to 13 px. Click on OK to apply the style. You have now completed making the transparent 3D text layer style.

STEP 19. Setting Up a Layer Style for the CD

From the Layers Palette, choose the CD image layer (the one to which the gradient has been applied) and click on the Add a Layer Style button at the bottom.

Choose Stroke to open the Layer Style Panel and set the Size to 12 px, the Position to Inside, and the color to orange (RGB=255, 162, 0).

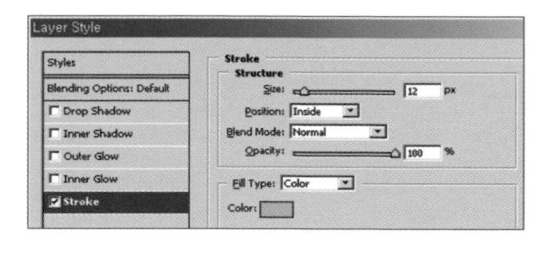
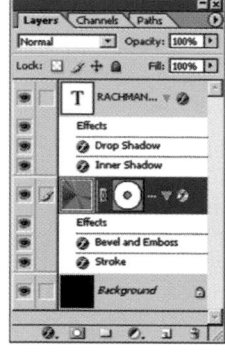
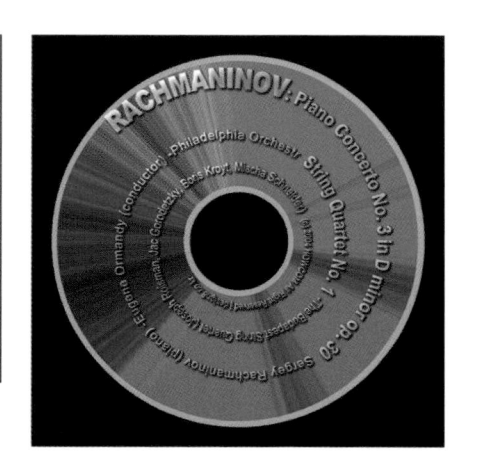

STEP 20. Adding Dimension to the CD

Now choose Bevel and Emboss from the list on the left side of the Layer Style Panel and set the Depth to 200%, the Size to 9 px, and the Soften to 0 px. Then, click on the drop-down list arrow next to the Gloss Contour graph and choose the graph shown here. Click on OK to apply the styles. This will add dimension to the CD label.

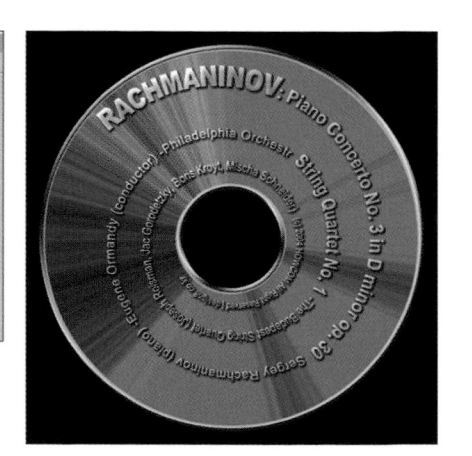

STEP 21. Entering the Subtitle

Click on the Foreground Color button and set the foreground color to dark red.

Then, use the Horizontal Type Tool to type in the desired text.

Choose the desired font and font size in the Character Palette.

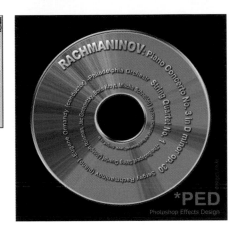

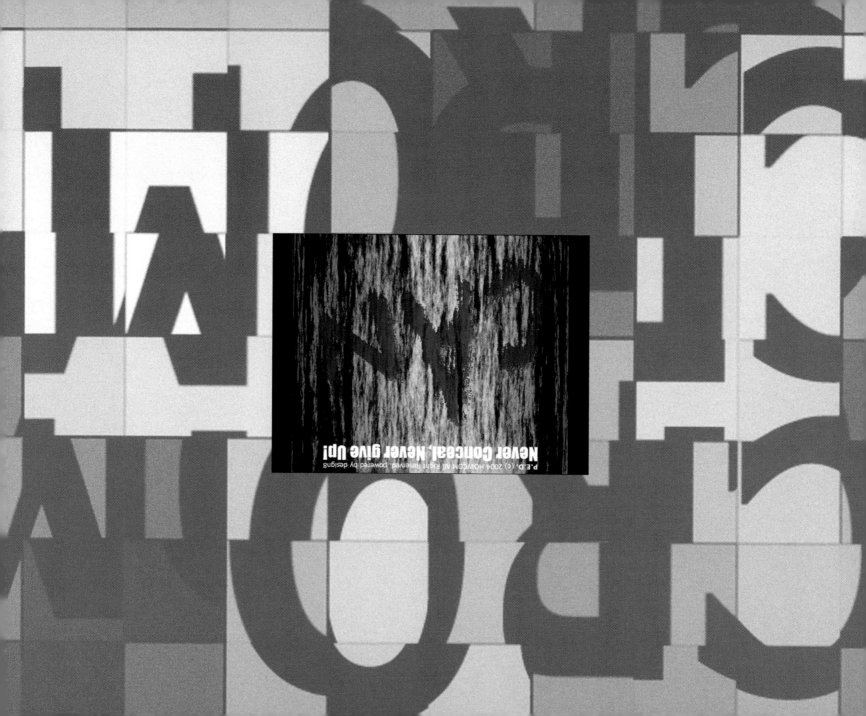

Effect 7: Painted on the Bark

This section looks at a type of text painted on the rough texture of a tree bark. The new Fibers Palette in the upgraded version of Photoshop CS allows you to make very realistic tree bark.

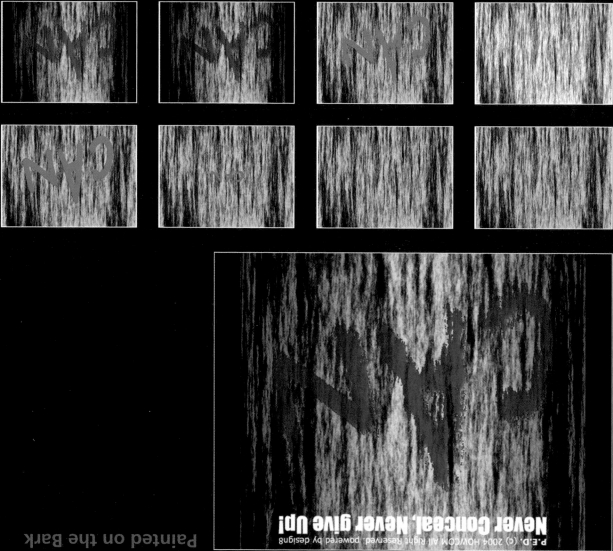

Effect 7: Painted on the Bark

Total Steps

STEP 1. Creating a New Work Window

STEP 2. Making the Tree Bark Texture

STEP 3. Saving the Source for the Displace Filter

STEP 4. Coloring the Tree Bark

STEP 5. Making the Color of the Tree Bark Darker

STEP 6. Making Faded Bark Texture

STEP 7. Adjusting the Color Saturation

STEP 8. Entering the Text

STEP 9. Adjusting the Size and Slant of the Text

STEP 10. Diversifying the Text Size

STEP 11. Applying the Displace Filter to the Text

STEP 12. Checking the Results of the Displace Filter

STEP 13. Rolling the Tree Bark Texture

STEP 14. Rolling the Text Image

STEP 15. Making a Black Background Layer

STEP 16. Adjusting the Width of the Image

STEP 17. Setting Up the Gradient

STEP 18. Darkening the Sides of the Tree Bark

STEP 19. Blending the Gradient Image

STEP 20. Blending the Text

STEP 21. Making the Text Lighter

STEP 22. Creating 3D Text

STEP 23. Entering the Subtitle

STEP 1. Creating a New Work Window

Press Ctrl+N to create a new work window. Click on the Preset box and choose 640×480 to create a 640×480-pixel workspace.

STEP 2. Making the Tree Bark Texture

In the toolbox, click on the Default Foreground and Background Colors icon to set up the default color, and set the foreground color to black and the background color to white.

Choose Filter > Render > Fibers from the menu at the top and apply the filter using the default setting.

This will create a vertically striped tree bark texture.

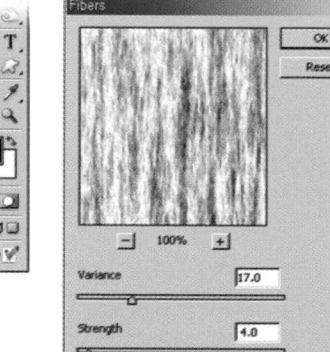
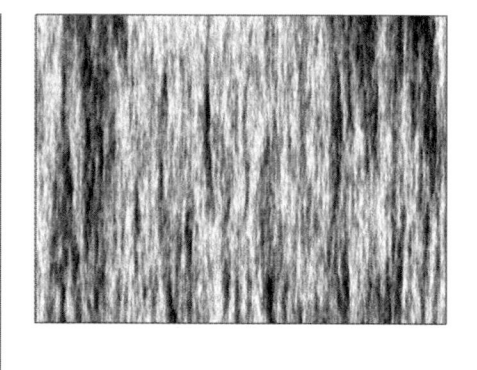

STEP 3. Saving the Source for the Displace Filter

Press Ctrl+Alt+S to save the mosaic image as a PSD file of a different name (disp_map2.psd). This file is included on the supplementary CD-ROM.

STEP 4. Coloring the Tree Bark

Next, you can color the tree bark. Choose Image > Adjustments > Hue/Saturation from the menu at the top. Check Colorize and then set the Hue to 36, the Saturation to 40, and the Lightness to –35. The tree bark will be a light, yellowish brown.

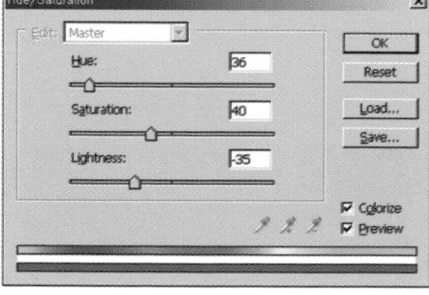
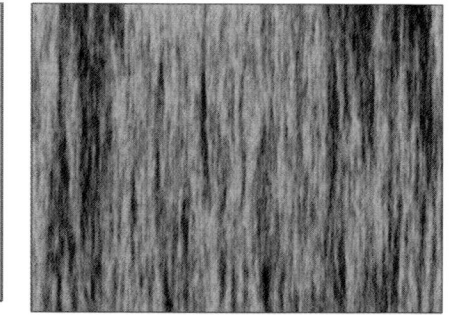

STEP 5. Making the Color of the Tree Bark Darker

Choose Image > Adjustments > Curves from the menu at the top and adjust the shape of the graph so it is in the shape of an S, as shown here. This will make the color richer and darker. Click on the graph to add handles, and drag the handles to adjust the shape of the graph. Drag the handles out of the work window to delete them if you make a mistake.

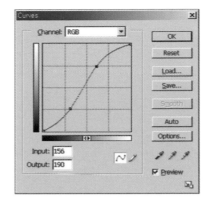

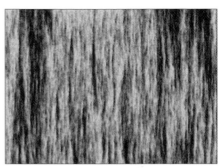

STEP 6. Making Faded Bark Texture

The lighter areas of the bark represent areas that have faded from exposure to the sun. Click on the Channels Palette to open it. Hold down the Ctrl key and click on the RGB channel at the top to select only the lighter areas of the bark as the selection frame. Then, press Ctrl+H to hide the selection.

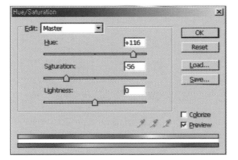

Choose Image > Adjustments > Hue/Saturation from the menu at the top and set the Hue to 116 and the Saturation to –56. The lighter areas of the selected image will change to a greenish tone of low saturation. However, as you can see, the effect is too much.

STEP 7. Adjusting the Color Saturation

After you apply the Hue/Saturation command, choose Edit > Fade > Hue/Saturation from the menu at the top and set the Opacity to 80% to reduce the effect of the previous command. This will make the color of the bark more natural. Press Ctrl+D to deselect the hidden selection.

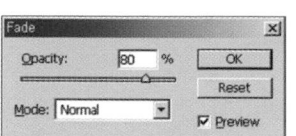

STEP 8. Entering the Text

Click on the Foreground Color button in the toolbox and set it to red. Choose the Horizontal Type Tool from the toolbox.

In the Character Palette, set the font to Comics Sans MS and the font size to 72 pt.

Then, click the tool on the work window and type in the desired text. Press Ctrl+Enter when you have finished typing.

STEP 9. Adjusting the Size and Slant of the Text

Press Ctrl+T to apply the Free Transform command. Drag out the handles on the text to make it larger. Hold down the Ctrl key while you drag the handles; this allows you to slant the text at the same time. Continue dragging out the handles until you are satisfied with the size and rotation. Press Enter to finalize the transformation.

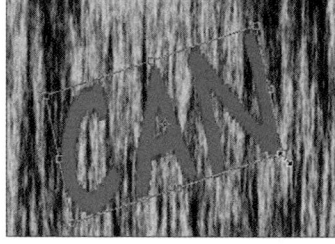

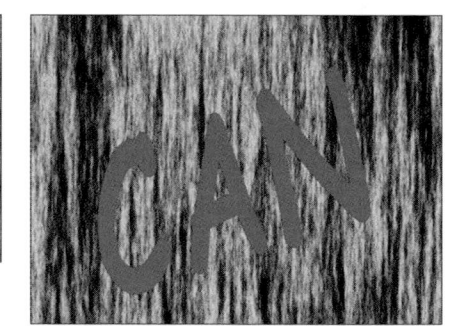

STEP 10. Diversifying the Text Size

Use the Horizontal Type Tool to select the text one letter at a time.

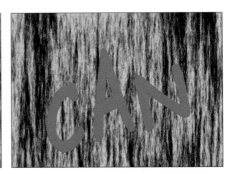

Adjust the font size, width, and height of each individual letter to diversify the text. Drag the icon next to the value field from left to right to adjust the value. Press Ctrl+Enter to accept the text changes.

STEP 11. Applying the Displace Filter to the Text

Choose Filter > Distort > Displace from the menu at the top. You will see a

message asking you whether you want to convert the text layer into a regular image layer in order to apply the filter.

Click on the OK button to open the panel. Set the Horizontal Scale and Vertical Scale to 16, and then click on OK. You should now see a dialog box from which you can choose the displace map source. Choose the source file you created earlier (disp_map2.psd). This file is included on the supplementary CD-ROM.

STEP 12. Checking the Results of the Displace Filter

The displace map source has roughened the texture of the text image. If you look closely, you will see that the shape of the text has transformed to the tree bark texture used as the map source.

Looking at the Layers Palette, you will also notice that the text layer has been converted into a regular image layer.

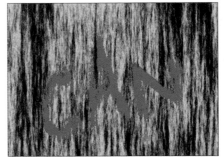

STEP 13. Rolling the Tree Bark Texture

You will now attempt to roll the tree bark in a horizontal direction. First, press Ctrl+A to select the entire image, and then choose the Background layer from the Layers Palette.

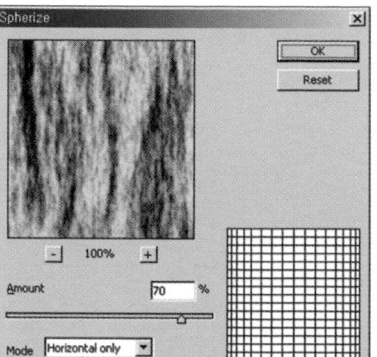
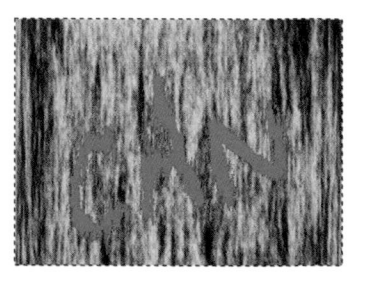

Choose Filter > Distort > Spherize from the menu at the top and set the Amount to 70% and the Mode to Horizontal Only. The center of the image will protrude and the sides will narrow to create a slant.

STEP 14. Rolling the Text Image

Select the text layer from the Layers Palette and press Ctrl+F to repeat the application of the filter. The text image will be rolled along with the tree bark texture. Press Ctrl+D to deselect the selection.

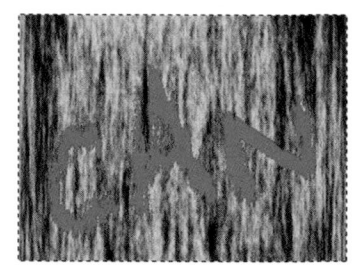

STEP 15. Making a Black Background Layer

Select the Background layer from the Layers Palette and press Ctrl+J to make another copy of it (Layer 1). If the layer copy is created with a different name, double-click on that name and type **Layer 1**.

Select the Background layer again, click on the Foreground Color button in the toolbox, and set it to black. Then, press Alt+Del to make the Background layer black.

STEP 16. Adjusting the
Width of the Image

Select the tree bark layer from the
Layers Palette and click on the link
icon of the text layer directly above
it to link the two layers.

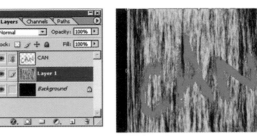

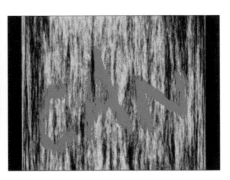

Press Ctrl+T to apply the Free
Transform command. Hold down
the Alt key and drag in the handles around the image. Press Enter to finalize the
transformation. This will narrow both the image and the text equally on both sides.

STEP 17. Setting Up the Gradient

Choose the Gradient Tool from the toolbox.
Click on the Linear Gradient button in the option
bar at the top to set up a linear gradient.

Then, click on the drop-down arrow button
beside the Gradient Color button to open the
Gradient Preset panel. Click on the second
thumbnail (Foreground to Transparent).

STEP 18. Darkening the Sides
of the Tree Bark

Click on the Create a New Layer button at
the bottom of the Layers Palette to make
a new layer. Drag it right below the text
layer at the very top.

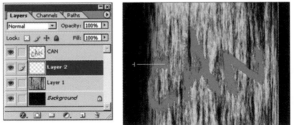

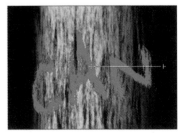

Choose the Gradient Tool, click on the
left edge of the work window, and drag
slightly toward the right to make the left side of the image dark, as shown here.

Next, click the Gradient Tool on the right edge of the work window and drag it over to the center to make the right side
of the image dark. Holding down the Shift key while you drag the Gradient Tool allows you to apply the gradient in a
straight line.

STEP 19. Blending the Gradient Image

In the Layers Palette, set the Blend Mode of the gradient image to Linear Burn and the Fill to 42%. Click on the Layer Visibility icon in front of the text layer to hide it so you can better see the effects of the blend. To create a softer blend, choose Filter > Blur > Gaussian Blur from the menu at the top to spread out the gradient more. Accept the default values in the Gaussian Blur dialog box, and then click on the OK button to accept the filter.

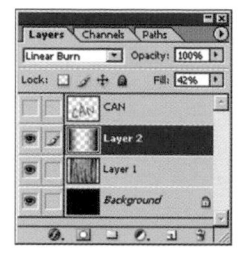

STEP 20. Blending the Text

Click on the text layer in the Layers Palette so it is visible again and set the Blend Mode to Color Burn. This will cause the text image to blend naturally with the tree bark texture below it. However, as you can see here, the text is too dark.

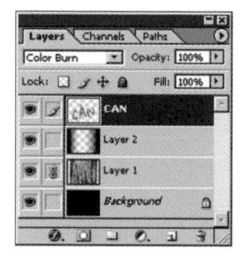

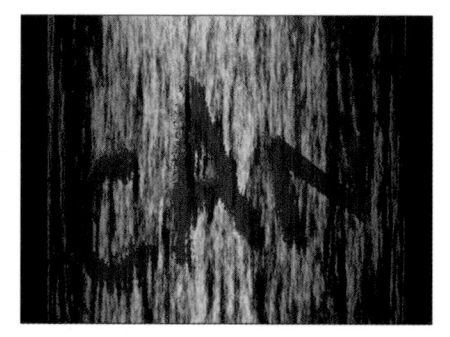

STEP 21. Making the Text Lighter

Press Ctrl+J to make another copy of the text layer. Select the duplicate text layer from the Layers Palette and set the Blend Mode to Linear Light and the Fill to 30%.

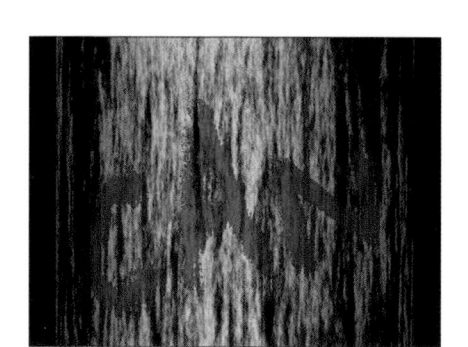

STEP 22. Creating 3D Text

Select the duplicate text layer from the Layers Palette and click on the Add a Layer Style button at the bottom.

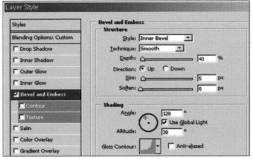

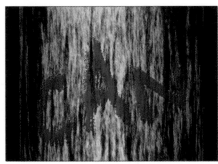

Choose Bevel and Emboss to open the Layer Style Panel. Set the Depth to 41%, the Size to 5 px, and the Soften to 0 px. Click on the Gloss Contour graph icon at the bottom and choose the graph shown here. Click on the OK button to apply the style. This will create a reflection in the top-left corner of the text to make it look three-dimensional.

STEP 23. Entering the Subtitle

Click on the Foreground Color button and set it to white. Then, use the Horizontal Type Tool to type in the desired text.

Choose the desired font and font size in the Character Palette.

Effect 8: Stone-Like Type

In this chapter, you will use the various Photoshop filters to create stone-carved text. To create the styles you want, try practicing with the different filters.

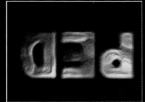

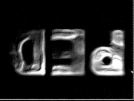

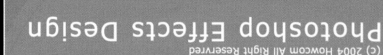

Photoshop Effects Design

(c) 2004 Howcom All Right Reserved

Stone-Like Type

www.design8.co.kr

(c) 2004 Howcom All Right R

Photoshop

Effect 8: Stone-Like Type

Total Steps

STEP 1. Creating a New Work Window

STEP 2. Entering the Title

STEP 3. Making the Text Larger

STEP 4. Blurring the Text

STEP 5. Making the Cloud Texture

STEP 6. Softening the Clouds

STEP 7. Blending the Clouds to the Text

STEP 8. Expanding the Bright Areas of the Text

STEP 9. Making 3D Text

STEP 10. Softening the Text

STEP 11. Emphasizing the Contours of the Texture

STEP 12. Emphasizing the Dimensionality of the Text

STEP 13. Adjusting the Degree of Dimensionality

STEP 14. Coloring the Text

STEP 15. Emphasizing the Text Color

STEP 16. Selecting the Background

STEP 17. Coloring the Background Gray

STEP 18. Offsetting the Background Image

STEP 19. Cutting Out Unnecessary Areas

STEP 20. Entering the Subtitle

STEP 1. Creating a New Work Window

Press Ctrl+N to create a new work window. Click on the Preset box and choose 640×480 to create a 640×480-pixel workspace.

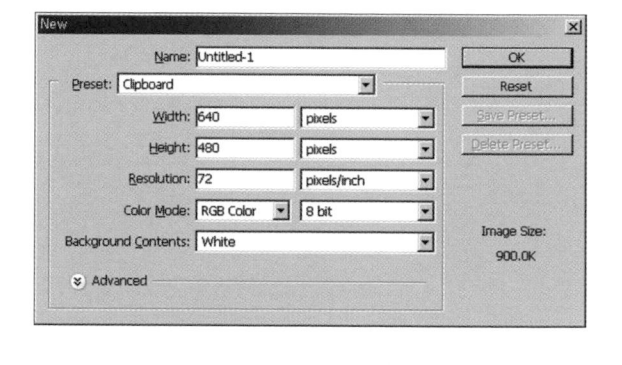

STEP 2. Entering the Title

In the toolbox, first click on the Default Foreground and Background Colors button to set up the default color. Then, click on the Switch Foreground and Background Colors button to set the foreground color to white and the background color to black. Then press Ctrl+Del to fill in the work window with the background color (black). Select the Horizontal Type Tool from the toolbox and click on the work window.

Type in the desired title. Press Ctrl+Enter when you are finished typing.

In the Character Palette, set the font to Arial Black and the font size to 72 pt. If you can't see the Character Palette, choose Window > Character from the menu at the top.

STEP 3. Making the Text Larger

Press Ctrl+T to apply the Free Transform command. Drag out the handles on the text to make it larger. Press Enter to apply the transformation.

STEP 4. Blurring the Text

Choose Filter > Blur > Gaussian Blur from the menu at the top. You will see a message asking you whether you want to convert the text layer into a regular image layer in order to apply the filter.

Click on the OK button to open the dialog box and set the Radius to 9 pixels. Click on OK to apply the filter. This will blur the text.

Looking at the Layers Palette, you will notice that the text layer has been converted into a regular image layer.

STEP 5. Making the Cloud Texture

In the Layers Palette, click on the Create a New Layer button at the bottom to create a new layer. Then, choose Filter > Render > Clouds from the menu at the top to create irregular clouds. Press Ctrl+F to apply the command again, and continue repeating the command until you arrive at the shape you want.

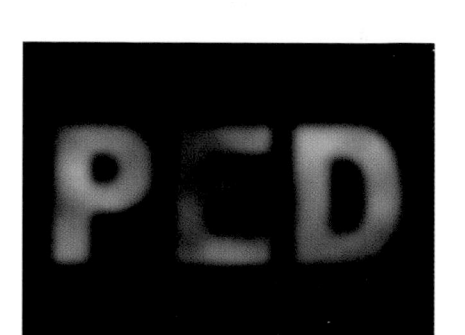

STEP 6. Softening the Clouds

Choose Filter > Blur > Gaussian Blur from the menu at the top and set the Radius to 9 pixels. Click on OK to apply the filter. This will soften the clouds.

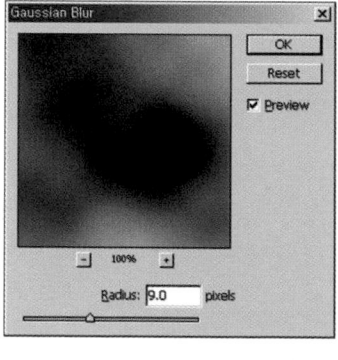

STEP 7. Blending the Clouds to the Text

In the Layers Palette, set the Blend Mode of the cloud layer to Multiply. The text will be covered with the cloud image.

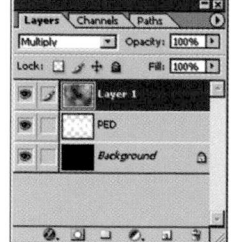

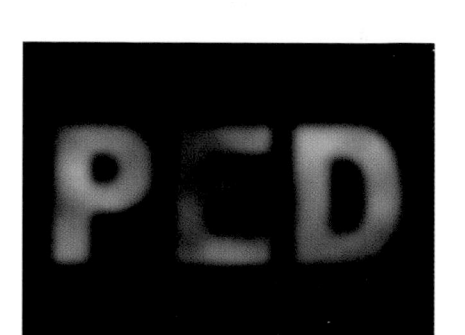

STEP 8. Expanding the Bright Areas of the Text

Choose Ctrl+A to select the entire image, and then press Shift+Ctrl+C to copy merge the visible images. Press Ctrl+V to paste the copied image into the layer.

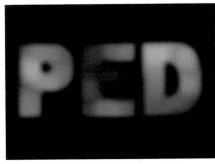

You will see the new layer (Layer 2) in the Layers Palette.

Choose Filter > Other > Maximum from the menu at the top and set the Radius to 7 pixels. Click on OK to apply the filter. This will expand the brighter pixels of the new image layer in the shape of a rectangle.

STEP 9. Making 3D Text

Choose Filter > Render > Lighting Effects from the menu at the top and adjust the graph on the left side of the panel as shown here. The line in the center shows the direction of the light. As the rounded border becomes more elongated, the angle at which the light shines becomes smaller. Drag the handles at the edges to adjust the angle and direction of light, and drag the handles in the center to adjust where the light shines. On the bottom-right of the panel, set the Texture Channel to Red to create dimensionality. Click on OK to apply the filter. This will create 3D lighting for the text.

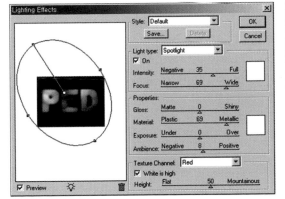

STEP 10. Softening the Text

Choose Filter > Noise > Median from the menu at the top and set the Radius to 8 pixels. Click on OK to apply the filter. The small particles will clump together to soften the image.

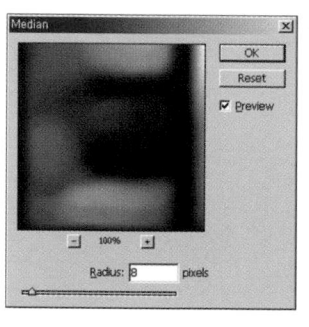

STEP 11. Emphasizing the Contours of the Texture

Choose Filter > Sharpen > Unsharp Mask from the menu at the top and set the Amount to 140%, the Radius to 15 pixels, and the Threshold to 6 levels. Click on OK to apply the filter. The lighter and darker areas of the image will be emphasized to draw out the contours of the texture. Normally, the Unsharp Mask filter is used to sharpen the edges of an image, but adjusting the Amount and Radius values allows you to create the effect shown here.

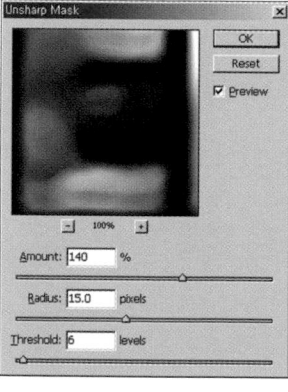

STEP 12. Emphasizing the Dimensionality of the Text

Choose Filter > Render > Lighting Effects from the menu at the top and adjust the graph on the left side of the panel, as shown here. Then, set the Texture Channel to Red to create dimensionality. Click on OK to apply the filter. This will further emphasize the 3D effect of the text.

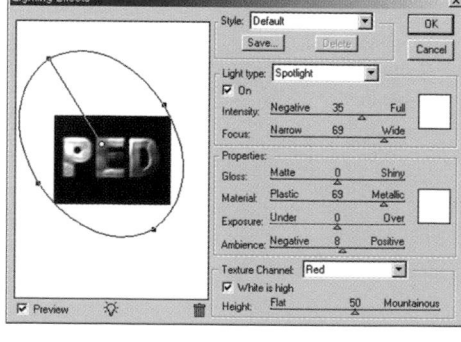

STEP 13. Adjusting the Degree of Dimensionality

After you apply the Lighting Effects filter, choose Edit > Fade Lighting Effects from the menu at the top and set the Opacity to 70% to soften the effect of the filter.

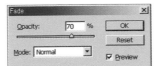

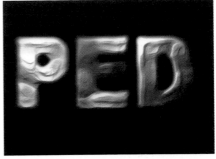

STEP 14. Coloring the Text

Click on the Create New Fill or Adjustment Layer button at the bottom of the Layers Palette and choose Hue/Saturation.

In the Hue/Saturation dialog box that appears, check Colorize and set the

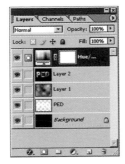

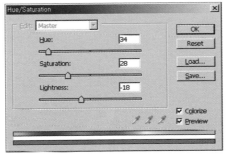

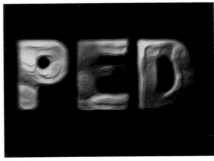

Hue to 34, the Saturation to 28, and the Lightness to –18. Click on OK to apply the change. The text color will now be brown. Looking at the Layers Palette, you can see that an adjustment layer has been added at the top. The adjustment layer works just like the Image/Adjustments menu, but unlike in that menu, you can change the values at any time by double-clicking on the effect layer, or you can apply a Blend Mode or Opacity to it.

STEP 15. Emphasizing the Text Color

Click on the Create New Fill or Adjustment Layer button at the bottom of the Layers Palette and choose Curves. Shape the graph as shown here to make the text color richer and fuller. Click on OK to apply the change.

Looking at the Layers Palette, you can see that a Curves adjustment layer has been made.

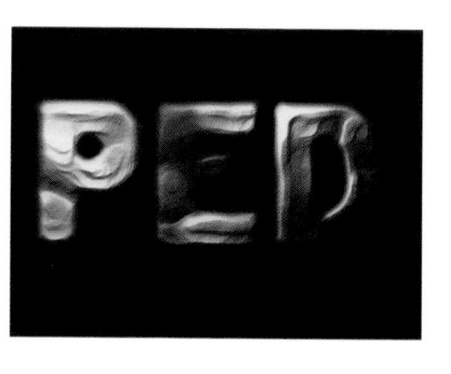

STEP 16. Selecting the Background

Choose Select > Color Range from the menu at the top. Click on the black areas of the work window and then set the Fuzziness to 12. Click on OK to complete the selection. This will allow you to select all the black regions at the same time.

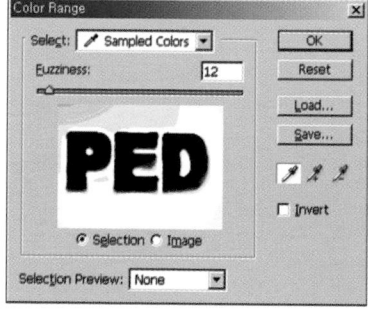

STEP 17. Coloring the Background Gray

Click on the Create a New Layer button at the bottom of the Layers Palette to make a new layer.

Click on the Foreground Color button in the toolbox and set it to gray. Then, press Alt+Del to make the Background layer gray.

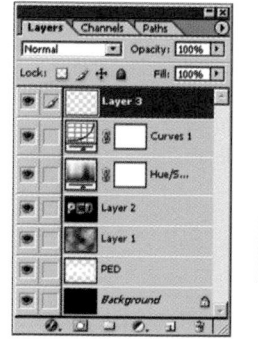
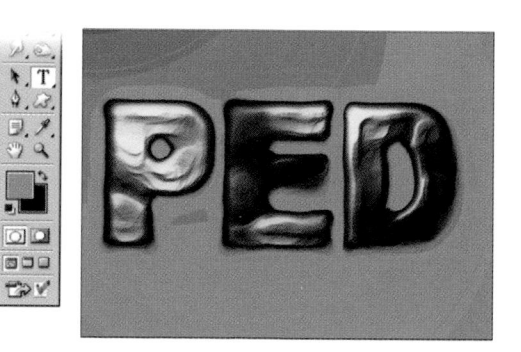

STEP 18. Offsetting the Background Image

Press Ctrl+D to deselect the selection, and then hold down the Ctrl key and press the right arrow key and the down arrow key on the keyboard two or three times to move the background image to the right and down. The darker areas of the bottom-right corner of the text will show up more to emphasize the 3D effect.

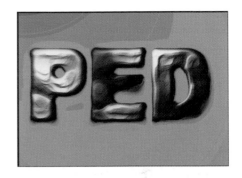

STEP 19. Cutting Out Unnecessary Areas

Choose the Crop Tool from the toolbox. Drag the tool over the areas of the image that you don't need and then press Enter. The outer areas of the image will be cropped.

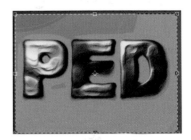

STEP 20. Entering the Subtitle

Click on the Foreground Color button and set the foreground color to white. Then, use the Horizontal Type Tool to type in the desired subtitle.

Choose the desired font and font size in the Character Palette.

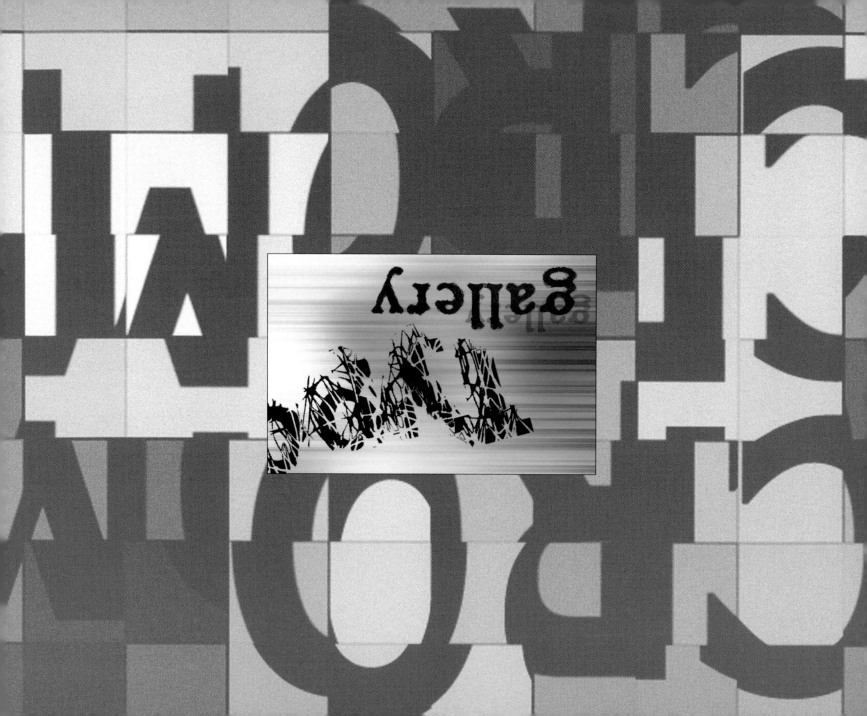

Effect 9: Grunge Type

You can create messy text using the Displace filter.
This technique enables you to incorporate text into
the texture for the image.

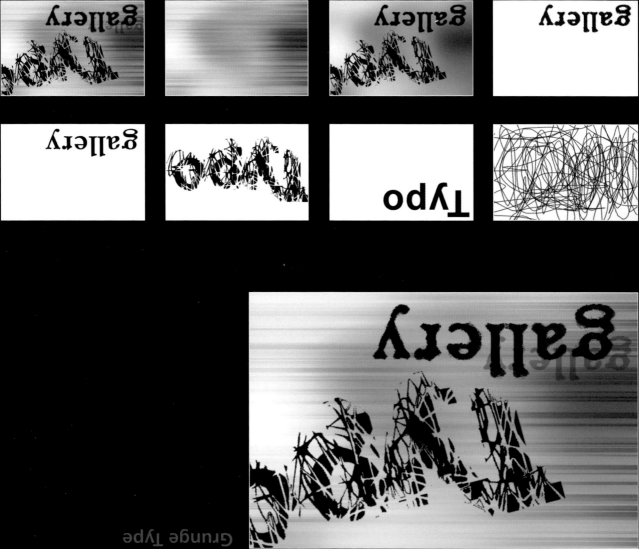

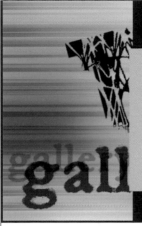

Effect 9: Grunge Type

Total Steps

STEP 1. Creating an Image with Lines

STEP 2. Saving the File for Use as a Displace Map

STEP 3. Entering Text in a New File

STEP 4. Transforming the Text Using a Displace Filter

STEP 5. Entering More Text

STEP 6. Adding a Text-Shaped Selection to a New Layer

STEP 7. Blurring the Text

STEP 8. Texturing the Text

STEP 9. Adjusting the Color of the Rough Text

STEP 10. Importing a Background Image

STEP 11. Blurring the Background Image and Changing Its Color

STEP 12. Adding a White Layer

STEP 13. Applying Noise to the Layer

STEP 14. Clumping the Noise Speckles

STEP 15. Stretching the Noise Texture

STEP 16. Lightening the Noise Effect

STEP 17. Completing the Image

STEP 1. Creating an Image with Lines

Choose File > New (Ctrl+N) from the menu bar to open the New dialog box. Set the Width to 600 pixels and the Height to 400 pixels. Also, set the Resolution to 150 pixels/inch, and then click on OK.

Choose the Brush Tool from the toolbox, and click on the Click to Open the Brush Preset Picker button on the Options bar. Choose the Hard Round 3 Pixels brush, and press Enter to close the Brush Preset Picker. Set the foreground color to black, and draw vertical and horizontal lines as shown here.

STEP 2. Saving the File for Use as a Displace Map

Choose Filter > Artistic > Cutout from the menu bar to open the Cutout dialog box. Change the Number of Levels and Edge Simplicity settings as shown here, and then click on OK.

Gray surfaces will enhance the pattern of lines, as shown here.

Choose File > Save (Ctrl+S) from the menu bar, and save the image as a Photoshop (*.psd) file, as shown here. You will use this image as a displace map source file. For your convenience, you can instead use the source file offered on the supplementary CD-ROM (Book\Sources\Grunge_Disp.psd). Close the file that you've created.

STEP 3. Entering Text in a New File

Make an image by choosing File > New (Ctrl+N) from the menu bar. Set the Width to 600 pixels, the Height to 400 pixels, and the Resolution to 150 pixels/inch. Click on OK.

Set the foreground color to black, and then choose the Horizontal Type Tool from the toolbox. Click on the Toggle the Character and Paragraph Palettes button on the Options bar, and choose the palette settings shown here.

Type the word **Typo** in the image window, and then click on the Commit Any Current Edits button on the Options bar.

STEP 4. Transforming the Text Using a Displace Filter

Choose Edit > Free
Transform (Ctrl+T) from
the menu bar and drag
the selection handles to
increase the text to fill
the window, as shown
here. You might need to
move the image to put it
in the position shown.
Press Enter to apply the
transformation.

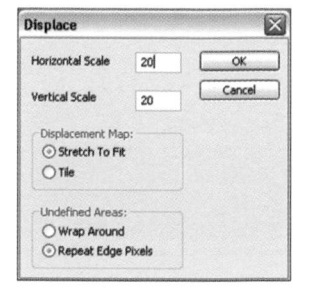

Choose Filter > Distort > Displace from the
menu bar. Click on OK when Photoshop asks
whether to rasterize the type.

In the Displace dialog box that opens, specify
the settings shown here, and then click on OK.

Use the Choose a Displacement Map dialog
box that appears to select the Photoshop
(*.psd) file you saved in Step 2—the
Grunge_Disp.psd file. Click on Open to trans-
form the text using the displace map file.

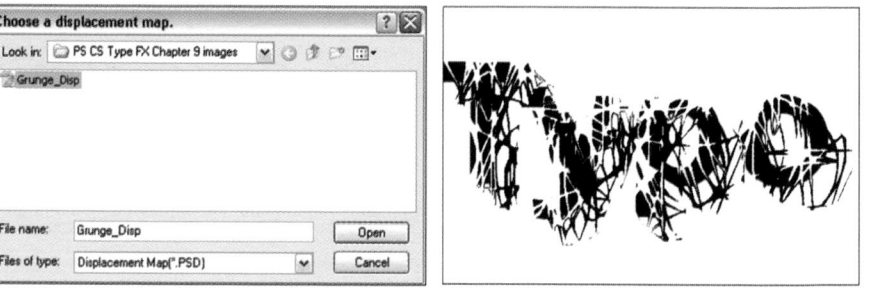

STEP 5. Entering More Text

Choose Edit > Transform > Rotate from the menu bar. Drag outside the selection handles to rotate the beginning of the text downward, and drag within the text to move it to the upper-right

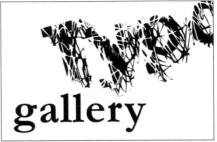

corner of the window. Press Enter to finish the transformation.

Choose the Horizontal Type Tool, specify the font settings shown here in the Character Palette, and then type the word **gallery** in the lower-left corner of the image. If you do not have ITC Garamond, use Garamond or a similar font. Click on the Commit Any Current Edits button at the right end of the Options bar to finish adding the text.

STEP 6. Adding a Text-Shaped Selection to a New Layer

Click on the Create a New Layer button (Shift+Ctrl+N) in the Layers Palette to add a new layer named Layer 1 above the text layer (the gallery layer) you just created. Set the foreground color to white and press Alt+Del to fill the new layer with white.

Hold down the Ctrl key and click on the gallery layer in the Layers Palette to add a selection marquee in the shape of the letters. Set the foreground color to black, and then press Alt+Del to color the text black. Choose Select > Deselect (Ctrl+D) to remove the selection marquee.

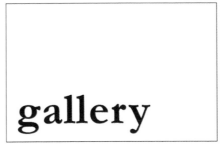

STEP 7. Blurring the Text

Choose Filter > Blur > Gaussian Blur from the menu bar to open the Gaussian Blur dialog box. Change the Radius setting to approximately 3.2, and then click on OK.

Choose Image > Adjustments > Levels to open the Levels dialog box. Drag the center and rightmost Input Levels sliders to the settings shown here, and then click on OK. These settings will combine to blur and thin the letters.

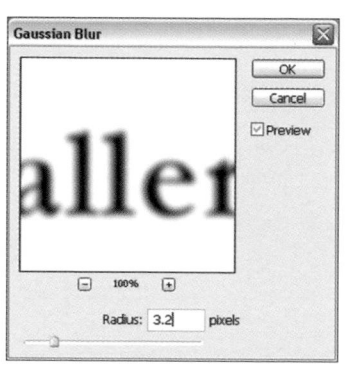

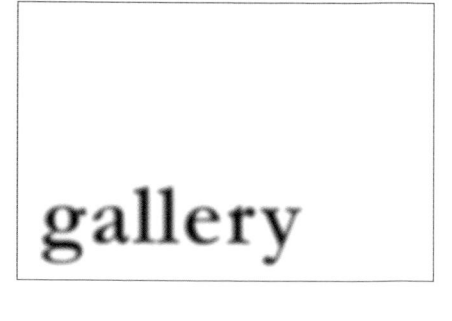

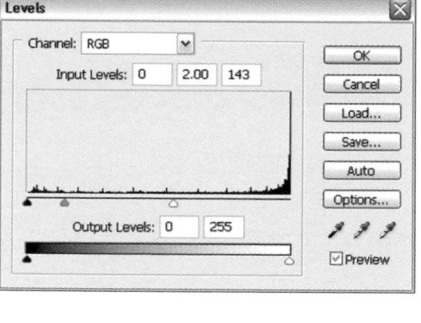

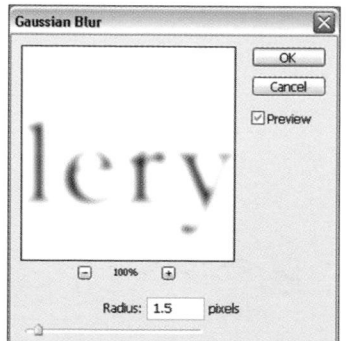

STEP 8. Texturing the Text

With the Layer 1 layer still selected in the Layers Palette, choose Filter > Blur > Gaussian Blur from the menu bar. Reduce the Radius to 1.5, and then click on OK.

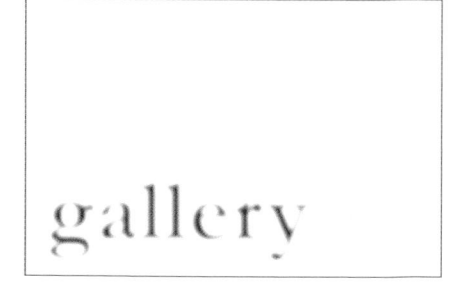

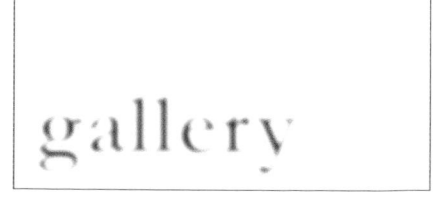

Choose Filter > Artistic > Fresco, and then choose the settings shown here in the Fresco dialog box. Click on OK to finish roughing or texturing the edges of the letters.

STEP 9. Adjusting the Color of the Rough Text

Choose Image > Adjustments > Hue/Saturation (Ctrl+U) from the menu bar to open the Hue/Saturation dialog box. Click on the Colorize check box to select it, drag the three color sliders to the settings shown here, and then click on OK.

The black letters will take on a bluish tone. Click on the Add a Layer Style button on the Layers Palette, and then click on Blending Options. Choose Multiply from the Blend Mode drop-down list, and then click on OK.

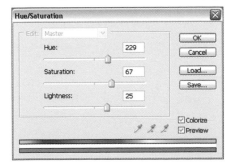

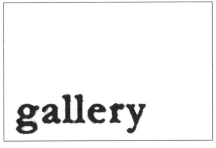

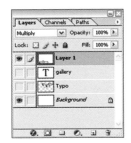

STEP 10. Importing a Background Image

Choose File > Open (Ctrl+O), and open the Book\Sources\ Entrance_Ch_09.jpg file from this book's supplementary CD-ROM.

 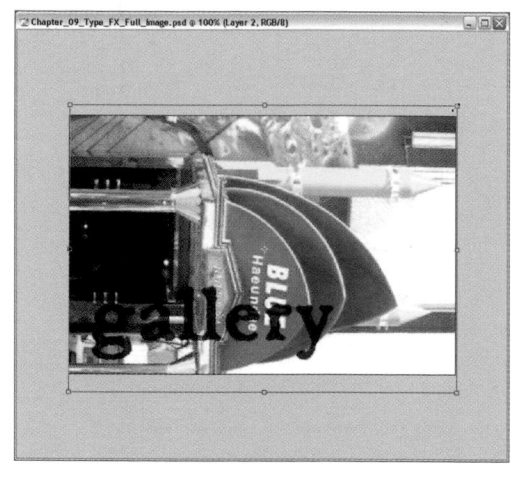

Choose Select > All (Ctrl+A) to select the entire image. Press Ctrl+C to copy the selection, and then close the file. Return to the image file you created for this project, and then press Ctrl+V to paste the copied image onto a new layer named Layer 2. In the Layers Palette, drag Layer 2 down and place it just above the Background layer. Click on the Layer Visibility icons next to the gallery layer and the Typo layer to hide them from sight.

Choose Edit > Transform > Rotate 90° CW to rotate the copied image. Choose Edit > Free Transform (Ctrl+T), drag the handles to resize the layer content to fill the image window, and then press Enter.

STEP 11. Blurring the Background Image and Changing Its Color

With the Layer 2 layer still selected in the Layers Palette, choose Filter > Blur > Gaussian Blur from the menu bar. In the Gaussian Blur dialog box, increase the Radius setting to 40, and then click on OK.

This will blur the image so only its original colors can be seen. Make the gallery and Typo layers visible and compare your screen to the figure.

 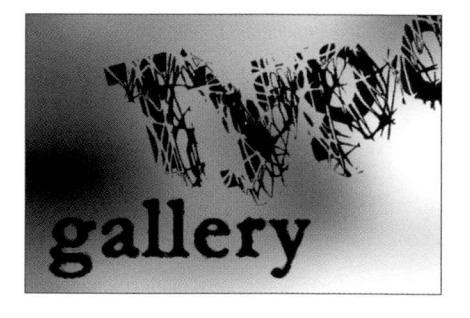

Choose Image > Adjustments > Variations to open the Variations dialog box. Click on the More Green and More Yellow thumbnails in the dialog box to add more greenish tones into the layer, and then click on OK.

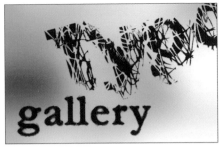

STEP 12. Adding a White Layer

Click on the Create a New Layer button (Shift+Ctrl+N) in the Layers Palette to add a new layer named Layer 3. Leave it positioned above Layer 2. Set the foreground color to white and press Alt+Del to fill the new layer with white. Click on the Layer Visibility icon beside each of the layers above Layer 3 in the Layers Palette to hide it.

STEP 13. Applying Noise to the Layer

With Layer 3 still selected, choose Filter > Noise > Add Noise from the menu bar. In the Add Noise dialog box, increase the Amount setting to approximately 115 and click on the Monochromatic check box to select it. Click on OK to fill the layer with noise speckles.

Then, choose Filter > Blur > Gaussian Blur from the menu bar. Change the Radius setting to approximately 2.7, and then click on OK. The speckles will now blur together.

STEP 14. Clumping the Noise Speckles

With Layer 3 still selected, choose Image > Adjustments > Levels (Ctrl+L) from the menu bar to open the Levels dialog box. Drag the left and right Input Levels sliders toward the center to the positions shown here, and then click on OK to create a sharp black and white image.

Then, choose Filter > Texture > Grain. Choose the settings shown here in the Grain dialog box, and then click on OK to add white noise to the black areas in the image.

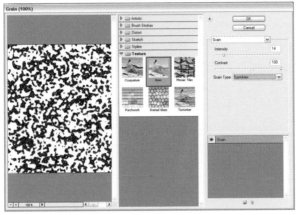

STEP 15. Stretching the Noise Texture

Using the Rectangular Marquee Tool, select a vertical rectangle in the image. Choose Edit > Free Transform (Ctrl+T), drag the left and right handles that appear on the selection to stretch the selection horizontally to fill the layer, and then press Enter. Choose Select > Deselect (Ctrl+D) to remove the selection marquee.

STEP 16. Lightening the Noise Effect

With Layer 3 still selected, choose Filter > Blur > Motion Blur from the menu bar. In the Motion Blur dialog box, set the Angle to 0 and the Distance to 564, and then click on OK.

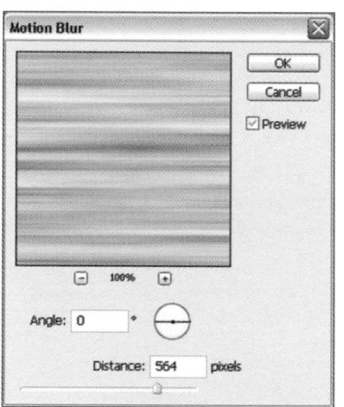

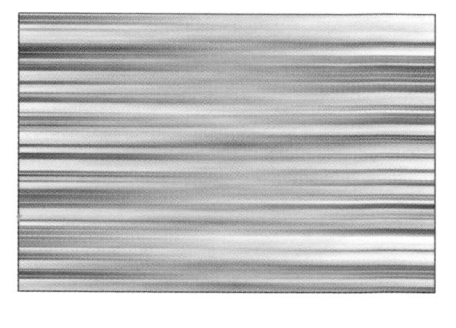

Then, click on the Add a Layer Style button on the Layers Palette and click on Blending Options. Choose Overlay from the Blend Mode drop-down list and set the Opacity to 61%. Click on OK. This will blend the horizontal stripes of light to the background image.

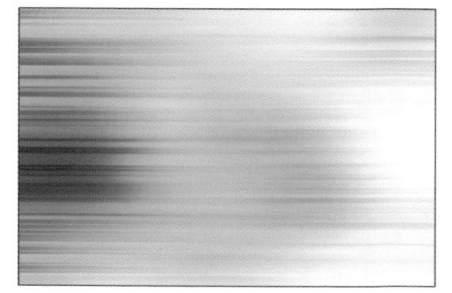

STEP 17. Completing the Image

In the Layers Palette, drag the gallery text layer onto the Delete Layer button to delete the layer from the image. Click on the box for the Layer Visibility icon beside each of the hidden layers to redisplay it. Click on the Layer 1 layer to select it, and then choose Layer > New > Layer via Copy (Ctrl+J). Click on the Layer 1 copy layer in the Layers Palette.

Use the Move Tool to move the layer content, and use the Edit > Free Transform command to reduce its size. Also, use the Opacity setting on the Layers Palette to make the text copy more transparent to complete the image.

 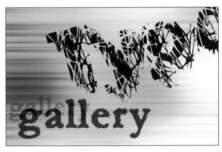

Effect 10: Smoky Type

You can use various distortion effects to create smoky text.
The Distort and Liquify filters distort the image in various ways
and can be used to create fun and interesting text styles as
well as textured backgrounds.

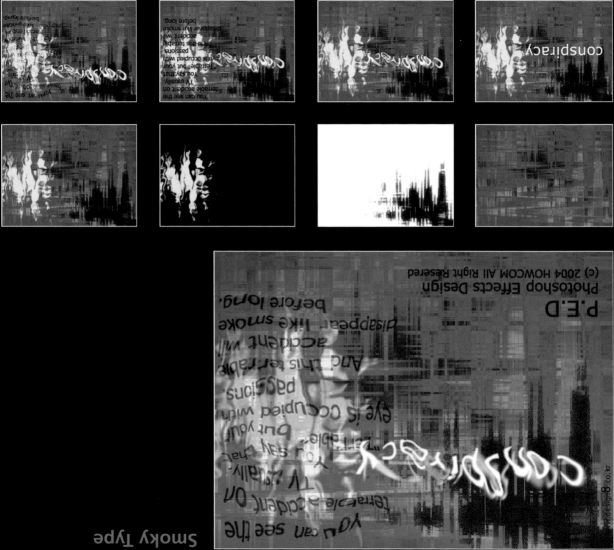

Smoky Type

conspiracy

P.E.D
Photoshop Effects Design
(c) 2004 HOWCOM All Right Resered

You can see the
terrable accident On
TV usually.
You say that
"...terrable: but your
eye is occupied with
passions.
And this terrable
accident will
disappear like smoke
before long.

P.E.D
Photoshop Effects Desi[gn]
(c) 2004 HOWCOM All Right Re[served]

Effect 10: Smoky Type

Total Steps

STEP 1. Creating a New Work Window
STEP 2. Coloring the Background Red
STEP 3. Making the Cloud Texture
STEP 4. Creating a Lattice Texture
STEP 5. Coloring the Texture
STEP 6. Emphasizing the Texture Color
STEP 7. Blending the Texture Image
STEP 8. Setting Up the Brush
STEP 9. Drawing with the Brush
STEP 10. Changing the Shape of the Image to a Lattice
STEP 11. Glowing Image Edges
STEP 12. Blending the Black Texture
STEP 13. Making a Yellow Texture
STEP 14. Changing the Shape of the Texture to a Lattice

STEP 15. Blurring the Texture
STEP 16. Emphasizing the Image Color
STEP 17. Creating an Agitated Distortion
STEP 18. Blending the Yellow Texture
STEP 19. Entering the Title
STEP 20. Creating Turbulence in the Text
STEP 21. Previewing the Distorted Text
STEP 22. Copying the Text Layer
STEP 23. Distorting the Duplicated Text
STEP 24. Setting Up the Text Field
STEP 25. Entering Text into the Text Field
STEP 26. Distorting the Text
STEP 27. A Darker Text Blend
STEP 28. Entering the Subtitle

STEP 1. Creating a New Work Window

Press Ctrl+N to create a new work window. Click on the Preset box and choose 640×480 to create a 640×480-pixel workspace.

STEP 2. Coloring the Background Red

Click on the Foreground Color button in the toolbox and set the color to red (RGB=209, 0, 0). Press Alt+Del to color the background red.

STEP 3. Making the Cloud Texture

In the Layers Palette, click on the Create a New Layer button at the bottom to create a new layer (Layer 1).

In the toolbox, click on the Default Foreground and Background Colors button to set up the default color, and set the foreground color to black and the background color to white. Then, choose Filter > Render > Clouds from the menu at the top to create irregular clouds. Press Ctrl+F to apply the command again, and continue repeating the command until you arrive at the shape you want.

STEP 4. Creating a Lattice Texture

Choose Filter > Distort > Wave from the menu at the top and set the Number of Generators to 15, the Wavelength to 24/120, the Amplitude to 5/35, the Scale to 100/100%, and the Type to Square. Click on OK to apply the filter. This will create strong, wavy distortions on the image in both the horizontal and vertical directions, making it look like a lattice.

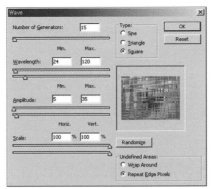

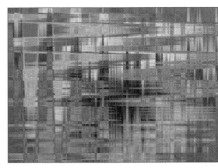

STEP 5. Coloring the Texture

Choose Image > Adjustments > Hue/Saturation from the menu at the top. Check the Colorize option and then set the Hue to 23, the Saturation to 25, and the Lightness to –26. Click on OK to apply the adjustment. The texture will be a dark brown.

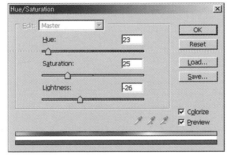

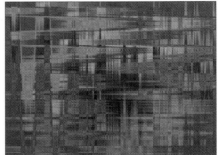

STEP 6. Emphasizing the Texture Color

Choose Image > Adjustments > Curves from the menu at the top and shape the graph into an S shape, as shown here. Click on OK to apply the adjustment. This will make the image color richer and fuller.

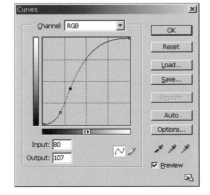

STEP 7. Blending the Texture Image

Choose the texture layer from the Layers Palette, set the Blend Mode to Hard Light, and set the Fill to 70%. The texture image will blend with the red background layer below it and turn red.

STEP 8. Setting Up the Brush

Click on the Foreground Color button in the toolbox and set the color to black. Then, choose the Brush Tool from the toolbox.

Right-click on the work window to open the Brush Preset Panel and choose the Charcoal Large Smear brush, 36 px diameter.

STEP 9. Drawing with the Brush

Click on the Create a New Layer button at the bottom of the Layers Palette to make a new layer, and then press Ctrl+Del to fill in the layer with the background color (white).

Use the preset Brush Tool to draw a simple sketch on the work window, as shown here.

STEP 10. Changing the Shape of the Image to a Lattice

Choose Filter > Distort > Wave from the menu at the top and set the Number of Generators to 8, the Wavelength to 1/94, the Amplitude to 24/50, the Scale to 40/70%, and the Type to Square. Click on OK to apply the filter. This will create irregular, wavy distortions on the image in both the horizontal and vertical directions.

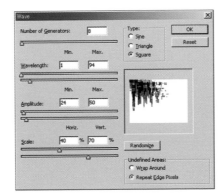

STEP 11. Glowing Image Edges

Choose Filter > Distort > Diffuse Glow from the menu at the top and set the Graininess to 10, the Glow Amount to 2, and the Clear Amount to 6. Click on OK to apply the filter. The red particles will make the image edges look like they are glowing.

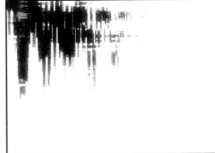

STEP 12. Blending the Black Texture

In the Layers Palette, set the Blend Mode of the active texture layer to Multiply and the Fill to 88%. This will blend the black image naturally with the background.

STEP 13. Making a Yellow Texture

Click on the Create a New Layer button at the bottom of the Layers Palette to make a new layer.

In the toolbox, set the foreground color to yellow (RGB=255, 222, 0) and the background color to black. Press Ctrl+Del to fill in the layer with the background color (black), and then use the Brush Tool to draw a yellow lump on the right side.

STEP 14. Changing the Shape of the Texture to a Lattice

Choose Filter > Distort > Wave from the menu at the top using the values you used in the "Changing the Shape of the Image to a Lattice" step. (Set the Number of Generators to 8, the Wavelength to 1/94, the Amplitude to 24/50, the Scale to 40/70%, and the Type to Square.) This will create irregular, wavy distortions on the image in both the horizontal and vertical directions.

STEP 15. Blurring the Texture

Choose Filter > Blur > Gaussian Blur from the menu at the top and set the Radius to 3 pixels. Click on OK to apply the filter. This will blur the image slightly.

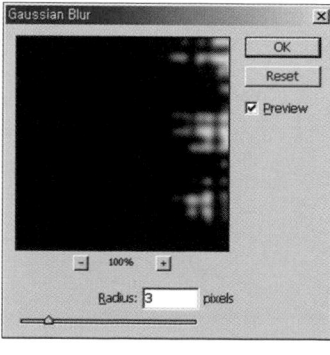

STEP 16. Emphasizing the Image Color

Choose Image > Adjustments > Curves from the menu at the top and shape the graph into an S shape, as shown here. Click on OK to apply the adjustment. This will make the color fuller and richer.

STEP 17. Creating an Agitated Distortion

Choose Filter > Distort > Glass from the menu at the top and set the Distortion to 16, the Smoothness to 15, the Texture to Frosted, and the Scaling to 145%. Click on OK to apply the filter. This will create an irregular, agitated distortion.

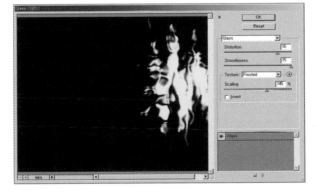

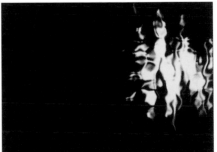

STEP 18. Blending the Yellow Texture

In the Layers Palette, set the Blend Mode of the active texture layer to Linear Dodge. This will blend the yellow texture naturally with the image.

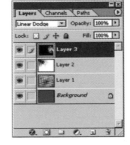

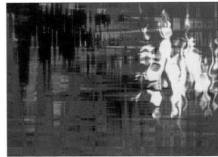

STEP 19. Entering the Title

Click on the Foreground Color button in the toolbox and set the color to white. Then select the Horizontal Type Tool from the toolbox and type in the desired title. Press Ctrl+Enter after typing the title.

In the Character Palette, set the font to Tahoma and the font size to 72 pt. If you can't see the Character Palette, choose Window > Character from the menu at the top.

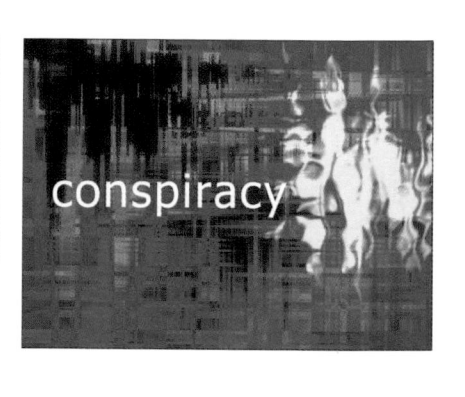

STEP 20. Creating Turbulence in the Text

Choose Filter > Liquify from the menu at the top to apply the filter to the text layer. You will see a message asking you whether you want to convert the text layer into a regular image layer in order to apply the filter.

Click on the OK button to open the panel. Choose the Turbulence Tool from the top-left of the panel and set the Brush Size to 300. Set the Reconstruct Options Mode to Stiff. Check Show Backdrop and set Use to Background and Mode to Behind so you can preview your work as you go. Click and hold the tool on the text in the center for a while, and you will soon see the text become distorted. If you click and drag the mouse, the text will distort in the direction of the drag. If you've gone too far with the distortion, press Alt to undo the steps or until you arrive back at the original image. Click on OK to apply the filter.

STEP 21. Previewing the Distorted Text

Choose Filter > Blur > Blur More from the menu at the top to blur the image. Looking at the Layers Palette, you will notice that the text layer has been converted into a regular image layer.

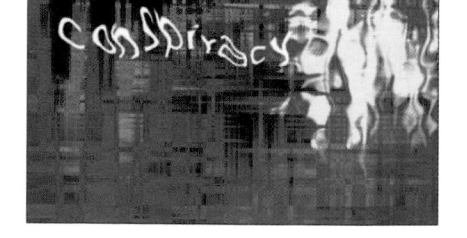

STEP 22. Copying the Text Layer

Press Ctrl + J to make another copy of the selected layer. Then, choose Filter > Blur > Gaussian Blur from the menu at the top and set the Radius to 3 pixels. Click on OK to apply the filter. This will blur the overlapping text image.

STEP 23. Distorting the Duplicated Text

Choose Filter > Distort > Zigzag from the menu at the top and set the Amount to 24, the Ridges to 4, and the Style to Pond Ripples. Click on OK to apply the filter. This will create a stronger distortion.

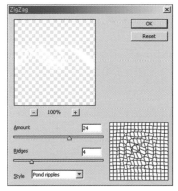

STEP 24. Setting Up the Text Field

In the toolbox, click on the Default Foreground and Background Colors button to set up the default color, and set the foreground color to black. Then, choose the Horizontal Type Tool.

Drag the tool over the top-right side of the work window to create the text field, as shown here.

STEP 25. Entering Text into the Text Field

In the Character Palette, set the font to Tahoma and the font size to 30 pt, and then type the desired text in the text field. When you reach the end of the text field, the cursor will drop down to the next line so you can continue typing in the text. Press Ctrl+Enter when you are finished typing.

 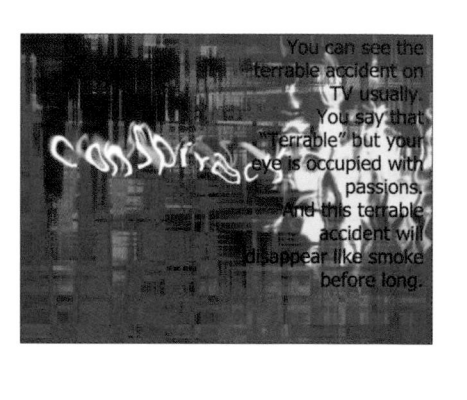

Open the Paragraph Palette and click on the Right-Align Text button to right-align the text field.

STEP 26. Distorting the Text

Choose Filter > Liquify from the menu at the top. You will see a message asking you if you want to convert the text layer into a regular image layer in order to apply the filter. Click on OK to open the panel. Click on the Turbulence Tool from the top-left side of the panel. Set Use to Background. Click on the text in the text field to create distortion. Click on OK to apply the filter.

Looking at the Layers Palette, you will notice that the text layer has been converted into a regular image layer. Move this text layer right above the yellow texture layer, and then set the Blend Mode to Color Burn and the Fill to 75%. The text image will blend naturally with the background. However, you can see that the yellow texture hides the text completely.

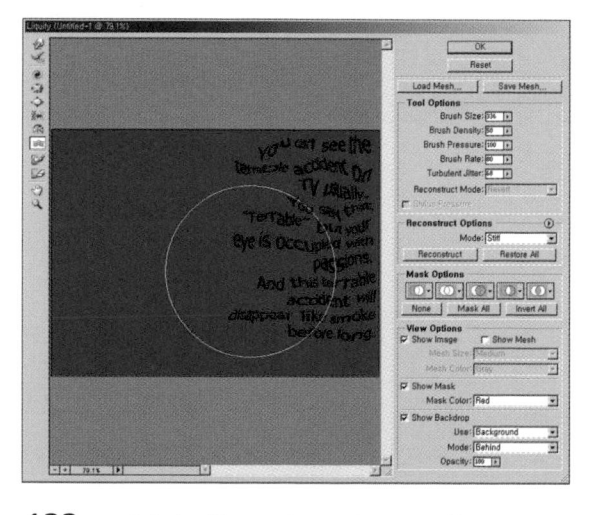 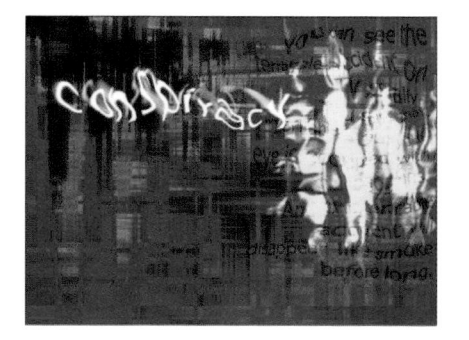

STEP 27. A Darker Text Blend

Press Ctrl+J to make another copy of the active layer. In the Layers Palette, set the Blend Mode to Linear Burn and the Fill to 25%. The text will be visible through the yellow background.

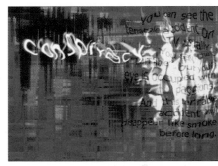

STEP 28. Entering the Subtitle

Finally, type in the desired subtitle to complete your work. The yellow texture on the right side of the image is too strong, so reduce the Fill value to 75%.

point-of-purchase

Effect 11: Caught in a Net

In this project, you will create text with effects that make the text appear to be caught in a net. You will learn how to use the Displace filter to bend the lines in the net to fit the text.

Caught in a Net

Effect 11: Caught in a Net

Total Steps

STEP 1. Making a New Image with a Gray Background

STEP 2. Entering Text

STEP 3. Resizing and Blurring the Text

STEP 4. Adding a New White Layer

STEP 5. Making a Black Square

STEP 6. Creating the Grid Pattern

STEP 7. Applying the Grid Pattern

STEP 8. Inverting the Text Color

STEP 9. Changing the Text Color

STEP 10. Adding 3D Contours to the Text

STEP 11. Selecting the Spider Layer

STEP 12. Adjusting the Grid Pattern Color

STEP 13. Applying the Displace Filter to the Grid

STEP 14. Enhancing Shadows in the Spider Web Image

STEP 15. Fading the Shadows

STEP 16. Overlapping Text Layers

STEP 17. Brightly Blending the Text Layers

STEP 18. Entering the Remaining Text

STEP 19. Adding Contrast Above and Below the Text

STEP 20. Completing the Image

STEP 1. Making a New Image with a Gray Background

Choose File > New (Ctrl+N) from the menu bar to open the New dialog box. Set the Width to 1000 pixels, the Height to 500 pixels, and the Resolution to 72 pixels/inch. Click on OK.

Use the Color Palette to set the foreground color to a medium gray (RGB=128, 128, 128), and then use the Paint Bucket Tool or press Alt+Del to fill the Background layer with the gray color.

STEP 2. Entering Text

Choose the Horizontal Type Tool from the toolbox. Open the Character Palette by clicking on the Toggle the Character and Paragraph Palettes button on the Options bar. In the Character Palette, choose the font settings shown here. (If the Verdana font is not available, choose a similar sans serif font.) Click in the image window, enter the text as shown, and click on the Commit Any Current Edits button on the Options bar.

STEP 3. Resizing and Blurring the Text

Choose Edit > Free Transform (Ctrl+T) from the menu bar. Drag the handles to increase the size of the text so it fills the image window. Press Enter to finish the transformation.

Choose Filter > Blur > Gaussian Blur from the menu bar. Click on OK in the dialog box that prompts you to rasterize the text. In the Gaussian Blur dialog box, set the Radius to 20, and then click on OK to blur the image. Use File > Save (Ctrl+S) to save the current file as pop.psd. You will use this file as the displace map. For your convenience, the file is included on the supplementary CD-ROM (Book\Sources\pop.psd).

STEP 4. Adding a New White Layer

Click on the Create a New Layer button (Shift+Ctrl+N) in the Layers Palette to add a new layer. Double-click on the layer name, type **spider**, and then press Enter to rename the layer. Set the foreground color to white, and then use the Paint Bucket Tool or press Alt+Del to fill the layer with white.

STEP 5. Making a Black Square

You next need to make a grid (which you'll later transform to a spider web) on the new spider layer. To start, choose the Rectangular Marquee Tool from the toolbox. Press and hold the Shift key, and then drag on the white spider layer to create a square selection frame.

Set the foreground color to black. Choose Edit > Stroke from the menu bar, increase the Width setting to 2 px, click on the Inside option button in the Stroke dialog box, and then click on OK. This will create a black outline around the square selection.

STEP 6. Creating the Grid Pattern

With the square still selected, convert it into a pattern. Choose Edit > Define Pattern from the menu bar. Type a pattern name, if desired, and then click on OK.

STEP 7. Applying the Grid Pattern

Choose Select > All (Ctrl+A) to select the entire spider layer. Choose Edit > Fill from the menu bar to open the Fill dialog box. Choose Pattern from the Use drop-down list, and then choose the pattern you created in Step 6 from the Custom Pattern Palette.

Click on OK to fill the selection with a grid of black lines. Choose Select > Deselect (Ctrl+D) to remove the selection marquee.

STEP 8. Inverting the Text Color

In the Layers Palette, drag the spider layer to place it below the text (pop) layer. Click on the pop layer to select it. Choose Image > Adjustments > Invert (Ctrl+I) to invert the color of the text from black to white.

STEP 9. Changing the Text Color

Choose Image > Adjustments > Hue/Saturation (Ctrl+U) from the menu bar. In the Hue/Saturation dialog box, click on the Colorize check box to select it, and then choose the Hue, Saturation, and Lightness settings shown here. Click on OK to apply the color change to the text.

STEP 10. Adding 3D Contours to the Text

With the pop layer still selected, choose Filter > Render > Lighting Effects from the menu bar. Adjust the handles in the Preview area as shown here to redirect the light to shine from the upper-left corner. Choose Pop Transparency from the Texture Channel drop-down list, and then click on OK. The softened edges of the text will make the contours appear natural.

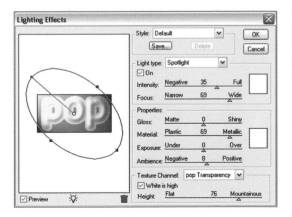

STEP 11. Selecting the Spider Layer

You next need to adjust the color of the grid pattern you applied earlier to the spider layer. To start, click on the spider layer in the Layers Palette to select it.

STEP 12. Adjusting the Grid Pattern Color

Choose Image > Adjustments > Hue/Saturation (Ctrl+U) from the menu bar. In the Hue/Saturation dialog box, click on the Colorize check box to select it, and then choose the Hue, Saturation, and Lightness settings shown here. Click on OK to apply the color change to the grid.

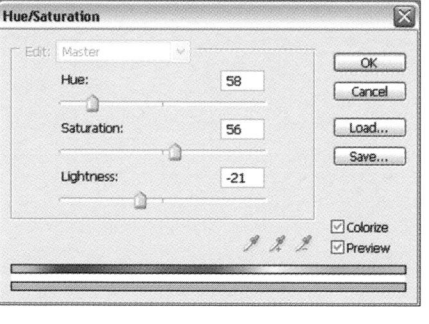
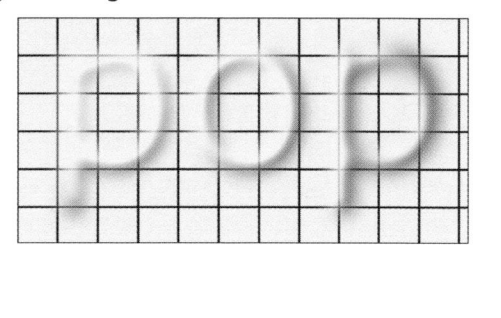

STEP 13. Applying the Displace Filter to the Grid

With the spider layer still selected, choose Filter > Distort > Displace from the menu bar. Choose the settings shown here in the Displace dialog box, and then click on OK.

In the Choose a Displacement Map dialog box, select the pop.psd file, and then click on Open. (You can choose Book\Sources\pop.psd from the supplementary CD-ROM if you did not save your own file earlier.) When Photoshop applies the color of the displace map to the spider layer, the lines of the grid will bend to follow the brighter colors of the letters in the displace map file.

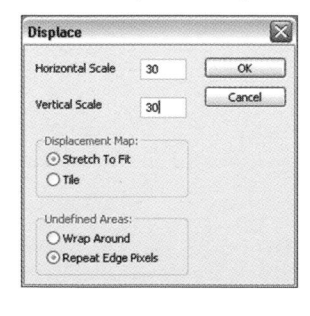
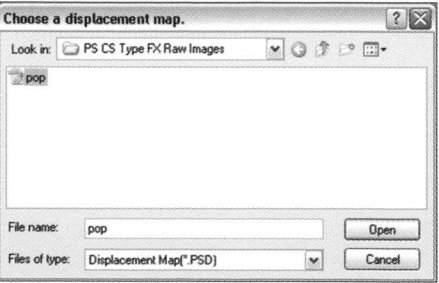
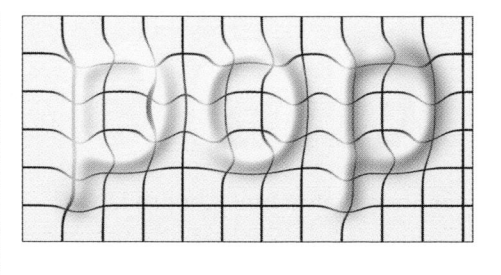

STEP 14. Enhancing Shadows in the Spider Web Image

With the spider layer still selected in the Layers Palette, choose Filter > Render > Lighting Effects. Adjust the handles in the Preview area as shown here to concentrate the light shining on the image. Leave None selected in the Texture Channel drop-down list, and then click on OK. Darker shadows will appear in the lower-left and upper-right corners of the layer.

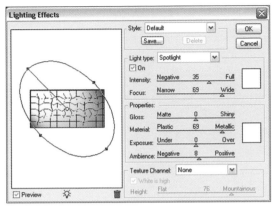
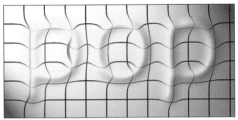

STEP 15. Fading the Shadows

Next, adjust the intensity of the shadows you just added. Choose Edit > Fade Lighting Effects (Shift+Ctrl+F) from the menu bar. In the Fade dialog box, change the Opacity setting to 45, as shown here, and then click on OK.

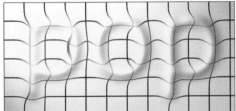

STEP 16. Overlapping Text Layers

Click on the pop text layer to select it. Choose Layer > New > Layer via Copy (Ctrl+J) to copy the layer. Click on the original pop layer in the Layers Palette to reselect it, and then click on the Add a Layer Style button at the bottom of the palette. Click on Blending Options in the menu to open the Layer Style dialog box. Choose Linear Burn from the Blend Mode drop-down list, and then click on OK. This will darken the blend of the two layers.

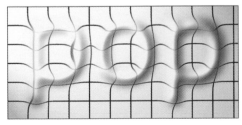

STEP 17. Brightly Blending the Text Layers

In the Layers Palette, click on the pop copy text layer.
Click on the Add a Layer Style button at the bottom of
the palette, and then click on Blending Options in the
menu. In the Layer Style dialog box, choose Hard Light
from the Blend Mode drop-down list. Change the Fill set-
ting to 61%, and then click on OK. This will intensify
both the dark and light areas of the layer, making the
dark areas darker and the light areas lighter.

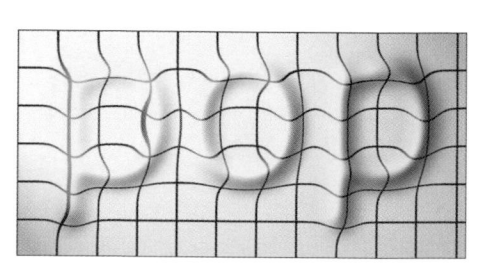

STEP 18. Entering the Remaining Text

Choose the Horizontal Type Tool from the toolbox. Adjust the settings in the Character Palette as shown here, and then
click on the image and enter the remaining text. Click on the Commit Any Current Edits button to finish the new text.

Click on the Create a New Layer button (Shift+Ctrl+N) in the Layers Palette to add a new layer named Layer 1. Use the
Rectangular Marquee Tool to select the bottom portion of the new layer, as shown here.

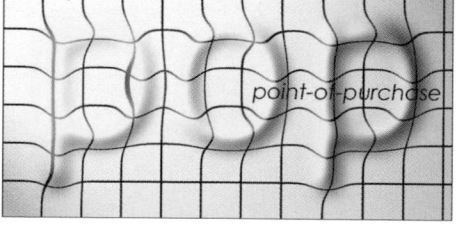

STEP 19. Adding Contrast Above and Below the Text

Click on the Default Foreground and Background Colors button in the toolbox to make the foreground color black and the background color white. Choose the Gradient Tool from the toolbox. Click on the Linear Gradient button on the Options bar, and then drag from the bottom of the selection frame to the top to fill it with the gradient.

Click on the Move Tool in the toolbox. Press and hold the Alt key while you drag from the center of the selection to copy the selection and move the copy to the top of the image window. Choose Edit > Transform > Rotate 180° to create the effect shown here. Choose Select > Deselect (Ctrl+D) to deselect the area.

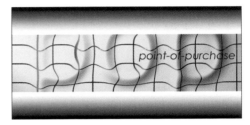

STEP 20. Completing the Image

Double-click on the name of Layer 1 in the Layers Palette, type **shadow**, and press Enter to rename the layer.

Click on the Add a Layer Style button on the Layers Palette, and then click on Blending Options. In the Layer Style dialog box, choose Multiply from the Blend Mode drop-down list, and then click on OK. This will blend the gradients on the shadow layer with the layers below it to make the dark areas darker.

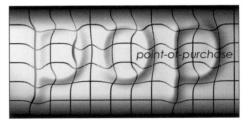

Effect 12: Blur Effect Type

In this project, you will create depth in an image by focusing the foreground text and blurring the background text. The blurred background letters will make the foreground text appear as if it's placed on a transparent glass surface.

Effect 12: Blur Effect Type

Cre

Total Steps

STEP 1. Making a New Image with a Sky Blue Background

STEP 2. Entering Text

STEP 3. Sizing and Realigning the Text

STEP 4. Rasterizing the Text

STEP 5. Blurring the Text Shapes

STEP 6. Blurring the Text Even More

STEP 7. Blurring the Other Rasterized Layer

STEP 8. Blending the Blurred Layers

STEP 9. Entering the Title

STEP 10. Adding Black Shadows to the Text

STEP 11. Making a Crosshair in the Image

STEP 12. Adding Text to the Image

STEP 13. Resizing and Positioning the Text

STEP 14. Drawing a Black Circle

STEP 15. Copying the Circle and Adding a Glow

STEP 16. Adding a Circle

STEP 17. Blurring the New Circle

STEP 18. Making a New White Layer

STEP 19. Changing the Image Color

STEP 20. Adjusting the Image Color

STEP 1. Making a New Image with a Sky Blue Background

Choose File > New (Ctrl+N) from the menu bar to open the New dialog box. Set the Width to 800 pixels and the Height to 600 pixels. Set the Resolution to 100 pixels/inch, and then click on OK.

Use the Color Palette to set the foreground color to sky blue (RGB=51, 196, 244). Use the Paint Bucket Tool or press Alt+Del to fill the Background layer with sky blue.

STEP 2. Entering Text

Choose the Horizontal Type Tool from the toolbox. Open the Character Palette by clicking on the Toggle the Character and Paragraph Palettes button on the Options bar. In the Character Palette, choose the font settings shown here. Click in the image window, enter the text as shown, and click on the Commit Any Current Edits button on the Options bar.

These Projects
are based on the classic
memory game.
The rules are simple but the
process of play exercise

STEP 3. Sizing and Realigning the Text

Click on the text on the text layer, click on the Center Text button on the Options bar, and then click on the Commit Any Current Edits button. Choose the Move Tool from the toolbox, and then drag the newly aligned text into a centered position in the image window. Reselect the Horizontal Type Tool. Select individual lines of the text and adjust the size and the spacing between words using the Character Palette. Try to have the text span the image window, as shown here. Click on the Commit Any Current Edits button on the Options bar to finish.

STEP 4. Rasterizing the Text

With the text layer still selected in the Layers Palette, choose Layer > New > Layer via Copy (Ctrl+J). Click on the Layer Visibility icon beside the original text layer to hide it.

Right-click on the text layer copy, and then click on Rasterize Layer to convert the vector text to a bitmap image.

Copy the rasterized layer by choosing Layer > New > Layer via Copy (Ctrl+J). Click on the Layer Visibility icon beside the newest layer to hide it, and then click on the original rasterized layer below it.

Next, hold down the Ctrl button and click on the original rasterized layer to make a selection in the shape of the letters.

Choose Select > Modify > Expand from the menu bar to open the Expand Selection dialog box. Change the Expand By setting to 5, and then click on OK.

STEP 5. Blurring the Text Shapes

Choose Select > Feather from the menu bar to open the Feather Selection dialog box. Set the Feather Radius value to 5, and then click on OK to soften the edges of the selection frame. Set the foreground color to black, and then use the Paint Bucket Tool or press Alt+Del to fill the modified selection with black.

STEP 6. Blurring the Text Even More

Choose Select > Deselect (Ctrl+D) from the menu bar to remove the selection marquee. Choose Filter > Blur > Gaussian Blur to open the Gaussian Blur dialog box. Change the Radius setting to 30, and then click on OK to blur the layer contents.

STEP 7. Blurring the Other Rasterized Layer

Click on the layer thumbnail for the copy of the rasterized layer (the top layer in the Layers Palette) to both select and redisplay it.

Choose Filter > Blur > Gaussian Blur to open the Gaussian Blur dialog box. Change the Radius setting to approximately 9.7, and then click on OK to blur the layer contents.

STEP 8. Blending the Blurred Layers

With the top layer (the copy of the rasterized layer) still selected, open the Opacity slider on the Layers Palette. Change the slider setting to 34%, and then press Enter.

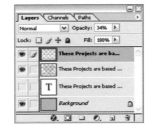

STEP 9. Entering the Title

Click on the Create a New Layer button (Shift+Ctrl+N) in the Layers Palette to add a new layer named Layer 1.

Use the Color Palette to set the foreground color to sky blue (RGB=5, 196, 244).

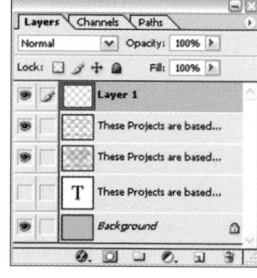

Chose the Horizontal Type Tool. Choose the font and font settings shown here in the Character Palette. Click on the Left-Align Text button on the Options bar. Click in the image window, enter the text as shown, and click on the Commit Any Current Edits button on the Options bar.

STEP 10. Adding Black Shadows to the Text

With the new text layer (the Creative layer) still selected in the Layers Palette, click on the Add a Layer Style button at the bottom of the palette. Click on Outer Glow to open the Layer Style dialog box with the Outer Glow settings displayed. Adjust the dialog box settings as shown here, and then click on OK to add a black and blurry shadow around the title text.

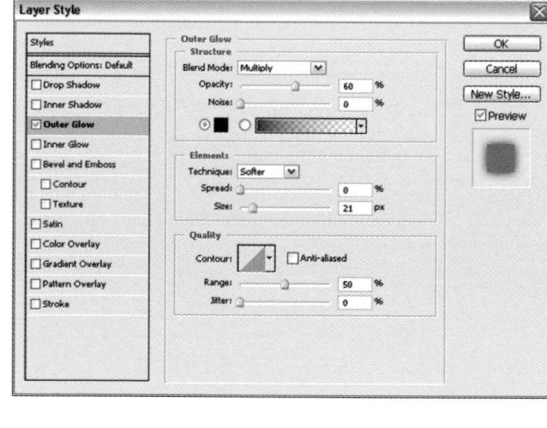

STEP 11. Making a Crosshair in the Image

With the foreground color still set to the sky blue you specified earlier, click on the Create a New Layer button (Shift+Ctrl+N) on the Layers Palette to add a new layer named Layer 1. Choose View > Rulers (Ctrl+R) from the menu bar to display the rulers. Drag down from the horizontal ruler at the top of the image window to add a guideline just below the word "Creative," as shown. Drag right from the vertical ruler at the left to create a guideline between the letters "v" and "e," as shown.

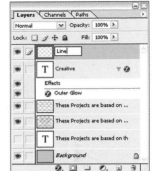

Choose the Pencil Tool from the toolbox. Use the Brush Preset Picker from the Options bar to set the brush size to 1 pixel, if necessary. Press and hold Shift key, and then draw a line over each of the guidelines. Double-click on the layer name, type **Line**, and press Enter to rename the layer. Choose View > Rulers (Ctrl+R) and View > Show > Guides to hide the ruler and guides.

STEP 12. Adding Text to the Image

Choose the Horizontal Type Tool. Specify the font and font settings shown here in the Character Palette. Click in the image window, type the letter **p** as shown, and then click on the Commit Any Current Edits button on the Options bar.

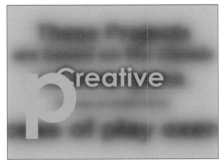

STEP 13. Resizing and Positioning the Text

Click on the Create a New Layer button (Shift+Ctrl+N) on the Layers Palette to add a new layer named Layer 1. Choose the Horizontal Type Tool from the toolbox. Specify the font and font settings shown here in the Character Palette.

Click in the image window, type **hotoshop** as shown, and then click on the Commit Any Current Edits button on the Options bar. Choose the Move Tool from the toolbox. Click on the p layer in the Layers Palette, and then drag the p to the bottom-left corner of the layer. Click on the hotoshop layer in the Layers Palette, and then drag the hotoshop to the bottom-right corner of its layer, aligning the left side of the letter "h" to the vertical blue line you added in Step 11.

STEP 14. Drawing a Black Circle

Click on the Create a New Layer button (Shift+Ctrl+N) on the Layers Palette to make a new layer named Layer 1. Double-click on the layer name, type **Pointimage**, and press Enter to rename the layer.

Set the foreground color to black by clicking on the Default Foreground and Background Colors button in the toolbox. Choose the Elliptical Marquee Tool from the toolbox, and press and hold the Shift key while you drag to draw a circular selection on the new layer. Use the Paint Bucket Tool or press Alt+Del to fill the circle with black, as shown here.

STEP 15. Copying the Circle and Adding a Glow

With the original circle still selected, drag the selection marquee to another location on the layer, as shown here, and press Alt+Del to fill it. Repeat the process to add a third circle on the layer, positioned near the bottom. Choose Select > Deselect (Ctrl+D) to remove the selection marquee.

Click on the Add a Layer Style button on the Layers Palette, and then click on Outer Glow. Choose the settings shown here in the Layer Style dialog box, and then click on OK to add a sky blue glow around each of the black circles.

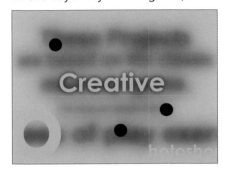 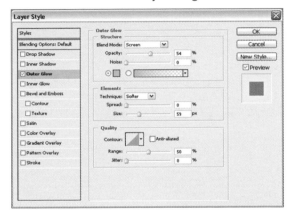 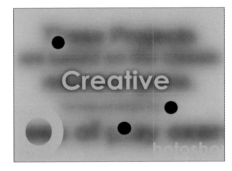

STEP 16. Adding a Circle

Click on the Create a New Layer button (Shift+Ctrl+N) on the Layers Palette to add a new layer named Layer 1. Double-click on the layer name, type **Pointimage_2**, and press Enter to rename the layer. Choose the Elliptical Marquee Tool from the toolbox, and press and hold the Shift key while you drag to draw a circular selection on the new layer. Use the Paint Bucket Tool or press Alt+Del to fill the circle with black, as shown here. Choose Select > Deselect (Ctrl+D) to remove the selection marquee.

 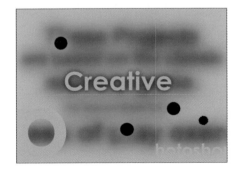

STEP 17. Blurring the New Circle

Choose Filter > Blur > Gaussian Blur from the menu bar to open the Gaussian Blur dialog box. Set the Radius to approximately 5.2, and then click on OK to blur the circle you added to the newest layer. Blurring the circle will add depth to the image.

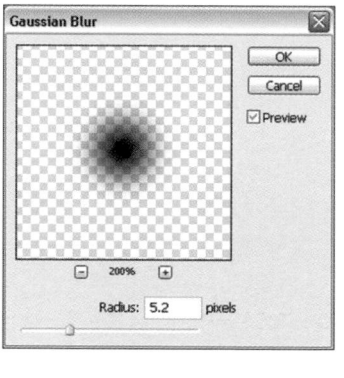

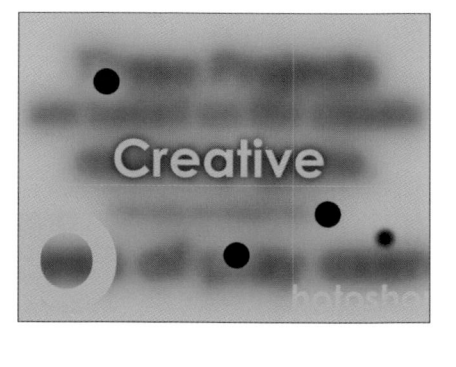

STEP 18. Making a New White Layer

Try changing the color of the whole image to create an entirely different effect. Click on the Create a New Layer button (Shift+Ctrl+N) on the Layers Palette to add a new layer named Layer 1. Double-click on the layer name, type **Shell**, and press Enter to rename the layer. Set the foreground color to white by clicking on the Switch Foreground and Background Colors button in the toolbox. Use the Paint Bucket Tool or press Alt+Del to fill the new layer with white.

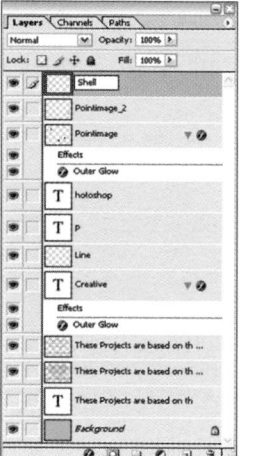

STEP 19. Changing the Image Color

With the new Shell layer still selected in the Layers Palette, click on the Add a Layer Style button on the Layers Palette, and then click on Blending Options. In the Layer Style dialog box, choose Difference from the Blend Mode drop-down list, and change the Opacity setting to 85. Click on OK to view the results.

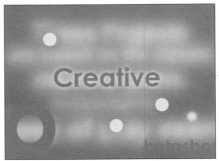

STEP 20. Adjusting the Image Color

Use an adjustment layer to tone down the image's color. Click on the Create New Fill or Adjustment Layer button at the bottom of the Layers Palette, and then click on Hue/Saturation.

Adjust the settings in the Hue/Saturation dialog box as shown here, and then click on OK.

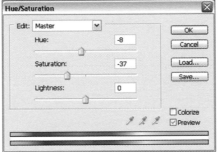

Effect 13: Simple Glass Type

In this project, you will learn how to use a variety of different effects to create texture, as well as how to blend pictures to create the imprint of a leaf. You'll use one of the styles provided in Photoshop to create a simple glass effect on the type.

Simple Glass Type

Typographic trea
punctuate this continuou
flow of **imagery** whi
includes material from
a variety of
media.

Effect 13: Simple Glass Type

Photoshop Effect Design PED

Total Steps

STEP 1. Making a New Image

STEP 2. Adding a Cloud Texture

STEP 3. Selecting a Leaf Shape

STEP 4. Drawing a Leaf Shape

STEP 5. Making a Selection in the Shape of the Leaf

STEP 6. Adjusting and Filling the Leaf Selection

STEP 7. Moving the Selection Frame and Coloring it Black

STEP 8. Deleting Leaf-Shaped Content

STEP 9. Coloring a Leaf Shape

STEP 10. Naming the Leaf Layer

STEP 11. Importing a Source Image into the Leaf

STEP 12. Blurring the Pasted Image

STEP 13. Blending the Leaf Image

STEP 14. Applying the Soft Light Blend Mode

STEP 15. Entering Text and Adjusting Its Size

STEP 16. Typing @ and Adjusting Its Size

STEP 17. Applying a Layer Style to the @ Layer

STEP 18. Modifying the Shape of the Applied Style

STEP 19. Applying a Shadow to the Text

STEP 20. Completing the Image

STEP 1. Making a New Image

Choose File > New (Ctrl+N) from the menu bar to open the New dialog box. Enter **typo_11** in the Name box and set the Width and Height to 600 pixels each. Also, set the Resolution to 100 pixels/inch, and then click on OK.

STEP 2. Adding a Cloud Texture

Click on the Default Foreground and Background Colors button in the toolbox to reset the foreground color to black and the background color to white. Then, choose Filter > Render > Difference Clouds from the menu bar. Press Ctrl+F to reapply the filter until the texture has the desired appearance.

Choose Filter > Render > Lighting Effects to open the Lighting Effects dialog box. Adjust the handles in the Preview area, as shown here, to redirect the light to shine from the upper-left corner and to make the light more diffuse. Choose Red from the Texture Channel drop-down list, and then click on OK.

STEP 3. Selecting a Leaf Shape

Choose the Custom Shape Tool from the toolbox.

Click on the down arrow to open Custom Shape Picker on the Options bar. Click on the Palette Menu button in the upper-right corner of the palette that appears, and then click on Nature. Click on OK or Append as Needed in the message box that appears to replace or append the shapes. Scroll down (if necessary), click on the Leaf 5 (Maple leaf) shape, and then press Enter.

STEP 4. Drawing a Leaf Shape

Click on the Shape Layers button on the Options bar, if necessary.

Also, click on the Switch Foreground and Background Colors button in the toolbox to change the foreground color to white and the background color to black. Drag the mouse in the image window to create the leaf shape.

In the Layers Palette, click on the image of the leaf (Shape 1) so that it is selected there.

Choose Edit > Free Transform Path (Ctrl+T) from the menu bar. Use the selection handles to adjust the rotation and size of the leaf, and then press Enter.

STEP 5. Making a Selection in the Shape of the Leaf

Click on the Create a New Layer button (Shift+Ctrl+N) in the Layers Palette to make a new layer named Layer 1. Double-click on the Layer 1 layer name, type **engraving**, and then press Enter to rename the layer. Hold down the Ctrl key and click on the Shape 1 (leaf) layer to create a selection marquee in the shape of the leaf.

STEP 6. Adjusting and Filling the Leaf Selection

Choose Select > Feather from the menu bar to open the Feather Selection dialog box. Set the Feather Radius to 5, and then click on OK.

Press the right arrow and down arrow keys twice each to move the marquee slightly down and to the right. Set the foreground color to white, if necessary, and then use the Paint Bucket Tool or press Alt+Del to fill the selection with white.

STEP 7. Moving the Selection Frame and Coloring it Black

Press the left arrow and up arrow keys four times each to move the selection marquee slightly up and to the left. Set the foreground color to black, and then use the Paint Bucket Tool or press Alt+Del to fill the selection with black.

STEP 8. Deleting Leaf-Shaped Content

With the engraving layer still selected in the Layers Palette, hold down the Ctrl key and click on the Shape 1 (leaf) layer to reselect the original leaf selection. Click on the Layer Visibility icon next to the Shape 1 layer to hide it. Press the Del key to remove the black fill from the selection. Choose Select > Deselect (Ctrl+D) to see that the Background layer now appears to have a leaf imprint.

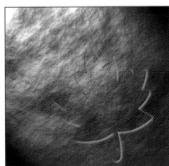

STEP 9. Coloring a Leaf Shape

Click on the Create a New Layer button (Shift+Ctrl+N) in the Layers Palette to make a new layer named Layer 1. With the new layer selected, hold down the Ctrl key and click on the Shape 1 layer to make a leaf-shaped selection on the new layer.

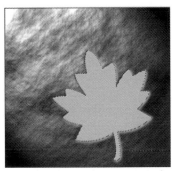

Double-click on the Set Foreground Color button in the toolbox, use the Color Picker dialog box to choose the foreground color shown here, and then click on OK. Use the Paint Bucket Tool or press Alt+Del to fill the selection with the new foreground color. Leave the selection marquee in place.

STEP 10. Naming the Leaf Layer

Double-click on the Layer 1 layer name, type **leaf**, and then press Enter to rename the layer.

STEP 11. Importing a Source Image into the Leaf

Choose File > Open (Ctrl+O) and open the Book\Sources\gogh_01_Ch_13.jpg file from the supplementary CD-ROM.

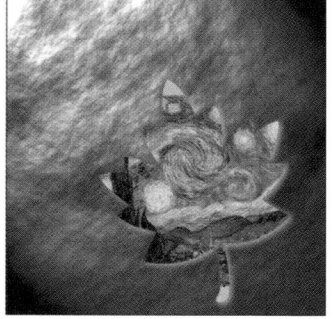

You will fill the leaf's interior with this image. With gogh_01_Ch_13.jpg as the active image, choose Select > All (Ctrl+A) from the menu bar to select the entire image. Press Ctrl+C to copy the selection, and then choose File > Close (Ctrl+W) to close the file. Back in the project file, choose Edit > Paste Into (Shift+Ctrl+V) to paste the copied image file into the selection—the interior of the leaf.

Double-click on the Layer 1 layer name, type **image1**, and then press Enter to rename the layer.

STEP 12. Blurring the Pasted Image

Click on the layer that holds the newly pasted image. Select the Move Tool from the toolbox, if necessary. Choose Edit > Free Transform (Ctrl+T) from the menu bar. Use the selection handles to adjust the size and position of the pasted image so it completely fills the leaf, and then press Enter.

Choose Filter > Blur > Gaussian Blur from the menu bar to open the Gaussian Blur dialog box. Set the Radius to 5, and then click on OK to blur the pasted image.

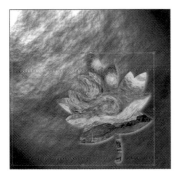
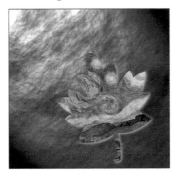

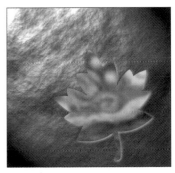

STEP 13. Blending the Leaf Image

With the image1 layer selected in the Layers Palette, click on the Add a Layer Style button, and then click on Blending Options. In the Layer Style dialog box, choose Soft Light from the Blend Mode drop-down list, and then click on OK.

Click on the leaf layer, and then use the Opacity slider on the Layers Palette to reduce its opacity to approximately 15%, so that it blends in naturally with the background texture.

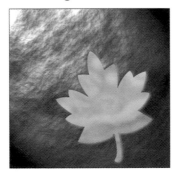

STEP 14. Applying the Soft Light Blend Mode

Click on the image1 layer in the Layers Palette to select it, and then choose Layer > New > Layer via Copy (Ctrl+J) to create a copy of the layer. Double-click on the copied layer's name, type **image2**, and then press Enter to rename the layer.

Click on the Add a Layer Style button, and then click on Blending Options. In the Layer Style dialog box, choose Soft Light from the Blend Mode drop-down list, and then click on OK.

STEP 15. Entering Text and Adjusting Its Size

Click on the Set Default Foreground and Background Colors button in the toolbox to reset the foreground color to black. Choose the Horizontal Type Tool from the toolbox, and then click on the Toggle the Character and Paragraph Palettes button on the Options bar to open the Character Palette, if necessary. Specify the font and font settings shown here in the Character Palette.

Click in the image window, enter the text as shown, and click on the Commit Any Current Edits button on the Options bar. Also, use the Character Palette to adjust the size and color of selected words as shown. Click on the Commit Any Current Edits button on the Options bar after you make the final changes.

STEP 16. Typing @ and Adjusting Its Size

Click on the image2 layer in the Layers Palette to select that layer. Specify the font and font settings shown here in the Character Palette.

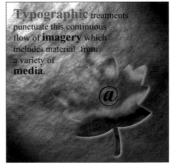

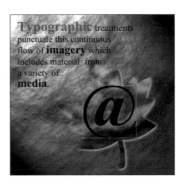

Click in the image window, type **@**, and click on the Commit Any Current Edits button on the Options bar.

Choose Edit > Free Transform (Ctrl+T) from the menu bar, use the selection handles to adjust the size and position of the @ symbol, and then press Enter.

STEP 17. Applying a Layer Style to the @ Layer

Drag the @ layer above the other layers in the Layers Palette.

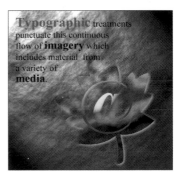

With the @ layer selected, display the Styles Palette by choosing Window > Styles from the menu bar. Click on the Blue Glass style (the fifth style on the top row, by default) to apply it to the @ symbol. Choose Window > Color to redisplay the Color Palette.

STEP 18. Modifying the Shape of the Applied Style

If you examine the @ layer in the Layers Palette, you can see that the Blue Glass style you applied in the last step actually was a shortcut for applying four different layer effects.

You can adjust any of these effects. In this case, double-click on the Bevel and Emboss effect below the layer name to open the Layer Style dialog box. Adjust the dialog box settings as shown here to emphasize the 3D shape of the text, and then click on OK.

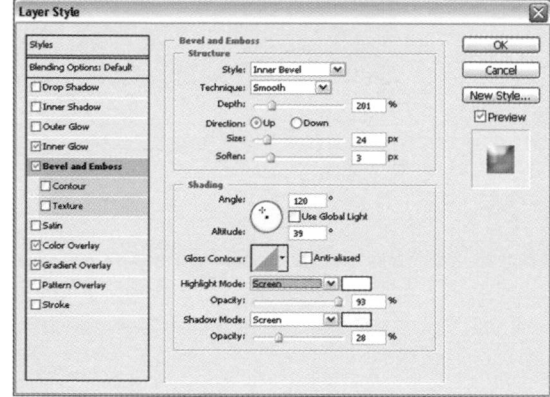
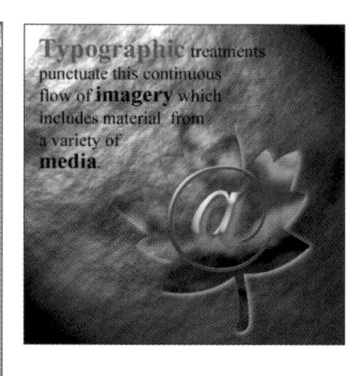

STEP 19. Applying a Shadow to the Text

With the @ layer still selected in the Layers Palette, click on the Add a Layer Style button, and then click on Drop Shadow. Adjust the dialog box settings as shown here, and then click on OK.

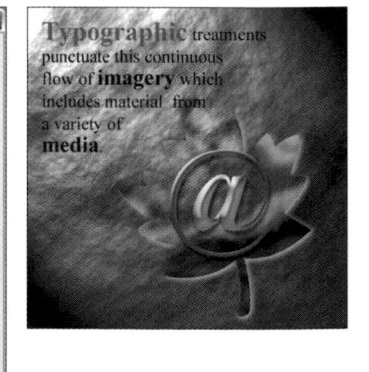

STEP 20. Completing the Image

Click on the Create a New Layer button (Shift+Ctrl+N) on the Layers Palette to make a new layer named Layer 1. Set the foreground color to white, and then choose the Horizontal Type Tool from the toolbox. Specify the font settings as shown here in the Character Palette. Choose a font size that suits your liking, and choose a similar sans serif font if the font shown isn't available. Click in the image window, enter the text as shown, and click on the Commit Any Current Edits button on the Options bar.

Effect 14: Fire Shock

In this chapter, you will use the Wind filter to create a fiery effect around text. Then, you will use the Lens Flare filter along with other effects to develop an attractive stone texture. An image like this makes a fantastic focal point for a Web site, animation, or printed piece.

Effect 14: Fire Shock

Total Steps

STEP 1. Making a New Work Window

STEP 2. Entering White Text on a Black Background

STEP 3. Applying the Wind Filter

STEP 4. Applying Wind from the Other Side

STEP 5. Rotating the Text

STEP 6. Applying Wind to the Top and Bottom of the Text

STEP 7. Rotating the Text to Its Original Orientation

STEP 8. Establishing Fiery Color

STEP 9. Changing the Text Color on the Text Layer

STEP 10. Adding a Blur to the Text

STEP 11. Adding a Glow to the Text

STEP 12. Adding a Cloud Texture

STEP 13. Applying Directional Light to the Cloud Texture

STEP 14. Blending the Cloud Layer with a Red Layer

STEP 15. Blending the Background and the Text

STEP 16. Entering More Text

STEP 17. Illuminating the Edges

STEP 18. Making a Halo of Light Using the Lens Flare Filter

STEP 19. Blending the Halo of Light

STEP 20. Cropping the Image

STEP 1. Making a New Work Window

Choose File > New (Ctrl+N) from the menu bar to open the New dialog box. Enter **Fire Storm** in the Name text box, set the Width to 800 pixels and the Height to 600 pixels, and then set the Resolution to 150 pixels/inch. Click on OK.

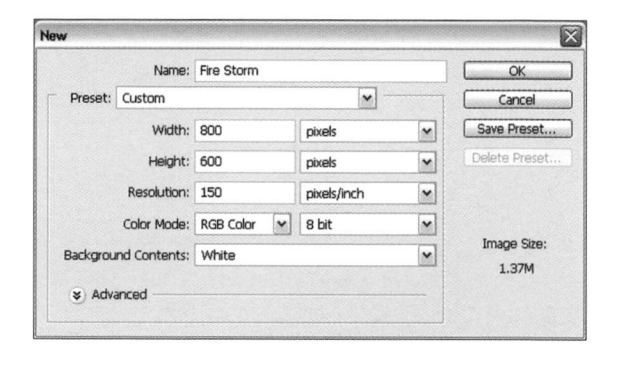

STEP 2. Entering White Text on a Black Background

After you set the foreground color to black, use the Paint Bucket Tool or press Alt+Del to fill the Background layer with black. Click on the Switch Default Foreground and Background Colors button in the toolbox to set the foreground color to white. Choose the Horizontal Type Tool from the toolbox, and then click on the Toggle the Character and Paragraph Palettes button on the Options bar to open the Character Palette, if necessary. Specify the font and font settings shown here in the Character Palette. Click in the image window, enter the text as shown, and then click on the Commit Any Current Edits button on the Options bar.

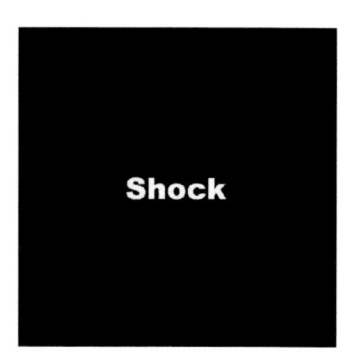

Choose Layer > New > Layer via Copy (Ctrl+J) to copy the new text layer, and then click on the original Shock layer in the Layers Palette to reselect it.

STEP 3. Applying the Wind Filter

Click on the Palette menu button in the upper-right corner of the Layers Palette, and then click on Merge Down to merge the Shock layer and the black Shock copy layer.

Click on the eye icon beside the Shock copy layer to hide it. Choose Filter > Stylize > Wind from the menu bar. Verify that the Wind dialog box has the settings shown here, and then click on OK. The text will look as if it is being blown across the page by wind from the right. To make the effect stronger, press Ctrl+F twice to apply the Wind filter two more times.

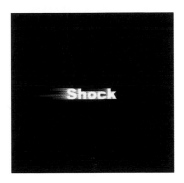

STEP 4. Applying Wind from the Other Side

Choose Filter > Stylize > Wind from the menu bar again. In the Wind dialog box, click on the From the Left option button, and then click on OK. This time, the wind will appear to come from the left to blow the text. Press Ctrl+F twice to apply the Wind filter command two more times. Strong rays of light now will appear to be crossing the text.

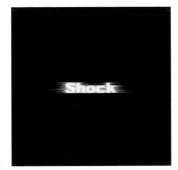

STEP 5. Rotating the Text

You now want to create the same kind of rays of light from the top and bottom of the text. Because the Wind command can only be applied in the horizontal direction, rotate the image 90° before you apply the filter. Choose Image > Rotate Canvas > 90° CW to rotate the image 90° clockwise.

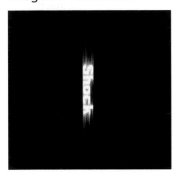

STEP 6. Applying Wind to the Top and Bottom of the Text

Choose Filter > Stylize > Wind from the menu bar. In the Wind dialog box, click on the From the Right option button, and then click on OK. Press Ctrl+F to apply the filter one more time.

Choose Filter > Stylize > Wind from the menu bar. In the Wind dialog box, click on the From the Left option button, and then click on OK. Press Ctrl+F to apply the command one more time.

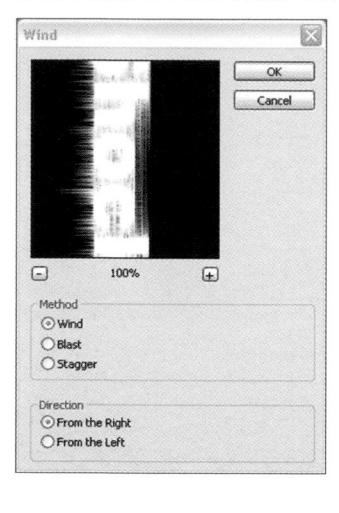
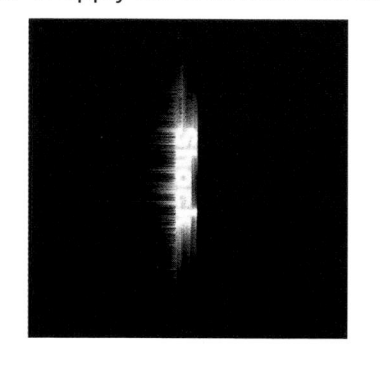
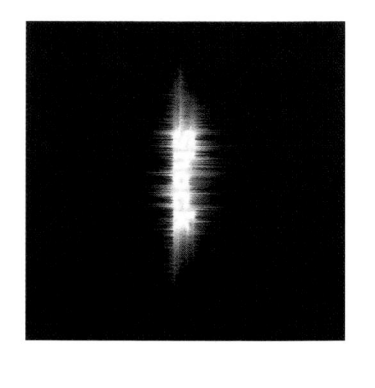
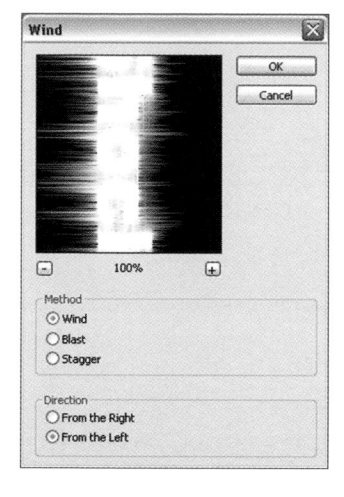

STEP 7. Rotating the Text to Its Original Orientation

Choose Image > Rotate Canvas > 90° CCW from the menu bar to rotate the image 90° counter-clockwise. Rays of light now will shoot up and down from the text.

Choose Filter > Blur > Gaussian Blur. In the Gaussian Blur dialog box, set the Radius to approximately 1.6 pixels, and then click on OK to soften the rays of light.

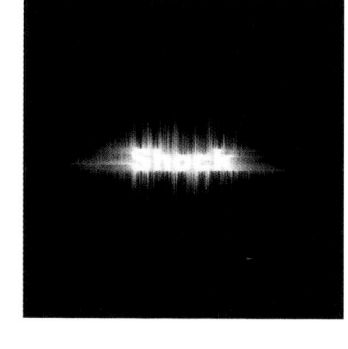
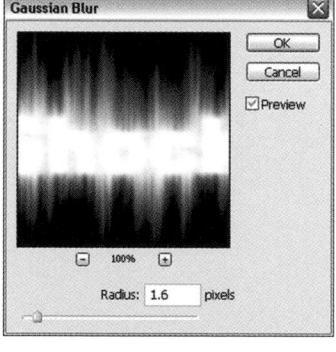
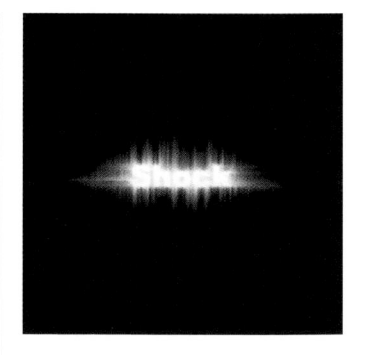

STEP 8. Establishing Fiery Color

Click on the Default Foreground and Background Colors button in the toolbox to reset the foreground color to black. Choose Image > Adjustments > Gradient Map from the menu bar to open the Gradient Map dialog box.

Click on the box under Gradient Used for Grayscale Mapping to open the Gradient Editor dialog box. Click on the first gradient preset in the Presets area, and then create two more color stops at the bottom of the gradient preview to include additional gradient colors. To set up a stop, click on the bottom of the gradient preview, and then use the Color box (not the Color scroll arrow) at the bottom of the dialog box to choose the color for that stop. Click on the bottom of the gradient graph and double-click on the color stop to set up the gradient color, or drag the color stop from side to side to delete.

Click on OK to close the Gradient Editor dialog box, and then click on OK again to apply the gradient.

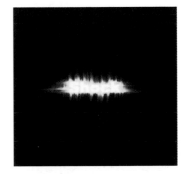

STEP 9. Changing the Text Color on the Text Layer

Click on the Shock copy layer in the Layers Palette to select and redisplay that layer.

In the Character Palette, change the Color setting to a dark brown.

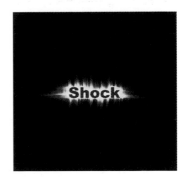

STEP 10. Adding a Blur to the Text

With the Shock copy layer still selected in the Layers Palette, click on the Add a Layer Style button at the bottom of the Layers Palette, and then click on Inner Shadow. Adjust the settings in the Layer Style dialog box, as shown here, and then click on OK. This will create a blurry white shadow on the inside of the brown text.

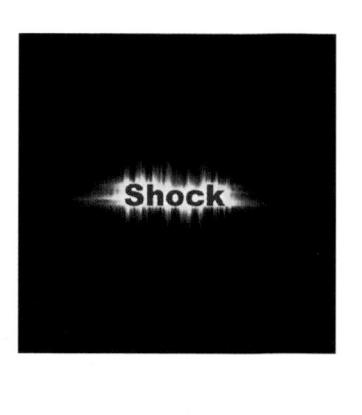

STEP 11. Adding a Glow to the Text

With the Shock copy layer still selected, click on the Add a Layer Style button at the bottom of the Layers Palette, and then click on Inner Glow. Adjust the settings in the Layer Style dialog box as shown here, and then click on OK. This will apply a red inner glow to the text.

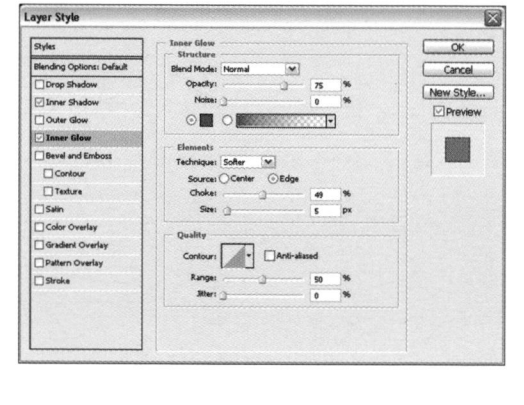

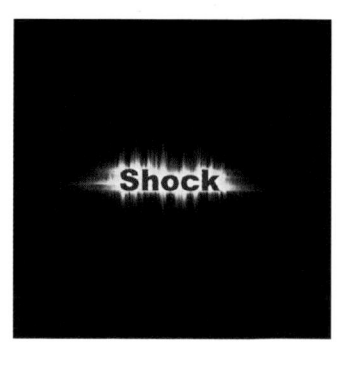

STEP 12. Adding a Cloud Texture

Double-click on the Background layer in the Layers Palette, and then click on OK in the New Layer dialog box to convert the Background layer into a regular layer named Layer 0.

Click on the Create a New Layer button (Shift+Ctrl+N) in the Layers Palette to add a new layer named Layer 1. Drag the Cloud layer to the bottom of the Layers Palette, and then click on the eye icon beside each layer above the Layer 1 layer to hide it.

Click on the Default Foreground and Background Colors button in the toolbox to make the foreground color black and the background color white. Choose Filter > Render > Clouds from the menu bar to add a cloud texture to the Cloud layer.

STEP 13. Applying Directional Light to the Cloud Texture

Choose Filter > Render > Lighting Effects from the menu bar to open the Lighting Effects dialog box. Adjust the handles in the Preview area as shown here to redirect the light to shine from the lower-left corner and to make the light more diffuse. Choose Red from the Texture Channel drop-down list, and then click on OK.

STEP 14. Blending the Cloud Layer with a Red Layer

Click on the Create a New Layer button (Shift+Ctrl+N) on the Layers Palette to make a new layer named Layer 1. Drag Layer 1 below the Cloud layer in the Layers Palette. After you set the foreground color to red, use the Paint Bucket Tool or press Alt+Del to fill the new layer with red.

Click on the Cloud layer in the Layers Palette to select it. Click on the Add a Layer Style button, and then click on Blending Options. In the Layer Style dialog box, choose Darken from the Blend Mode drop-down list, and then click on OK to blend the cloud image with the red background.

STEP 15. Blending the Background and the Text

Click on the box for the Layer Visibility icon beside each hidden layer in the Layers Palette to redisplay it. Click on Layer 0 in the Layers Palette to select that layer. Click on the Add a Layer Style button, and then click on Blending Options. In the Layer Style dialog box, choose Screen from the Blend Mode drop-down list, and then click on OK to remove the black background from around the text and blend the fiery text into the red background.

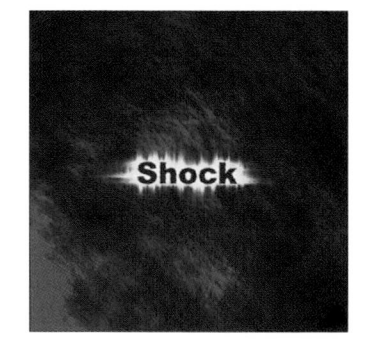

STEP 16. Entering More Text

Click on the Shock copy layer in the Layers Palette to select it, and then click on the Linked Layer box next to the Layer 0 layer so that a chain link appears, indicating that the layers are now linked.

Choose the Move Tool from the toolbox and drag the fiery text to the desired location on the Shock copy layer. The linked Layer 0 content also will move.

Choose the Horizontal Type Tool from the toolbox, type **Fire**, and then specify the font and font settings shown here in the Character Palette. Click on the Commit Any Current Edits button on the Options bar.

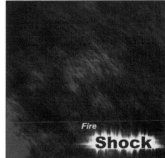

STEP 17. Illuminating the Edges

With the Fire layer still selected in the Layers Palette, click on the Add a Layer Style button at the bottom of the Palette, and then click on Outer Glow. Change the settings in the Layer Style dialog box, as shown here, and then click on OK.

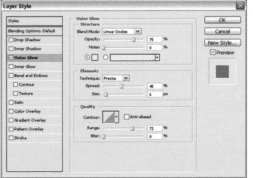
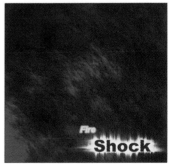

Use the Fill slider on the Layers Palette to change the fill for the Fire layer to 0%. The text will become transparent, but the glow effect around it will remain.

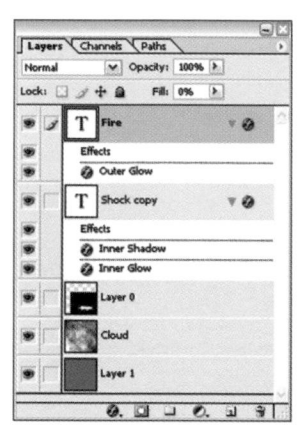

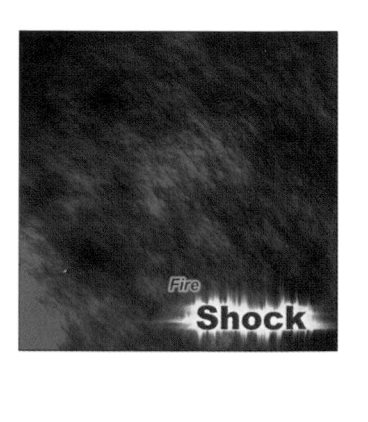

STEP 18. Making a Halo of Light Using the Lens Flare Filter

Click on the Create a New Layer button (Shift+Ctrl+N) in the Layers Palette to make a new layer named Layer 2. Double-click on the new layer's name, type **Flare**, and then press Enter to rename the layer. Drag the Flare layer to the top of the Layers Palette, if necessary.

Click on the Default Foreground and Background Colors button in the toolbox to reset the foreground color to black, and then use the Paint Bucket Tool or press Alt+Del to fill the new layer with black. Choose Filter > Render > Lens Flare from the menu bar. In the Lens Flare dialog box, click near the lower-left corner of the Flare Center box to position the halo of light, as shown here. Click on OK. A halo of light resembling an optical lens effect will appear on the black layer.

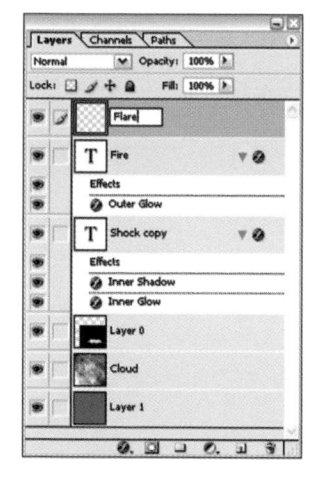

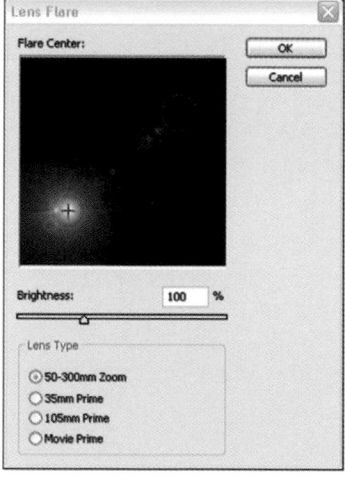

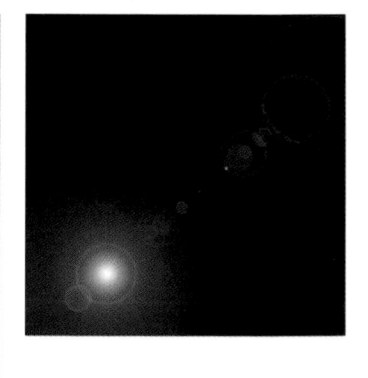

STEP 19. Blending the Halo of Light

With the Flare layer still selected in the Layers Palette, click on the Add a Layer Style button at the bottom of the palette, and then click on Blending Options. Choose Linear Dodge from the Blend Mode drop-down list, and then click on OK. The layer's black fill will become transparent, and the halo of light will blend naturally with the other layers. If desired, use the Move Tool to position the halo of light on the Flare layer in the desired location.

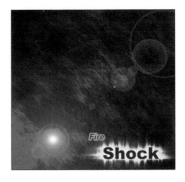

STEP 20. Cropping the Image

Choose the Rectangular Marquee Tool from the toolbox. Select the desired portion of the image, and then choose Image > Crop from the menu bar to remove areas outside the selection.

Effect 15: Universal Light

In this chapter, you will create a windblown light that
appears to originate behind an object. This technique
will add depth to the image. Also, you will use layer
blending modes and opacity settings to create text
that appears to be made of light.

Universal Light

Total Steps

STEP 1. Adding Text to a New Image

STEP 2. Blurring the Text

STEP 3. Making the Text Outline

STEP 4. Applying the Wind Filter to the Text

STEP 5. Rotating the Image and Applying the Wind Filter

STEP 6. Rotating the Image and Applying the Wind Filter Again

STEP 7. Spreading the Light

STEP 8. Adding Color to the Text

STEP 9. Adjusting the Text Transparency

STEP 10. Colorizing the Light

STEP 11. Illuminating the Edges of the Text

STEP 12. Inserting the Earth Image

STEP 13. Arranging the Earth Image

STEP 14. Sending the Earth Image Back

STEP 15. Making the Background Black

STEP 16. Sharpening the Earth Image

STEP 17. Adding a New Layer

STEP 18. Applying the Wind Filter to the New Layer

STEP 19. Creating a Light Burst

STEP 20. Blending the Circular Light Image

STEP 21. Adding a Glow to the Earth

STEP 1. Adding Text to a New Image

Choose File > New (Ctrl+N) from the menu bar to open the New dialog box. Set the Width to 800 pixels and the Height to 650 pixels. Set the Resolution to 100 pixels/inch, and then click on OK.

Click on the Default Foreground and Background Colors button in the toolbox, and then choose the Horizontal Type Tool from the toolbox. Click on the Toggle the Character and Paragraphs Palette button on the Options bar to open the Character Palette, if needed. Specify the font and font settings shown here in the Character Palette.

Click in the image window, enter the text as shown, and click on the Commit Any Current Edits button on the Options bar.

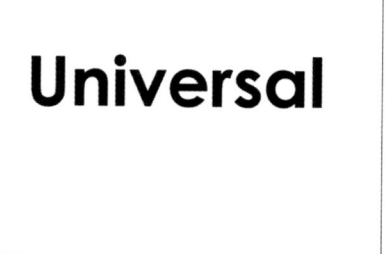

Choose Layer > New > Layer via Copy (Ctrl+J) to copy the text layer. Click on the Create a New Layer button (Shift+Ctrl+N) in the Layers Palette to make a new layer named Layer 1. Drag Layer 1 above the Background layer in the Layers Palette. Click on the Switch Foreground and Background Colors button in the toolbox to set the foreground color to white, and then press Alt+Del to fill the new layer with white. Click on the original text (Universal) layer in the Layers Palette.

Choose Layer > Merge Down (Ctrl+E) from the menu bar to merge the layers. Click on the eye icon beside the Universal copy layer to hide it.

STEP 2. Blurring the Text

Double-click on the Layer 1 layer name, type **Universal** as the new layer name, and then press Enter to rename the layer.

With the Universal layer still selected in the Layers Palette, choose Filter > Blur > Gaussian Blur to open the Gaussian Blur dialog box. Set the Radius to 5, and then click on OK to blur the text.

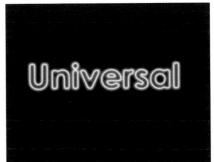

STEP 3. Making the Text Outline

Choose Filter > Stylize > Solarize from the menu bar to make the edges of the text white.

Choose Image > Adjustments > Auto Levels (Shift+Ctrl+L) to optimize the outline's brightness.

STEP 4. Applying the Wind Filter to the Text

Choose Filter > Stylize > Wind from the menu bar to open the Wind dialog box. Choose the settings shown here, and then click on OK to apply the wind to the text.

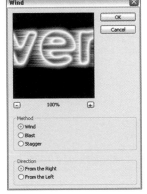

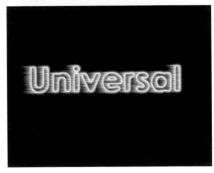

STEP 5. Rotating the Image and Applying the Wind Filter

Choose Image > Rotate Canvas > 90° CW from the menu bar to rotate the image.

Choose Filter > Stylize > Wind, and then click on OK in the Wind dialog box.

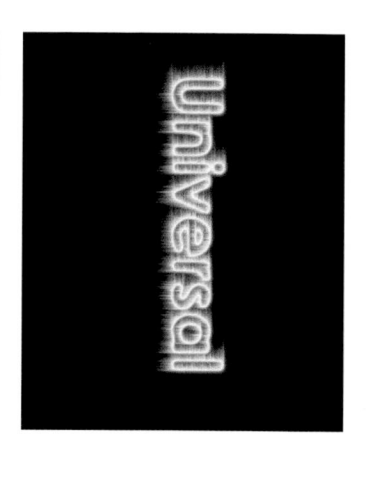

STEP 6. Rotating the Image and Applying the Wind Filter Again

Choose Image > Rotate Canvas > 90° CW from the menu bar again to rotate the image.

Choose Filter > Stylize > Wind, and then click on OK in the Wind dialog box.

You now have created a windy, light effect on three sides of the text. Choose Image > Rotate Canvas > 180° one last time to rotate the image to its original orientation.

STEP 7. Spreading the Light

Choose Filter > Blur > Radial Blur from the menu bar to open the Radial Blur dialog box. Choose the settings shown here in the dialog box, and then click on OK to apply the blur. The text will look as if it is moving rapidly toward or away from you.

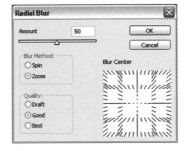 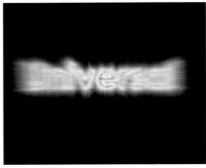

STEP 8. Adding Color to the Text

Click on the Universal copy layer in the Layers Palette to both select and redisplay that layer.

Choose the Horizontal Type Tool in the toolbox and select the text in the Universal copy layer. Then, use the Color Palette to change the text to the color shown here.

Double-click on the layer's name, type **Universal Copy** as the new layer name, and then press Enter to rename the layer.

STEP 9. Adjusting the Text Transparency

With the Universal Copy layer still selected, click on the Add a Layer Style button at the bottom of the Layers Palette, and then click on Blending Options. In the Layer Style dialog box, choose Multiply from the Blend Mode drop-down list, change the Opacity to 40%, and then click on OK. The text will become semi-transparent.

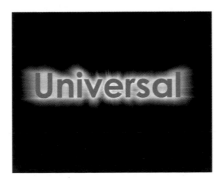

STEP 10. Colorizing the Light

Click on the Universal layer in the Layers Palette. Choose Image > Adjustments > Hue/Saturation (Ctrl+U) from the menu bar to open the Hue/Saturation dialog box. Click on the Colorize check box to select it, drag the sliders to adjust the settings as shown here, and then click on OK.

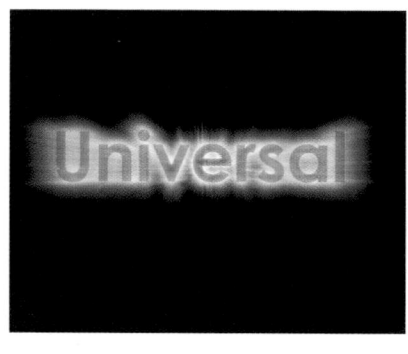

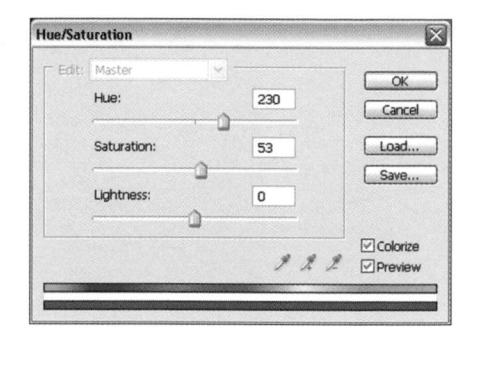

STEP 11. Illuminating the Edges of the Text

Click on the Universal Copy layer in the Layers Palette. Click on the Add a Layer Style button, and then click on Outer Glow. Choose the settings shown here in the Layer Style dialog box, and then click on OK.

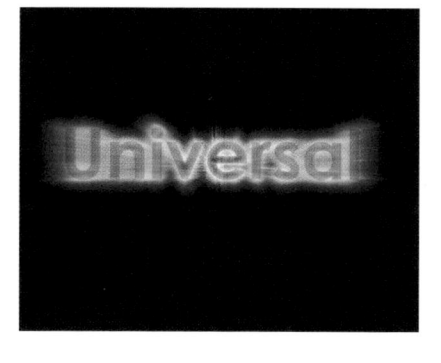

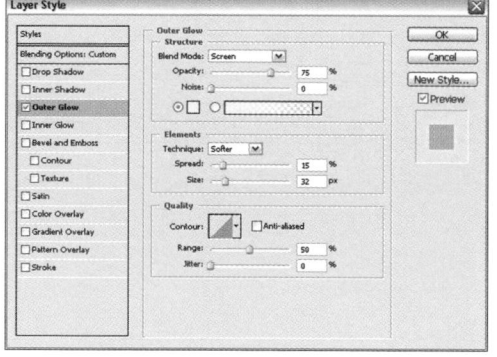

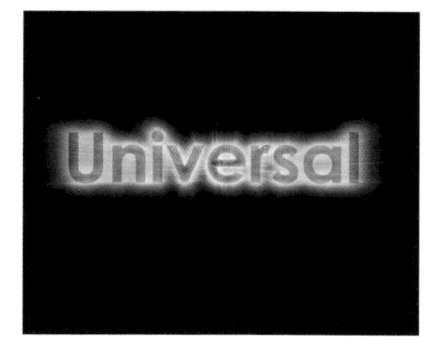

STEP 12. Inserting the Earth Image

Choose Window > File Browser, and then use the File Browser window to open the Book\Sources\earth_Ch_15.jpg file from the supplementary CD-ROM. Choose Window > File Browser again to close the File Browser.

Working in the earth_Ch_15.jpg image window, choose the Elliptical Marquee Tool from the toolbox. Press and hold the Shift key while you drag to create a circular selection marquee around the earth only. (Drag the selection to reposition it, if necessary.)

Press Ctrl+C to copy the selection. Choose File > Close and close the earth_Ch_15.jpg image file without attempting to save changes. Press Ctrl+V to paste the earth image into a new layer named Layer 1.

Double-click on the Layer 1 layer name in the Layers Palette, type **Earth** as the new name, and then press Enter to rename the layer.

STEP 13. Arranging the Earth Image

Choose Edit > Free Transform (Ctrl+T) from the menu bar, press and hold the Shift key, and drag a corner handle to reduce the size of the earth. Drag the earth to align it with the center of the text, and then press Enter to finish the transformation.

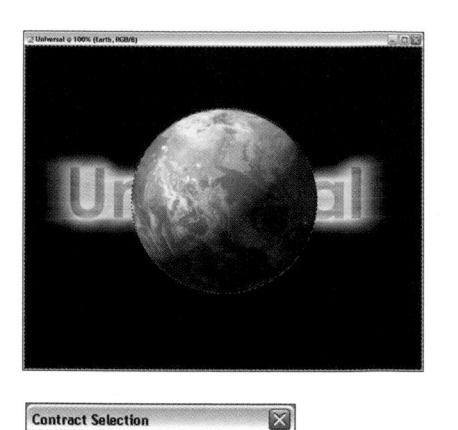

Hold down the Ctrl key and click on the Earth layer in the Layers Palette to select only the earth image on the layer. Choose Select > Modify > Contract from the menu bar to open the Contract Selection dialog box. Change the Contract By setting to 1, and then click on OK to reduce the selection size by one pixel all around. (You may need to contract the image more or less than one pixel, depending on how precisely you cropped the earth.jpg image.)

Choose Select > Inverse (Shift+Ctrl+I), and then press the Del key to clean up the edges of the earth image. Choose Select > Deselect (Ctrl+D) to remove the selection marquee.

STEP 14. Sending the Earth Image Back

In the Layers Palette, drag the Earth layer to move it to just above the Background layer.

Click on the Universal layer to select it. Click on the Add a Layer Style button at the bottom of the Layers Palette, and then click on Blending Options. In the Layer Style dialog box, choose Screen from the Blend Mode drop-down list, and then click on OK. The earth will now appear behind the text.

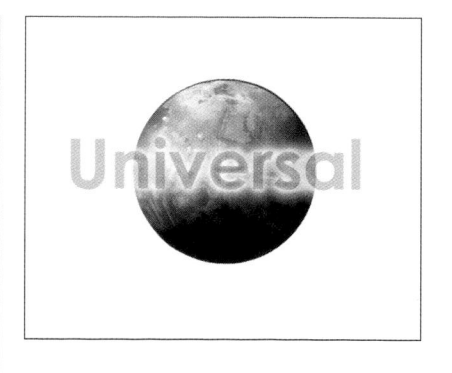

STEP 15. Making the Background Black

Click on the Background layer in the Layers Palette to select it. Click on the Default Foreground and Background Colors button in the toolbox to reset the foreground color to black. Use the Paint Bucket Tool or press Alt+Del to fill the Background layer with black.

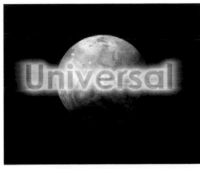

STEP 16. Sharpening the Earth Image

Click on the Earth layer in the Layers Palette to select it. Choose Layer > New > Layer via Copy (Ctrl+J) to copy the layer. With the new Earth copy layer selected in the Layers Palette, click on the Add a Layer Style button at the bottom of the Layers Palette, and then click on Blending Options. In the Layer Style dialog box, choose Overlay from the Blend Mode drop-down list, and then click on OK. The earth will now appear a bit more sharp and bright behind the text.

STEP 17. Adding a New Layer

Click on the Create a New Layer button (Shift+Ctrl+N) in the Layers Palette to add a new layer named Layer 1. Drag Layer 1 to the top of the Layers Palette, above the other layers. With black still selected as the foreground color, use the Paint Bucket Tool or press Alt+Del to fill the new layer with black.

Click on the Switch Foreground and Background Colors button in the toolbox to reset the foreground color to white. Choose the Rectangular Marquee Tool from the toolbox, and then select the right portion of the layer, as shown here. Use the Paint Bucket Tool or press Alt+Del to fill the Background layer with white. Choose Select > Deselect (Ctrl+D) to remove the selection marquee.

STEP 18. Applying the Wind Filter to the New Layer

Choose Filter > Stylize > Wind from the menu bar, make sure the From the Right option button is selected, and then click on OK in the Wind dialog box to add a windblown effect to the white area on the layer. Press Ctrl+F four times to reapply the Wind filter, emphasizing the windblown effect.

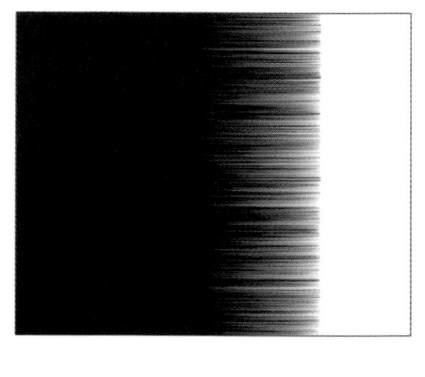

STEP 19. Creating a Light Burst

Choose Edit > Transform > Rotate 90° CCW to rotate the layer's contents so that the white area now appears at the top of the image window.

Choose the Rectangular Marquee Tool from the toolbox, press and hold the Shift key, and drag in the layer to make a square selection that includes the full white bar and the black area beneath it, down to the bottom of the image window.

Choose Filter > Distort > Polar Coordinates, and then click on OK to make the burst of light shown here. Change the foreground color to black and use the Paint Bucket Tool to fill in any white slivers that remain in the black area of the layer.

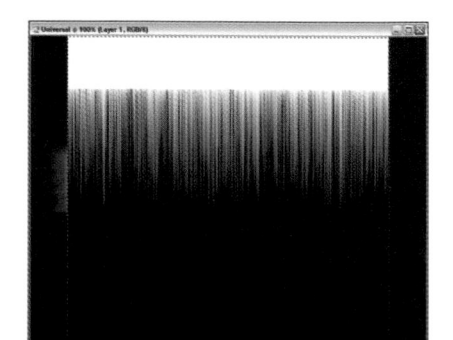

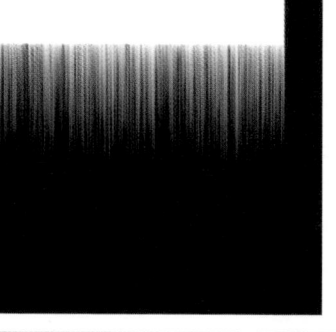

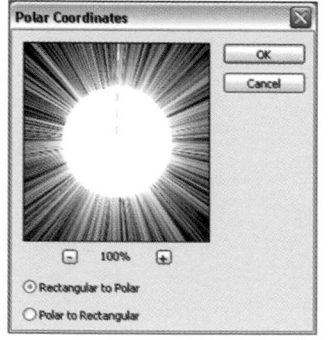

STEP 20. Blending the Circular Light Image

Choose Select > Deselect (Ctrl+D) to remove the selection marquee. Double-click on the Layer 1 layer name, type **Light** as the new layer name, and then press Enter to rename the layer.

Drag the Light layer to move it below the Earth layer. Click on the eye icon beside the both the Earth and Earth copy layers to hide them.

Use the Rectangular Marquee Tool to select only the light burst on the Light layer.

Choose Edit > Free Transform (Ctrl+T) from the menu bar, press and hold the Shift key while dragging a corner handle to resize the burst, drag the burst back to the center of the image, and then press Enter.

Click on the eye icon box beside the both the Earth and Earth copy layers to redisplay those layers and check the position of the burst.

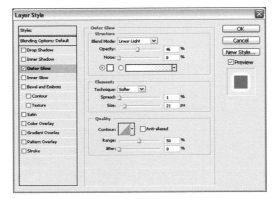
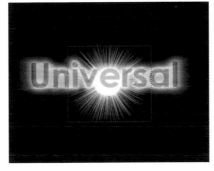

STEP 21. Adding a Glow to the Earth

Click on the Earth layer in the Layers Palette, click on the Add a Layer Style button at the bottom of the palette, and then click on Outer Glow. Make the configurations as shown here to apply an outer glow to the image, and then click on OK.

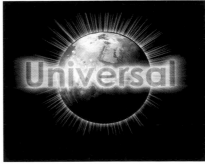

Effect 16: Neon Effect Type

In this chapter, you will use layer styles without the use of filters to create neon type of a desired color.

Professional

Professional

Professional

Professional

Professional

Professional

Professional

Neon Effect Type

Effect 16: Neon Effect Type

PHOTOSH

Total Steps

STEP 1. Creating a New File with a Black
Background

STEP 2. Adding White Text

STEP 3. Scaling and Duplicating the Text

STEP 4. Applying a Glow Effect to the
Original Text Layer

STEP 5. Applying a Glow Effect to the Copied
Text Layer

STEP 6. Inverting a Portion of the Image

STEP 7. Typing in the Remaining Text

STEP 1. Creating a New File with a Black Background

Choose File > New from the menu bar. In the Name box, enter **typo_02**. To accommodate the size of the text you will add, set the Width and Height of the new file to 800 pixels and 300 pixels, respectively. Also, set the Resolution to 100 pixels/inch, and then click on OK to finish creating the new file.

Set the foreground color to black, and then use the Paint Bucket Tool from the toolbox (or press Alt+Del) to fill the file window with the selected color. Adjust the image zoom to a larger percentage, if desired.

STEP 2. Adding White Text

Set the foreground color back to white and choose the Horizontal Type Tool from the toolbox. Click on the Toggle the Character and Paragraph Palettes button on the Options bar to open the Character Palette. Use the Character Palette to adjust the font, font size, and spacing, as shown here.

Click in the file window to position the insertion point, and then type the text shown here. The new text layer will appear above the Background layer in the Layers Palette. You can close the Character Palette if you want.

STEP 3. Scaling and Duplicating the Text

With the new text layer selected in the Layers Palette, choose Edit > Transform > Scale. Drag the selection handles that appear around the text to enlarge the letters so that they fill up the image window, and then press Enter.

To add the neon effect, you need to duplicate the text layer. To do so, make sure the text layer is selected in the Layers Palette, and then choose Layer > New > Layer via Copy (Ctrl+J) to copy the layer.

STEP 4. Applying a Glow Effect to the Original Text Layer

Click on the original text layer in the Layers Palette, click on the Add a Layer Style button at the bottom of the Layers Palette, and then click on Outer Glow. The Layer Style dialog box will open with the outer glow settings displayed.

Outer glow, as the name suggests, creates a glow along the outside of the text. Choose the values shown here to create narrow light diffusions along the outside of the text, and then click on OK.

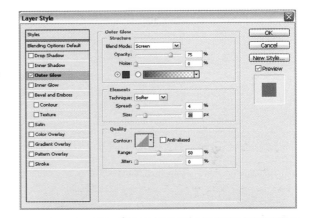

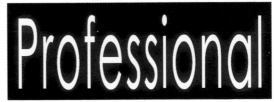

STEP 5. Applying a Glow Effect to the Copied Text Layer

Click on the text layer copy in the Layers Palette, click on the Add a Layer Style button at the bottom of the Layers Palette, and then click on Outer Glow. The Layer Style dialog box will open again. Choose the values shown here to apply a second, wider light diffusion on the copied layer, and then click on OK. When the two glow effects overlap, powerful light effects will appear near the text, creating a wider diffusion to mimic neon effects.

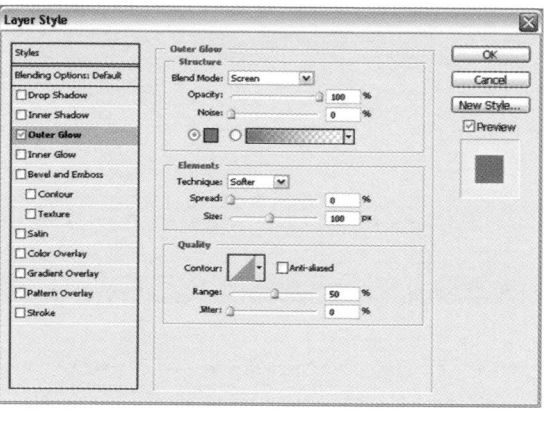
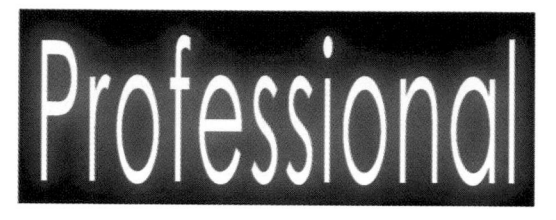

STEP 6. Inverting a Portion of the Image

To apply inverted effects to some portions of the text, click on the Create a New Layer button (Shift+Ctrl+N) in the Layers Palette to make a new layer, and then click on OK in the New Layer dialog box if it appears.

Use the Rectangular Marquee Tool from the toolbox to select the area that will be inverted, as shown here. Set the foreground color to white, and then use the Paint Bucket Tool (Alt+Del) to fill the selection.

Choose Select > Deselect (Ctrl+D) from the menu bar to remove the selection marquee. With the new layer still selected in the Layers Palette, click on the Add a Layer Style button at the bottom of the Layers Palette, and then click on Blending Options. Choose Difference as the Blend mode setting in the Layer Style dialog box, and then click on OK to create the inverted effect seen here.

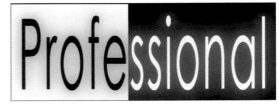

STEP 7. Typing in the Remaining Text

Click on the Create a New Layer button (Shift+Ctrl+N) in the Layers Palette to make a new layer. (Click on OK if the New Layer dialog box appears.)

Set the foreground color to black, and then use the Horizontal Type Tool from the toolbox to specify the font and font size shown here in the Character Palette.

Click just below the "P" in Professional, and then type the text shown at the bottom of the final illustration. Move this layer so that it is below Layer 1.

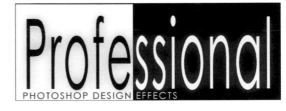

that it is obsolete?
Should it provide inspiration?
Ask questions?
illuminate the frustration inherent in
working?
Make you feel inadequate?

Effect 17: Irregular Cracks

In this project, you will add irregular cracks to fixed letter shapes. You can use the Define Pattern and Paint Bucket Tools to apply irregular crystallization to the entire background.

Irregular Cracks

Effect 17: Irregular Cracks

that it is obsolete?
Should it pro
Ask question
illuminate the
working
Make you

Total Steps

STEP 1. Crystallizing the Background

STEP 2. Sharpening the Background Color

STEP 3. Entering Text

STEP 4. Adjusting the Font Size and Color

STEP 5. Making a Pattern from Irregular Lines

STEP 6. Applying the Pattern to a Layer

STEP 7. Deleting the Pattern from the Text

STEP 8. Displaying the Background with the Cracked Text

STEP 9. Adjusting Text Size and Direction

STEP 10. Moving a Text Selection to a New Layer

STEP 11. Positioning the Text

STEP 12. Blending the Original Text's Colors

STEP 13. Viewing the Result

STEP 1. Crystallizing the Background

Choose File > Open (Ctrl+O) and open the Book\Sources\bg_source.jpg file from the supplementary CD-ROM.

To apply crystallization to this image, which serves as the Background layer for the project, choose Filter > Pixelate > Crystallize. In the Crystallize dialog box that appears, set the Cell Size to 25, and then click on OK.

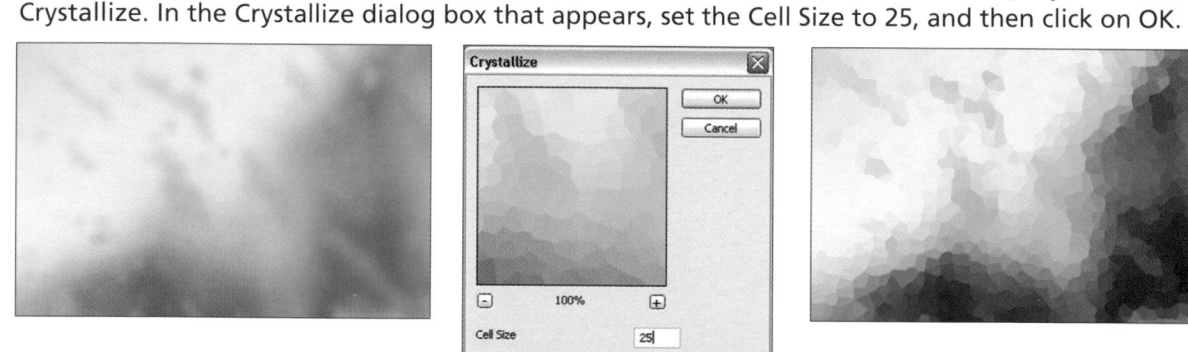

STEP 2. Sharpening the Background Color

Next, sharpen the Background layer's color using the Curves dialog box. Choose Image > Adjustments > Curves (Ctrl+M). In the Curves dialog box, bend the curve into an S-shape. To do so, click on the diagonal line to create two points on the curve, and then drag them into position. Click on OK to apply the changes to the image.

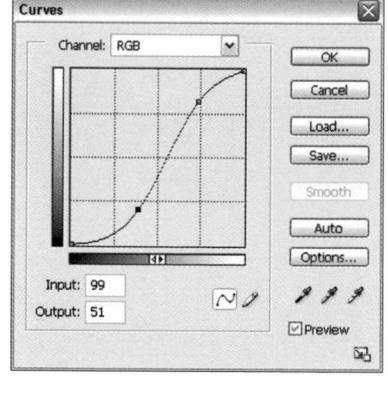

STEP 3. Entering Text

Set the foreground color to black and choose the Horizontal Type Tool from the toolbox. Click on the Toggle the Character and Paragraph Palettes button on the Options bar to open the Character Palette. Use the Character Palette to adjust the font, font size, and spacing as desired.

Click in the file window to position the insertion point, and then type the text. Click on the Commit Any Current Edits button at the right end of the Options bar to finish entering text. The new text layer will appear above the Background layer in the Layers Palette.

STEP 4. Adjusting the Font Size and Color

Alter the font size for selected words and lines to break the tedium and to make the text easier to read. Select each word or phrase, and then change settings on the Character Palette as desired. Click on the Commit Any Current Edits button at the right end of the Options bar to finish the changes. Choose Select > Deselect (Ctrl+D) to remove any selection. Click on the Color box on the Character Palette, choose a red in the Color Picker dialog box, and click on OK. This will change all the text to the red color. You can close the Character Palette if desired. Click on the Commit Any Current Edits button when you have finished editing the text.

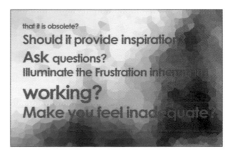

STEP 5. Making a Pattern from Irregular Lines

To create the irregular web-like lines that will be used as the pattern for the cracks in the letters, click on the Create a New Layer button at the bottom of the Layers Palette to make a new layer. Because this might interfere with the other images you have made up until this point, click on the Layer Visibility icon beside each of the other two layers to hide it.

Choose the Pencil Tool from the toolbox. In the Options bar, use the Brush Preset Picker to set the brush diameter to 1 px (1 pixel).

After you set the foreground color to black, if necessary, scribble irregular lines in a portion of the image window. Use the Rectangular Marquee Tool to select all or part of the area where you drew the lines.

Choose Edit > Define Pattern. Type a name for the pattern into the Name text box of the Pattern Name dialog box, and then click on OK to finish creating the pattern.

STEP 6. Applying the Pattern to a Layer

Choose Select > Deselect (Ctrl+D) from the menu bar to clear the selection on Layer 1. With Layer 1 still selected in the Layers Palette, choose Edit > Fill to open the Fill dialog box. Choose Pattern from the Use drop-down list. Click on the Custom Pattern selection icon, and then click on the custom pattern you created in the previous step. Click on OK to apply the pattern to the entire layer.

STEP 7. Deleting the Pattern from the Text

Click on the box for the Layer Visibility icon beside the text layer to redisplay the text. Right-click on the text layer in the Layers Palette, and then click on Rasterize Layer to convert the vector text layer to a bitmapped image layer.

With the text layer still selected, hold down the Ctrl key and click on the pattern layer (Layer 1) to select the pattern lines. Then, press the Del key to remove portions of the text that were covered by the lines. Choose Select > Deselect (Ctrl+D) to remove the selection. Click on the Layer Visibility icon beside the pattern (Layer 1) layer in the Layers Palette to hide it.

STEP 8. Displaying the Background with the Cracked Text

Click on the box for the Layer Visibility icon beside the Background layer to redisplay it. The colors of the Background layer now will show through the cracks in the text.

STEP 9. Adjusting Text Size and Direction

Now change the location and size of selected words or phrases on the text layer. Click on the text layer in the Layers Palette to select it. Choose the Rectangular Marquee Tool from the toolbox. Select a word or phrase on the layer, and then choose Edit > Free Transform (Ctrl+T). Use the selection handles to rotate, reposition, or adjust the size of the selection. Press Enter to apply your changes. Repeat this step as needed for other selections.

STEP 10. Moving a Text Selection to a New Layer

Next, you need to adjust the blending options to make all the text (except the word "working") appear more natural. This requires first moving the word "working" to a new layer of its own. With the text layer still selected in the Layers Palette, use the Rectangular Marquee Tool to select the word "working."

Choose Edit > Cut (Ctrl+X) to remove the selection from the existing text layer. Choose Edit > Paste (Ctrl+V) to paste the cut selection into a new layer, named Layer 2 by default.

STEP 11. Positioning the Text

Choose the Move Tool from the toolbox, and use it to move the word "working" to its original position in the new layer, Layer 2.

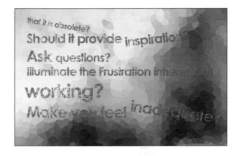

STEP 12. Blending the Original Text's Colors

Click on the original text layer in the Layers Palette to select it. Click on the Add a Layer Style button at the bottom of the Layers Palette and choose Blending Options. Choose Darken from the Blend Mode drop-down list, and then click on OK. This choice will compare the colors on the Background layer and the selected layer, applying the darker color to each non-transparent pixel on the selected layer.

STEP 13. Viewing the Result

You have now arranged the text naturally. You have also added cracks to the text and toned down all the text except the word "working." This makes the text look like a woodcut print made on old and crumpled paper.

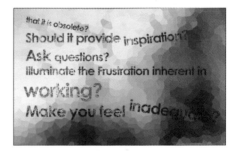

Effect 18: Punched Holes Array

In this project, you will use a lattice of punched-out holes to create a large number. You will learn how to use the Color Halftone filter to display the number as a lattice of colored dots. Then, you will build on the effect by adding a layer with the appearance of punched-out holes and using other filters and layer styles to create dimensionality.

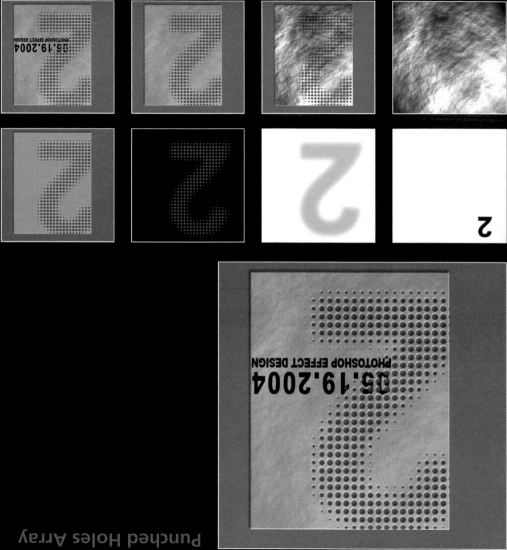

Punched Holes Array

Effect 18: Punched Holes Array

Total Steps

STEP 1. Entering a 2 in a New Image Window

STEP 2. Adjusting the Size and Color of the 2

STEP 3. Blurring the 2

STEP 4. Portraying the Text as Colored Dots

STEP 5. Adding a Black Background

STEP 6. Adding Red to the Black Background

STEP 7. Making the Black Panel Gray

STEP 8. Applying Dimensionality to the
Gray Panel

STEP 9. Adding a Cloud Texture Layer

STEP 10. Adding Dimensional Lighting to
the Cloud Texture

STEP 11. Blending the Cloud Texture and
the Gray Panel

STEP 12. Softening the Texture

STEP 13. Adding Text to Complete the Image

STEP 1. Entering a 2 in a New Image Window

Choose File > New (Ctrl+N) to create a new file. Set both the Width and Height of the new file to 600 pixels. Change the Resolution to 150 pixels/inch. Click on OK.

Choose the Horizontal Type Tool from the toolbox, click in the image window, and enter the number **2**. Click on the Commit Any Current Edits button at the right end of the Options bar to finish entering the text.

STEP 2. Adjusting the Size and Color of the 2

Click on the new text layer in the Layers Palette.

With the Horizontal Type Tool still selected, open the Character Palette and change the settings to match the figure.

Click on the Color box to display the Color Picker dialog box. Choose a light red. To specify the precise color shown here, enter 255, 160, and 160 in the R, G, and B boxes, respectively. Click on OK to set the text color to light red.

Close the Character Palette, if desired. Choose Edit > Free Transform (Ctrl+T). Use the selection handles to stretch the number to fill the screen, and then press Enter to finish the change.

STEP 3. Blurring the 2

Click on the Palette Menu button at the top-right corner of the Layers Palette, and then click on Merge Visible (Shift+Ctrl+E) to combine the text and background layers.

Then, choose Filter > Blur > Gaussian Blur. In the Gaussian Blur dialog box, increase the Radius setting to approximately 12.6, and then click on OK to soften the edges of the number, as shown here.

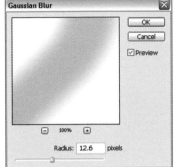

STEP 4. Portraying the Text as Colored Dots

Next, intensify the white tones in the image so the outer edge of the number becomes completely white. Choose Image > Adjustments > Levels (Ctrl+L) to open the Levels dialog box. Slowly drag the right-most Input Levels slider to the left until the right Input Levels value is approximately 245. Click on OK to apply the change.

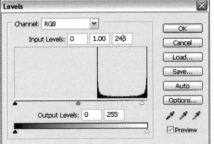

Choose Filter > Pixelate > Color Halftone to open the Color Halftone dialog box. Set the Max. Radius to 12 and set all Channel values (except Channel 1) to 0. (Leave the Channel 1 setting as is.) Click on OK. The red channel in the image will display a lattice of 12-pixel dots.

STEP 5. Adding a Black Background

Choose the Magic Wand Tool from the toolbox, and then click on the white background in the image to select only the background. Click on the Create a New Layer button (Shift+Ctrl+N) in the Layers Palette to make a new layer named Layer 1. After you set the foreground color to black, press Alt+Del to quickly fill in the selection with black on the new layer. Choose Select > Deselect (Ctrl+D) to remove the selection.

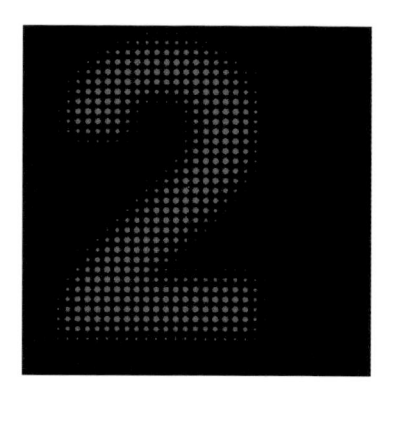

STEP 6. Adding Red to the Black Background

Use the Rectangular Marquee Tool to make the rectangular selection shown here on the Layer 1 layer.

Choose Select > Inverse (Shift+Ctrl+I) to invert the selection. Press the Del key to delete the outer area, which is now the selection frame. Choose Select > Deselect (Ctrl+D) to remove the selection. After you set the foreground color to red using the toolbox or the Color Palette, click on the Background layer in the Layers Palette and press Alt+Del to make the selected area in the Background layer red.

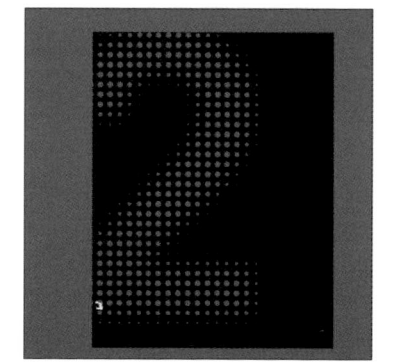

STEP 7. Making the Black Panel Gray

Click on the Layer 1 layer in the Layers Palette. Choose Image > Adjustments > Hue/Saturation (Ctrl+U). Drag the Lightness slider to the right to increase the Lightness to approximately 50. Click on OK to apply the change, which will lighten the black panel in the image to a grayish tone.

STEP 8. Applying Dimensionality to the Gray Panel

Click on the Add a Layer Style button on the Layers Palette, click on Drop Shadow, and click on OK in the Layer Style dialog box.

Click on the Add a Layer Style button on the Layers Palette, click on Bevel and Emboss, set the values shown in the figure, and click on OK in the Layer Style dialog box. These two layer styles will add a shadow and embossing to the gray panel. Icons for the layer styles will appear below the selected layer in the Layers Palette. If you want to adjust either value, double-click on the layer style in the Layers Palette to open the Layer Style dialog box, make the desired changes, and then click on OK.

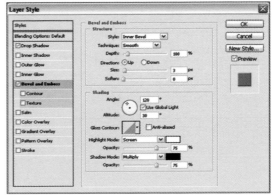

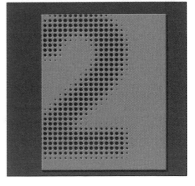

STEP 9. Adding a Cloud Texture Layer

With the gray panel area still selected, click on the Create a New Layer button (Shift+Ctrl+N) on the Layers Palette to make a new layer. After you set the foreground color to black and the background color to white, choose Filter > Render > Clouds. A cloud image will appear in the new layer.

Because the Clouds filter command changes the shape of the clouds randomly, it is nearly impossible to achieve the same results shown here. Reapply the Clouds filter by pressing Ctrl+F until you obtain the desired results.

STEP 10. Adding Dimensional Lighting to the Cloud Texture

Choose Filter > Render > Lighting Effects to open the Lighting Effects dialog box. Drag the handles in the Preview area to match the positions shown in the figure. Set the Texture Channel to Red. Drag the Height slider to the right to increase the Height setting to approximately 67, and then click on OK. The filter settings will adjust the cloud texture to create a jagged, rock-like appearance.

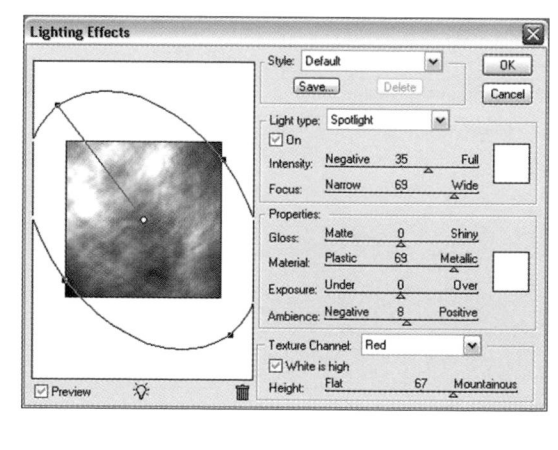

STEP 11. Blending the Cloud Texture and the Gray Panel

Look at the Layers Palette. Layer 2, with the now jagged, rock-like texture, appears above the Layer 1 layer, which holds the gray panel.

Press and hold the Alt key, and then click on the border between the two layers to group them together.

The transparent regions of the gray panel layer will be applied to the texture layer, so the holes in the grid will show through the texture.

STEP 12. Softening the Texture

The rock-like texture overpowers the image, so you can soften it. With Layer 2 (the texture layer) selected, choose Soft Light from the Blend Mode drop-down list. Drag the Opacity slider to reduce the Opacity setting to 45%. The softened texture combined with the gray panel will take on a metallic appearance.

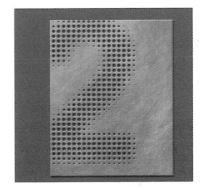

STEP 13. Adding Text to Complete the Image

Choose the Horizontal Type Tool from the toolbox. Display the Character Palette, choose the desired font and size, choose black as the color, and type **05.19.2004** to create the first text layer. Click on the Commit Any Current Edits button on the Options bar to finish adding the layer. Repeat the process to add the text shown here on additional layers.

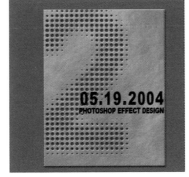

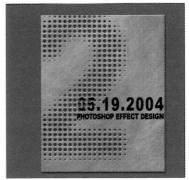

To have the red dots or holes show through the black lettering, hold down the Alt key and click on the border between the first text layer and Layer 2 (the texture layer) to group them together. (Hold down the Alt key and click on the border between additional text layers higher in the Layers Palette to group them with the layers below, too.) The shadow and bevel layer effects applied to Layer 1 (the texture layer) will be applied to all the grouped layers, too.

Projection and Reflection

Photoshop Effect Design

Effect 19: A Grotesque Monster

In this project, you will create 3D text that will appear to have been carved out of stone. You will add lighter areas to parts of the dark image to create the appearance of a gorilla's nose— an effect that's fun and scary all at the same time.

Total Steps

STEP 1. Making a New Image

STEP 2. Entering Text

STEP 3. Rasterizing the Text Layer

STEP 4. Blurring the Text

STEP 5. Merging the Text with the Background Layer

STEP 6. Adding a Cloud Effect

STEP 7. Darkening the Image

STEP 8. Applying Dimensional Lighting to the Image

STEP 9. Entering Text

STEP 10. Entering the Remaining Text and Applying a Glow

STEP 11. Making an Image Layer in the Shape of the Text

STEP 12. Applying Motion Blur to the New Text

STEP 13. Adding Text to Complete the Image

STEP 1. Making a New Image

Choose File > New (Ctrl+N). Enter **typo_08** in the Name text box. In the New dialog box, set the Width to 800 pixels and the Height to 600 pixels. Also, set the Resolution to 100 pixels/inch, and then click on OK.

STEP 2. Entering Text

Choose the Horizontal Type Tool from the tool-box. Open the Character Palette by clicking on the Toggle the Character and Paragraph Palettes button on the Options bar, if necessary. Specify the font and font size in the Character Palette, and then click in the image window and type the text shown here.

Click on the Commit Any Current Edits button on the Options bar to finish. Choose Edit > Free Transform (Ctrl+T) to drag the selection handles to further increase the size of the text, and then press Enter.

STEP 3. Rasterizing the Text Layer

In the Layers Palette, right-click on the text layer, and then click on Rasterize Layer in the shortcut menu. This will convert the vector text layer into a bitmapped image layer.

STEP 4. Blurring the Text

With the text layer still selected in the Layers Palette, choose Filter > Blur > Gaussian Blur. Set the radius to 12. Click on OK to apply the blur to the text.

STEP 5. Merging the Text with the Background Layer

Click on the Linked Layer icon beside the Background layer so that a chain link appears. This will link the Background layer to the text layer.

Click on the Palette Menu button in the top-right corner of the Layers Palette, and then click on Merge Linked (Ctrl+E) to merge the text into the Background layer.

STEP 6. Adding a Cloud Effect

Choose Filter > Render > Difference Clouds from the menu bar. You can reapply this filter to achieve a different effect. Alternate between pressing Ctrl+F to apply the filter effect and pressing Ctrl+Z to remove the filter effect until you achieve the desired result.

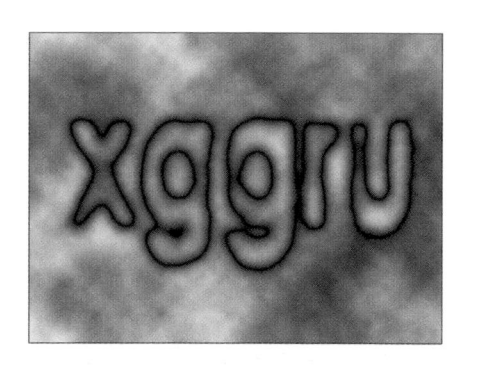

STEP 7. Darkening the Image

To darken the image overall, choose Image > Adjustments > Levels (Ctrl+L). In the Levels dialog box, drag the center Input Levels slider to the right to change the center Input Levels value to approximately .35. Click on OK.

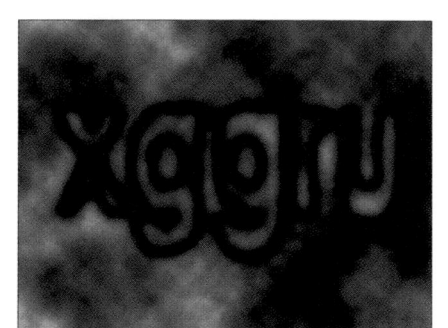

STEP 8. Applying Dimensional Lighting to the Image

Choose Filter > Render > Lighting Effects from the menu bar. Adjust the light source so it originates from the upper-left corner. Choose Red from the Texture Channel drop-down list, and then click on OK. This adjustment using the red channel will give more texture to the image. The shape of a gorilla's nose will subtly emerge.

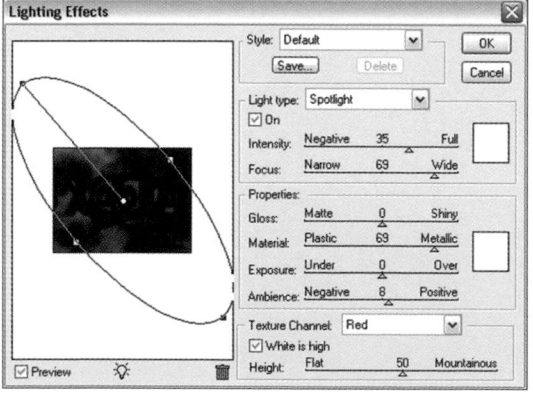

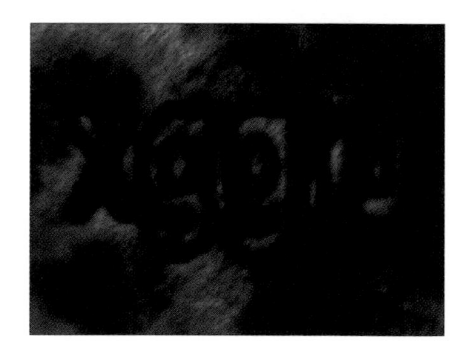

STEP 9. Entering Text

Enter the white text shown here using the Horizontal Type Tool. Use the Character Palette to specify the appropriate font, font size, and color. Click on the Commit Any Current Edits button on the Options bar to finish creating the text.

 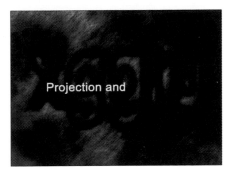

STEP 10. Entering the Remaining Text and Applying a Glow

With the Horizontal Type Tool still selected, type **Reflection**. Click on the Commit Any Current Edits button to finish adding the text, which will appear on a layer separate from the text you added in Step 9.

Use the Move Tool from the toolbox to position the newly added text. Click on the Add a Layer Style button at the bottom of the Layers Palette, and then click on Outer Glow. Choose a red color in the Structure area, and then increase the Size setting in the Elements area to 16. Be sure you make all of the changes shown here. Click on OK.

 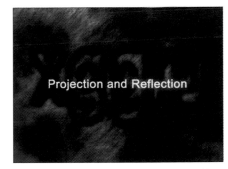

STEP 11. Making an Image Layer in the Shape of the Text

Hold down the Ctrl key and click on the Reflection layer thumbnail in the Layers Palette to select the letters. Choose the Rectangular Marquee Tool from the toolbox, and use it to drag the selection marquee to the center of the image. (Move the mouse pointer over the center of the letters until you see an arrow pointer with a marquee, and then drag to move the selection.) Click on the Create a New Layer button (Shift+Ctrl+N) at the bottom of the Layers Palette.

After you set the foreground color to white, use the Paint Bucket Tool to click within the selection marquee to make all the letters white.

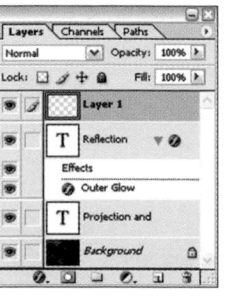

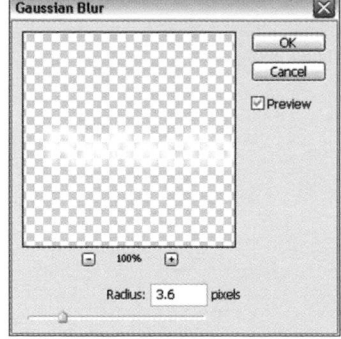

STEP 12. Applying Motion Blur to the New Text

Choose Select > Deselect (Ctrl+D). With the latest text layer (Layer 1) still selected in the Layers Palette, choose Filter > Blur > Gaussian Blur. Set the Radius to approximately 3.6 in the Gaussian Blur dialog box, and then click on OK.

Choose Filter > Blur > Motion Blur. Set the Angle to –90 and the Distance to 65 pixels in the Motion Blur dialog box, and then click on OK.

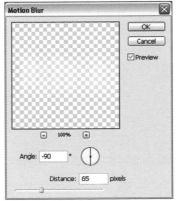

STEP 13. Adding Text to Complete the Image

Choose the Horizontal Type Tool from the toolbox. In the Character Palette, specify the font, font size, and spacing settings shown here. Type the remaining text as shown. Click on the Commit Any Current Edits button on the Options bar to finish, and then close the Character Palette.

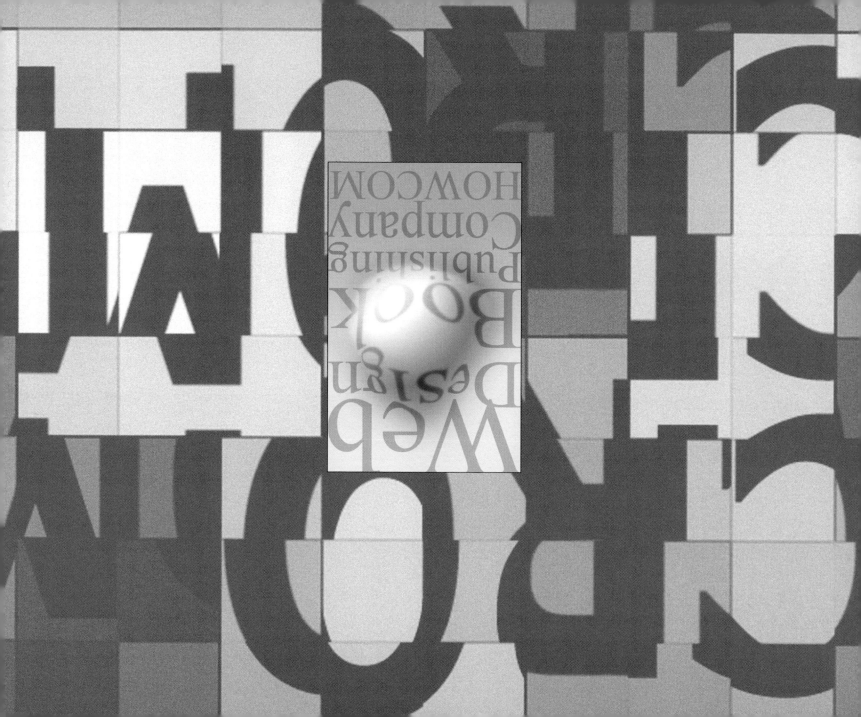

Effect 20: Water Drop Type

In this project, you will create text that appears to be distorted by a single water drop. You will use the Pinch filter to distort the text, and then apply various other techniques to portray the light that shines through the water drop.

Effect 20: Water Drop Type

Total Steps

STEP 1. Making a New Image with a Gray Background

STEP 2. Making Several Text Layers

STEP 3. Editing and Resizing Text

STEP 4. Flattening to the Background Layer

STEP 5. Creating and Copying a Water Drop Selection

STEP 6. Swelling the Water Drop

STEP 7. Making a White Water Drop Layer

STEP 8. Softening the Edges of the White Water Drop

STEP 9. Applying Directional Lighting to the Water Drop

STEP 10. Adding a Shadow to the Water Drop

STEP 11. Softening an Edge of the Water Drop Shadow

STEP 12. Selecting the Water Drop Shape Again

STEP 13. Blurring the Inside of the Water Drop

STEP 14. Sharpening the Water Drop Shadow

STEP 15. Applying a Gradient to the Background

STEP 16. Establishing a Blend Mode for the Gradient

STEP 1. Making a New Image with a Gray Background

Choose File > New (Ctrl+N) from the menu bar to open the New dialog box. Set the image Width to 500 pixels and the Height to 800 pixels. Also, set the Resolution to 150 pixels/inch, and then click on OK.

After you set the foreground color to gray (RGB=217, 217, 217), use the Paint Bucket Tool from the toolbox (Alt+Del) to fill the Background layer.

STEP 2. Making Several Text Layers

Choose the Horizontal Type Tool from the toolbox. Display the Character Palette (click on the Toggle the Character and Paragraph Palettes button on the Options bar), and then choose a serif font and a darker gray color, as shown in the figure.

Type **Web** in the image window, and then click on the Commit Any Current Edits button on the Options bar.

Choose the Move Tool from the toolbox. Press and hold the Alt key while dragging the word "Web" to copy the text and create a new layer to hold the copy. In addition to the Alt key, you can hold the Shift key to keep each copy aligned with the original as you drag. Use the Alt-drag technique to create five more copies of the text.

STEP 3. Editing and Resizing Text

Choose the Horizontal Type Tool from the toolbox. To edit each instance of the word "Web," double-click on the word to select it and its layer. Referring to the illustration here, type new text and click on the Commit Any Current Edits button on the Options bar for each layer.

Click on the layer for each word in the Layers Palette and choose Edit > Transform > Scale. Drag the selection handles to resize the word to fill the breadth of the image, drag the text to reposition it as needed, and then press Enter.

STEP 4. Flattening to the Background Layer

Click on the Palette Menu button in the upper-right corner of the Layers Palette, and then choose Flatten Image to combine the text from all the layers onto the Background layer.

STEP 5. Creating and Copying a Water Drop Selection

Choose the Lasso Tool from the toolbox. Select an area in the shape of a water drop in the middle of the image.

Choose Select > Feather from the menu bar, set the Feather Radius to 5 pixels, and click on OK to soften the edge of the selection.

Copy (Ctrl+C) and paste (Ctrl+V) the selected portion. The copied selection automatically will appear on a new layer named Layer 1.

STEP 6. Swelling the Water Drop

Hold down the Ctrl key and click on Layer 1 in the Layers Palette to reselect the copied water drop shape. Choose Filter > Distort > Pinch from the menu bar. In the Pinch dialog box, change the Amount setting to –66 to magnify the center of the image, and then click on OK.

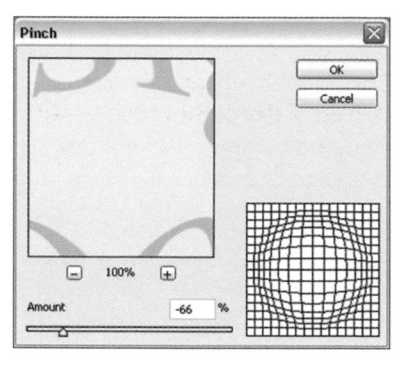

STEP 7. Making a White Water Drop Layer

Click on the Create a New Layer button (Shift+Ctrl+N) in the Layers Palette to add a new layer. The new layer (Layer 2) will be selected. Set the foreground color to white. Use the Paint Bucket Tool or press Alt+Del to fill the selection with white.

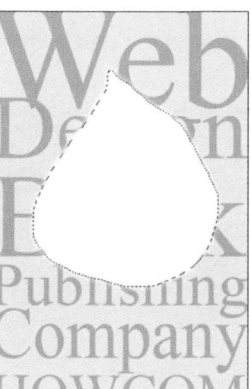

STEP 8. Softening the Edges of the White Water Drop

Choose Select > Deselect (Ctrl+D) from the menu bar to remove the selection marquee. Choose Filter > Blur > Gaussian Blur from the menu bar. In the Gaussian Blur dialog box, change the Radius setting to 40 pixels, and then click on OK.

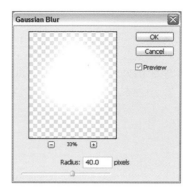

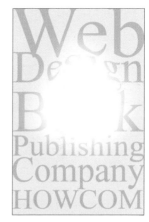

STEP 9. Applying Directional Lighting to the Water Drop

Choose Filter > Render > Lighting Effects from the menu bar to open the Lighting Effects dialog box. Adjust the handles in the Preview area, as shown here, to redirect the light to shine from the lower-right corner. Also, make sure None is selected from the Texture Channel drop-down list. Click on OK.

With Layer 2 still selected in the Layers Palette, click on the Add a Layer Style button, and then click on Blending Options. Choose Linear Light from the Blend Mode drop-down list, change the Fill setting to 79%, and then click on OK.

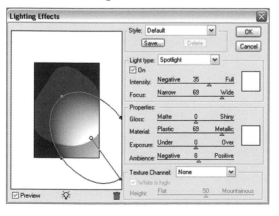

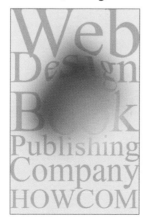

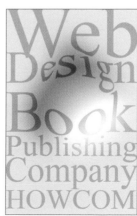

STEP 10. Adding a Shadow to the Water Drop

With Layer 2 still selected in the Layers Palette, click on the Add a Layer Style button, and then click on Drop Shadow. In the Layer Style dialog box, choose the settings shown here, and then click on OK.

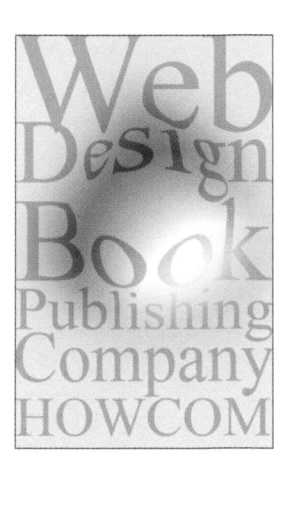

STEP 11. Softening an Edge of the Water Drop Shadow

The lower-right edge of the water drop shadow layer (Layer 2) is too strong. Leave that layer selected and choose the Eraser Tool from the toolbox.

Open the Brush Preset Picker from the Options bar. Choose the Soft Round 100 pixels brush, and then press Enter to close the Preset Picker.

Also, reduce the Opacity setting on the Options bar to 25%. Then, drag the brush over the lower-right edge of the shadow layer content as shown here to blend and soften the shadow.

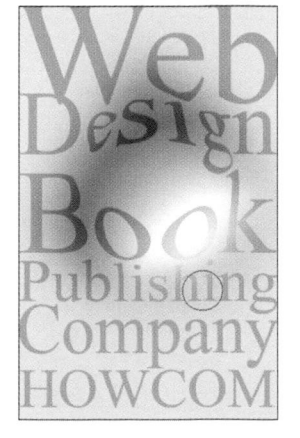

STEP 12. Selecting the Water Drop Shape Again

Click on Layer 1 in the Layers Palette to select that layer. Then, hold down the Ctrl key and click on Layer 2 to make a selection on Layer 1 in the shape of Layer 2's content.

STEP 13. Blurring the Inside of the Water Drop

Choose Filter > Blur > Gaussian Blur from the menu bar to open the Gaussian Blur dialog box. Change the Radius setting to 3 pixels, and then click on OK. This will blur the text seen through the water drop.

STEP 14. Sharpening the Water Drop Shadow

The blurry shadows on the edge of the water drop make it appear too indistinct. Adding a second shadow will make the water drop appear more pronounced. Click on Layer 1 the Layers Palette to select it. Click on the Add a Layer Style button at the bottom of the palette, and then click on Drop Shadow. Adjust the settings in the Layer Style dialog box as shown here, and then click on OK to add a shadow inside the previous shadow.

Choose Select > Deselect (Ctrl+D) to remove the selection marquee. Then, click on the Layer Visibility icon beside Layer 1 and Layer 2 to hide each one.

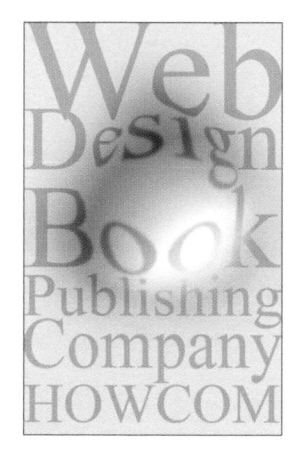

STEP 15. Applying a Gradient to the Background

Click on the Background layer in the Layers Palette, and then click on the Create a New Layer button (Shift+Ctrl+N) to add a new layer (Layer 3) above the Background layer.

Click on the Switch Foreground and Background Colors button in the tool-box to reset the foreground color to white and the background color to black. Choose the Gradient Tool from the toolbox, and then click on the Linear Gradient button on the Options bar. Then, drag straight down from the center of the image window to beyond the bottom of the window to apply the gradient. (Press and hold the Shift key while you drag to keep the direction straight.) You can then redisplay Layer 1 and Layer 2 by clicking on the Layer Visibility icon box beside each one.

STEP 16. Establishing a Blend Mode for the Gradient

With Layer 3 still selected in the Layers Palette, click on the Add a Layer Style button, and then click on Blending Options. In the Layer Style dialog box, choose Linear Burn from the Blend Mode drop-down list. Also, change the Opacity setting to 33%, and then click on OK. This will darken the outer portions of the Background layer to create a deeper effect.

Index